THE
CYCLE

ALSO BY SHALENE GUPTA

The Power of Trust

THE
CYCLE

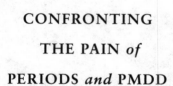

CONFRONTING
THE PAIN *of*
PERIODS *and* PMDD

Shalene Gupta

FLATIRON
BOOKS
NEW YORK

THE CYCLE. Copyright © 2024 by Shalene Gupta. All rights reserved. Printed in the
United States of America. For information, address Flatiron Books, 120 Broadway,
New York, NY 10271.

www.flatironbooks.com

Designed by Kelly S. Too

The Library of Congress Cataloging-in-Publication Data is available upon request.

ISBN 978-1-250-88289-9 (hardcover)
ISBN 978-1-250-88290-5 (ebook)

Our books may be purchased in bulk for promotional, educational, or
business use. Please contact your local bookseller or the Macmillan Corporate
and Premium Sales Department at 1-800-221-7945, extension 5442, or by email at
MacmillanSpecialMarkets@macmillan.com.

First Edition: 2024

10 9 8 7 6 5 4 3 2 1

*For my parents
and Usheer,
beacons of light
that shine brightly
through every storm*

CONTENTS

moment a doctor
all, that I was
behave ba
"I
yo

Shortly after I was diagnosed with premenstrual dysphoric disorder (PMDD), I was talking to a close friend from high school who has depression and anxiety. "Have you ever had a serious mental health issue?" she asked.

Part of me felt insulted. She sounded as if she were talking about an exclusive club, and I wanted in. Then part of me realized I was already in the club and had been a member for a long time—I just hadn't known. "I just found out I have PMDD," I said.

"I don't know what that is," my friend said.

"Think severe PMS," I said.

I could tell my explanation wasn't landing so I gave her a short description. Having PMDD means that for a few days a month, right before my period, I morph from a quiet, conflict-averse introvert to an implacable storm of anxiety, depression, and rage. I scream; I throw things; occasionally, I attempt suicide. Then, just as suddenly as the storm appears, it vanishes only to come back next month. Before I got diagnosed in 2020, I'd never heard of PMDD. Instead, for years, I assumed I was a bad person with poor emotional control, and because of this I worked hard to hide my episodes. Sometimes, my diagnosis still felt made up, as if at any

would call and say that PMDD wasn't real after
really just a disaster casting about for an excuse to
dly.

wouldn't say it's serious," I said. "Not compared to what
u've gone through."

"Honey," my friend said, "I've never been suicidal. I can't
believe you deal with this every month." Then she demanded,
"How have I never heard of this before? Why didn't I know?"

These were the same questions I asked when I was diag-
nosed. When the medical community first proposed that PMDD
should become an official diagnosis, the media conflated PMDD
with PMS, a much more common syndrome that refers to the
mild irritation and pain many people experience before their
periods. This confusion contributed to the public branding any-
one who menstruated as crazy. Because people don't talk about
PMDD, we don't understand that a small minority of people can
have severe psychiatric symptoms before their period. Because
we don't understand this, people with PMDD are not getting
the help they need, so they suffer in silence and shame—hiding
their symptoms instead of talking about them, and so the silence
grows deeper, trapping people with PMDD in a vicious cycle.

I wanted to write this book to break the cycle of silence and
to answer the question that too many still ask: What is PMDD,
and why have I never heard of it before?

But deciding to break my silence was easier than actually do-
ing it. As I read about PMDD, I was forced to walk through the
dusty chambers of my mind. I yanked stories and half-forgotten
moments from chests and cabinets that I'd locked up tight. I
dumped them on the floor and stared at the carnage. There was
nothing here that I wanted anyone to see. There wasn't anything
I wanted to revisit. I'd worked for so long to present a calm and
collected façade to the world even if I'd spent the night before
attempting suicide or screaming at my boyfriend. Why would I

want to tell anyone about the worst moments of my life now that I was finally getting treatment and doing better?

Then I thought about the first person I'd ever spoken to who also had PMDD, a woman named Joy. When Joy smiled, it looked like the sun was rising in her face. She spoke slowly and softly, taking great care with her words, and she had a habit of ending answers with questions that reeled me in.

PMDD riddled Joy's life with anxiety and panic attacks—the kind where you lock yourself in the bathroom and curl up sobbing all day. She saw doctor after doctor but no one could tell her what was wrong. Her solution was to isolate herself from everyone she knew. She left her husband in 2003 because she didn't want him to deal with her illness. After that, her life was a series of doctors' visits, until she was able to get a diagnosis and treatment in 2019.

We spoke for six hours and talked about everything: she told me about getting diagnosed as a Black woman; I told her about getting diagnosed as an Asian American woman. We talked about love and breakups and following your dreams. No matter what tangents we went off on, we circled back to PMDD, the disorder that affected our minds, our bodies, and the very course of our lives.

Shortly after her diagnosis and treatment, Joy made a video about her journey with PMDD and shared it on social media. Her ex-husband saw the video and reached out. He'd never remarried and he still thought about her. They found they were still deeply in love even though sixteen years had passed. When we talked, they'd been reunited for a year. At forty-six, she was looking forward to starting the rest of her life. Joy wanted to tell her story to as many people as possible. Now that we'd been treated and were doing better, she thought we had a duty to help others with PMDD so they could live their best lives.

In the spirit of doing this, I conducted over a hundred

interviews with researchers, doctors, and people with PMDD and their family members. *The Cycle* isn't just about the menstrual cycle but also about the sociopolitical cycles that surround PMDD: the never-ending loop of social stigma against menstruation that means menstrual disorders go untreated, adding more stigma to menstruation; the way knowledge about menstrual disorders goes on to feed sexist stereotypes; and the endless barriers to diagnosis and treatment. Chapter 1 provides an overview of what we know about premenstrual mood disorders, including PMDD. Chapter 2 examines how our society is mired in menstrual stigma, which creates a silence around menstruation and menstrual disorders. Chapters 3 and 4 chart the journey to get PMDD defined as a disorder. Chapters 5, 6, and 7 explore what life is like with PMDD: the challenges of treatment, and how people carry on with their careers and relationships. Finally, chapter 8 is a call for all of us to create a better world for people with PMDD, whether we have PMDD, love someone who does, or simply want more support for everyone. Wherever possible, I've tried to use gender-inclusive language but in some cases, for the sake of clarity, particularly when discussing sexism in history, I've chosen to use the words *woman* and *women*. At the request of some interviewees, I have used pseudonyms, as is the case with some of the people mentioned in my memories.

For years I imagined I was alone in my monthly PMDD spirals. I spent many nights wandering through my neighborhood because staying home meant a screaming battle with my boyfriend. I'd wonder where to go next and what I should do when I got cold or tired. I had friends who would have taken me in, but I did not think it was fair to make them cope with my monthly messes. Still, as I walked past lit windows and families settling down into their bedtime routines, I felt terribly alone.

I wondered what was wrong with me and my life. Month after month, I ended up in the same place, screaming at the person I loved best in the world, shuddering with rage and shame.

As I interviewed people for this book, I realized that during all those years, I had never walked alone. I'd always been part of a family. Perhaps we did not know each other by name, but in spirit we lived the same lives. Month after month, we battled our minds to stay alive in the hope that another, better day would come. For a few of us, the next day did not come. For some of us, better came and stayed, but for many, better would come only to vanish once again with the turning of our cycles.

This is our story. I wrote it for the people who ride the storm of their emotions every month but do not know what is happening or why, for the people who love them regardless, and for Joy.

The PMDD Problem

It is 3:00 AM in the early spring of 2020, the beginning of the pandemic, and I am carving stars into my leg with a butcher's knife. Or, at least, I'm trying to. Skin is surprisingly tough, knives are surprisingly painful, and a butcher's knife may not have been the right choice for the job at hand. The most I've been able to achieve are a few scratches, which fills me with a vague sense of embarrassment. If you're going to crack, you should at least do it properly.

The day didn't start promisingly. I'd woken up angry and depressed for no conceivable reason. My relationship was fantastic: I'd somehow found a man willing to listen to me blather on about Machiavelli and manga, flattering sweatpants, and my latest writing project. My career was going reasonably well: my boss and I had just submitted the final manuscript of our book on trust and business for publication. My childhood had zero trauma, unless BC Calculus and AP Physics count. Even then, my teachers let me off with a B-plus and nurturing advice: don't become a scientist.

All day I'd vacillated between fighting with my boyfriend, crying, and wrestling with a hurricane of anxiety and rage that spun me around and around. My boyfriend had gone to sleep,

exhausted from trying to calm me down while also trying to figure out why I suddenly hated him. The pain of cutting up my leg was at least soothing. It blunted the depression, leaving me calm.

My boyfriend, however, did not feel calm when he woke up and found me on the couch with a giant knife. When he took the knife away, I had nothing to take my mind off the depression. I started slapping myself. He yelled at me to stop. When that didn't work, he sat on me. I wriggled away and started slapping myself again. Finally, after two hours, I relented, exhausted. I had purple shadows on my jaw, a starburst across one eye, and bruises up and down my arms. Part of me was impressed. I don't have the upper-body strength to do a push-up, but I managed to pack an excellent punch. The other part was horrified. I looked like a victim of domestic violence. Except the abuser was me: I had done this to myself.

Ever since my teens, I've been prone to fits of depression and anger right before my period. For half of the month, I'm deadline obsessed, even-keeled, and incredibly boring. At parties, I drink mocktails and huddle in the corner, but mostly I don't go to parties because I'd rather organize my bookshelf or shoe collection. For the other half of the month, I'm still deadline obsessed, but also depressed or angry.

If I'm depressed, the typical routine is to clutch my boyfriend around the middle, then we'll trot off to the bakery and buy cakes. At home, I'll sob into those cakes. I love depression. I love depression because the alternative is so much worse. If I'm not depressed, I'm angry.

If I'm angry, my boyfriend and I will have a knock-down, drag-out fight. I'll scream at him to pack up his things because he obviously doesn't love me, we're done, we're over, and I never want to see him again. If it's really bad, I'll throw things: the contents of my desk, everything on my desk, the desk itself. . . . (Actually

not the desk itself, see also limited upper-body strength.) My only comfort is that I'm not physically abusive with anyone except myself—and, even so, I worry that one day the thin thread of control I retain that whispers *don't hurt anyone physically except yourself* will snap. What little self-respect I still have would completely melt away.

For most of my life, I assumed I was simply a bad person because, no matter how much I wanted to, I could never control my spiraling emotions. No matter how much I vowed I'd do better and be a better person next month, I failed. What I didn't know for years, and would find out a few weeks later, was that I wasn't a bad person. I was ill. I have a premenstrual mood disorder called PMDD: premenstrual dysphoric disorder.

PREMENSTRUAL MOOD DISORDERS 101

I had never heard of PMDD, or premenstrual mood disorders in general, before I was diagnosed in 2020. I'd heard of PMS (premenstrual syndrome). My understanding of PMS was based on a few health classes, a couple of conversations with friends, and some light scrolling through cheerfully worded health websites. In short, as I understood it, PMS means a few people might be grumpy or feel emotionally sensitive a couple of days before their period, or they might struggle with cramps, but the majority of people experience few if any symptoms. Avoid junk food, cut caffeine and alcohol, do some yoga, and go for a jog, and you'll be just fine. I did all these things and I never was.

There was very little information on PMDD, so shortly after my diagnosis, I contacted Dr. Tory Eisenlohr-Moul, one of the foremost experts on menstrual mood disorders. I conducted a series of interviews with her, culminating in a visit to her lab. Dr. Eisenlohr-Moul, who told me to call her Dr. Tory, is an associate professor of psychiatry at the University of Illinois Chicago, where

she researches premenstrual mood disorders. In addition to running her lab, she's the chair of the International Association for Premenstrual Disorders' clinical board and frequently conducts webinars for other clinicians and researchers.

Dr. Tory has a septum piercing and crinkly blond hair that reminded me of ramen. We walked down the wide avenues of UIC's campus as she explained both the nuts and bolts of PMDD and her work. We stopped by the ivy-covered building where people come for research studies.

Inside, it looked just like a doctor's office, right down to the lines of wood chairs upholstered in teal cloth in the waiting room. Later, we visited the wet labs, where she sends blood samples to be analyzed. The winding corridors of the lab open up into rooms filled with benches for running experiments and equipment: giant freezers full of blood samples and bulky mass spectrometers that can analyze hormone levels. Dr. Tory packed entire seminars about the biology and history of premenstrual mood disorders into her answers, which left me scrambling to take notes, but she was always patient with my questions, even if they meant going far back to science basics like what *exactly* are hormones?

Some quick biology 101. Hormones are the body's chemical messengers. They tell different parts of the body to turn certain processes on or off. Estrogen and progesterone, the two primary hormones associated with menstruation, are linked to sexual and reproductive development, but also to the regulation of cholesterol levels, bone density, mood, cardiovascular health, and skin.[1] During the menstrual cycle, these two hormones are in flux.

Menstrual cycles vary from twenty-one to thirty-five days, but for the sake of simplicity, I'll assume a typical menstrual cycle is twenty-eight days. The first half is known as the follicular phase: on the first day, bleeding starts because the uterus is in the

process of shedding its lining, which can last for about a week; estrogen and progesterone are at their lowest. During days 6 to 14, estrogen levels in the body rise and the uterus starts rebuilding its lining so a potential fertilized egg can implant.[2] Around day 14 (give or take a few days), one ovary will release an egg, an event called ovulation.[3] Estrogen levels drop right after ovulation.[4] During the second phase, called the luteal phase, estrogen and progesterone increase until about day 21 to thicken the lining of the uterus; then they drop if there's no fertilized egg present. Around day 28, bleeding begins and the cycle starts again.[5] These time frames vary from person to person, but the pattern is roughly the same—the uterine lining builds up, estrogen rises, ovulation happens, estrogen falls, both estrogen and progesterone levels increase and then fall, and then bleeding occurs as the lining is shed.

PMS, or premenstrual syndrome, refers to any of the changes the body goes through during the cycle. The phrase *premenstrual syndrome* is a bit of a misnomer. PMS can occur any time, usually after ovulation and up to five days after bleeding occurs.[6] Moreover, PMS isn't just about feeling grumpy and bloated. Over 150 PMS symptoms have been identified, including bloating, headaches, clumsiness, mood swings, and sleep disorders.[7] The menstrual cycle can exacerbate underlying medical conditions, which means symptoms are worse during the luteal phase of the cycle: about 40 percent of women with asthma have reported premenstrual exacerbation of asthma,[8] 50 percent of migraines in women are related to menstruation,[9] and up to a third of women with epilepsy have reported having more seizures shortly before or during menstruation.[10] This stands to reason, given how many different body processes progesterone and estrogen are linked to.

* * *

PMDD, WHICH IS what I have, means having severe mental and physical symptoms before your period. The *Diagnostic and Statistical Manual of Mental Disorders* (see Appendix C), the handbook that mental health professionals use to make a diagnosis, requires experiencing at least one symptom from this list:[11]

- increased mood swings
- anger/irritability
- depression
- anxiety

And at least one symptom from this list, for a total of at least five symptoms:

- decreased interest in activities
- difficulty concentrating
- lethargy
- marked change in appetite
- marked change in sleeping patterns
- sense of being overwhelmed
- physical symptoms such as breast tenderness, joint or muscle pain, bloating, or weight gain

To count as PMDD, these symptoms must be severe enough to cause distress or interfere with someone's work or education or relationships. The symptoms must also appear the week before menstruation and then disappear the week after menstruation finishes.[12]

At times, people are diagnosed with PMDD when they actually have another, lesser-known menstrual mood disorder: premenstrual exacerbation (PME). PME is most commonly associated with existing mental health disorders such as anxiety, depression, and eating disorders. According to one study,

60 percent of women with depression experienced premenstrual exacerbation of their symptoms,[13] while another found that 30 percent of women with panic attacks had more of them during the second half of their menstrual cycle.[14] Unfortunately, there's very little research on PME. Not much is known about why it happens or how to treat it, particularly with regard to mood disorders. As of now, it doesn't even have its own diagnostic criteria. It is simply packaged into the medical definition of PMDD as a sidenote (see Appendix C, item E).

PMDD is different from PME in that the symptoms vanish during the follicular phase, whereas people with PME and a preexisting condition such as depression will continue to experience depression throughout their cycle—their symptoms just get worse around their period. Dr. Tory noted we also don't know if PME is a type of PMDD, or if there are biological differences between PME and PMDD.

Dr. Tory told me that while PME is understudied, researchers do have some idea of what causes PMDD. During the luteal phase, progesterone levels typically rise. Progesterone creates allopregnanolone, a type of hormone produced in the brain that regulates behavior.[15] Allopregnanolone reduces depression and anxiety for most people when it's released. Typically, allopregnanolone binds to the $GABA_A$ receptor, a neurotransmitter receptor. Neurotransmitter receptors bind with brain chemicals, allowing for cell-to-cell communication.[16] Dr. Tory theorized that people with PMDD might have a problem with their $GABA_A$ receptor. Instead of becoming calmer as progesterone levels rise in their bodies, people with PMDD experience the *opposite*. They become anxious, angry, depressed, socially withdrawn, and at times suicidal.[17] In some ways, it's possible to think of PMDD as an allergy to allopregnanolone.

Dr. Tory also hypothesized that there could be up to three different types of PMDD. In the first type, which applies to about

65 percent of people, menstruators have moderate symptoms the week before their period. In the second type, which applies to 17.5 percent, menstruators have symptoms immediately after ovulation for the whole luteal phase. This second type is informally called half-life, since symptoms last for two weeks of the month. In the third type, symptoms occur about one week before menstruation but continue throughout the bleeding.[18]

Anecdotal evidence suggests a correlation between PMDD and autism and ADHD. One study suggested that over half of women with autism have PMDD, while about half of those with ADHD have PMDD.[19] However, these studies were small, and as of yet it's too early to draw conclusions from the existing research.

Similarly, some anecdotal evidence and research suggests childhood physical, emotional, and sexual abuse as well as trauma are also correlated with PMDD. A 2014 study of Turkish women found that those without PMDD scored an average of fifty-nine points on the Childhood Trauma Questionnaire, compared to those with PMDD, who scored an average of sixty-eight points, where the higher number indicates more likelihood of childhood trauma.[20] However, researchers still don't know much about why these correlations exist.

Studies estimate that 3 to 8 percent of menstruators meet the criteria for PMDD.[21] It's harder to get numbers on PME because it covers such a wide variety of symptoms and because it's understudied. One study reported that 40 percent of the women who seek treatment for PMDD actually have PME.[22] While 3 to 8 percent may not seem like a large share of the population, PMDD is narrowly defined. About 48 percent of menstruators experience some form of PMS,[23] and 20 percent don't fit the symptoms for PMDD but experience PMS that's severe enough to interfere with daily life.[24] Since they don't meet the criteria for PMDD, they are left without diagnosis or treatment, even though their lives are disrupted every month.

Psychiatry professor C. Neill Epperson, at the University of Colorado, who specializes in women's reproductive and behavioral health, played a key role in making PMDD an official diagnosis. She considers it a miracle that more people don't have premenstrual mood disorders given the vast impact hormones have on how our brains function. "Our brains are constantly changing to be able to adjust to hormone fluctuations," she said. "Progesterone gets broken down into a steroid that acts like a barbiturate. A woman's brain has to change to accommodate that; otherwise, she'll be sedated during her entire luteal phase."[25]

Experts are divided on the relationship between PMS and PMDD. Katharina Dalton, who pioneered the field of PMS research in the 1950s and ultimately the early studies on PMDD, talked about PMS as a spectrum. The symptoms that she identified as very severe PMS are what we now call PMDD.

Epperson thinks there's room for debate. PMS can include severe physical pain without mood symptoms, but PMDD requires severe mood symptoms. Whether that means there's a spectrum or that they are binary categories is still unclear.[26] A 2017 study compared cells between people who have PMDD and people who do not. The researchers found behavioral differences at the cellular level in people with PMDD: there were differences in the proteins that control how cells respond to ovarian hormones.[27]

Many people I interviewed who have PMDD were frustrated when people call the condition "PMS" or "severe PMS" because they feel as if it invalidates their experiences dealing with a severe illness that is not cured by yoga, Advil, or a hot-water bottle. At the same time, PMDD is a tightly defined group of symptoms that doesn't encompass other types of premenstrual suffering.

There's a growing awareness that PMDD isn't the only premenstrual disorder. One organization, IAPMD, the International Association for Premenstrual Disorders, is at the forefront

of advocating for people with premenstrual conditions. It started off as the National Association for Premenstrual Dysphoric Disorder in 2013, but ultimately decided to move to "premenstrual disorders" out of respect for people who may not have PMDD but do suffer from menstrual cycle symptoms.[28] Still, what is unnamed is frequently unknown. Most of the research that exists is conducted on PMDD. Most of the people I interviewed for this book had PMDD. Only a handful were diagnosed with PME, while others had one or two very severe PMS symptoms. As such, the bulk of this book will focus on PMDD, but it's important to remember that there may be many people who do not fit the criteria for PMDD but who still suffer greatly. Their suffering deserves to be taken seriously.

While having a disorder with a diagnosis is certainly a step up—it means, at least, that there's a name for your pain—on average it takes about twelve years to get a diagnosis for PMDD.[29] One study estimates PMDD will cost people 3.8 years of productivity during their reproductive years.[30] Meanwhile, people with PMDD continue to suffer, and the stakes are high. According to an IAPMD survey, 30 percent of people with PMDD have attempted suicide, and 70 percent have active suicidal ideation. Each of the people with PMDD I interviewed had a similar story. They mentioned a trail of broken relationships and dramatic dustups with friends, families, or partners, and many had trouble completing school or holding down jobs. All of them had been suicidal, and most of them had attempted suicide at least once.

Dawn, forty-two, is a self-identified hippie. Dawn is blond with an angular face and ends her sentences with a breathy laugh. In a previous life she'd worked at Club Med and then moved on to live in a commune. She is effortlessly cool, the kind of person who seems as if she could run into any crisis and bounce away unscathed.

When we chatted, Dawn was living in a farmhouse with her partner. The farmhouse was owned by an older man who let them stay for free. In return, Dawn and her partner helped out with chores. Dawn did as much as she could, except when she had PMDD. Then she isolated herself in an attic so she didn't fight with anyone.

However, the farmhouse owner wanted Dawn to commit to a chore rotation schedule, which she was afraid to do. She didn't tell him she had PMDD, but she did tell him she couldn't be part of a chore rotation. "I told him I can't be part of a team because I know I'm going to let the team down," Dawn said. She paused, her breathy laugh gone. "This is the best living situation I've ever been in, and I'm so afraid I'm going to ruin it for me and my partner. I've ruined so much shit for him." Her voice cracked.

She started describing all the ways in which, she felt, she'd ruined her partner's life because of PMDD. Once, she jumped out of a car while her partner was driving her to work and ran through the fields screaming.

"You know how you just get crazy when PMDD happens?" she said, trying to disguise her tears with a half laugh.

I knew.

THE PMDD PROBLEM DEFINED

After I got my diagnosis, I looked around for a conversation about PMDD. There wasn't much of one. Or, rather, there wasn't much of a serious one. Sure, there are plenty of jokes about PMS and TV shows that portray PMSing women as raging beasts—or, worse, people who imply PMS makes women incapable—but I couldn't find much nuanced conversation about how the menstrual cycle impacts people's bodies and minds.

It's surprisingly difficult to find clinicians who specialize

in PMDD, let alone in premenstrual mood disorders, and the world of PMDD researchers is small.

I asked Dr. Tory how she became interested in studying premenstrual mood disorders given how niche they are. Her interest began when she was a graduate student in clinical psychology at the University of Kentucky. She was training patients in dialectical behavior therapy (DBT). DBT, a type of talk therapy for people with chronic suicidal thoughts and behaviors, emphasizes accepting one's emotions and coupling them with strategic actions that can help them cope. For example, she explained, one might ask oneself, "I notice that I'm angry and have the urge to snap at someone. What skills can I use to protect my relationships?" Dr. Tory noticed that, once a month, some of her patients would suddenly lose their skills. "I'd become the enemy," she said. She did an internship at Duke, where she learned about PMDD. At first, she was skeptical. She did not believe someone's period could make them lose control of their emotions. "I had the typical feminist reaction of *this is not a thing*," she said.

At the same time, she realized she had a personal connection with PME. In college Dr. Tory struggled with alcohol addiction. She'd manage to quit for a few weeks, then she'd have a surge of confidence and think she didn't need to be as vigilant. She'd fall off the wagon and have to start over again. Dr. Tory realized that her addiction was tied to her menstrual cycle. Higher levels of estrogen made her feel more confident, making it harder for her to quit.

Her personal history turned into a professional passion to understand how the menstrual cycle impacts mood and behavior. Today, Dr. Tory is known for creating the Carolina Premenstrual Assessment Scoring System (C-PASS) for PMDD. Researchers use different scales to measure PMDD, which means it's difficult to compare results across studies. C-PASS aims to unify PMDD research. More recently, she's been studying the finer points of

premenstrual mood disorders, such as how ovarian hormones impact adolescent suicidality, ADHD symptoms, and alcohol use. Katja Schmalenberger, a postdoctoral fellow in her lab, studies how the menstrual cycle impacts executive function and working memory, as well as our ability to focus and shift from process to process.[31]

It seems like there's a staggering number of unanswered questions about PMDD, but Dr. Tory pointed out that science has already uncovered a fair amount. "We actually know more about the biology of what causes PMDD than we do about anxiety or depression," she said.[32] Researchers have known about PMDD since the 1950s. Not only that, but PMDD is relatively straightforward to treat. Usually, it requires either birth control or SSRIs (selective serotonin reuptake inhibitors), which are a type of antidepressant, or a combination of both. While SSRIs might take three to four weeks to work for depression or anxiety, they work within the same day for PMDD.[33] The problem arises when doctors and the general public don't talk about what we do know, and therefore we can't use the information to help people with PMDD.

I realized I'd suffered for over a decade before I got a diagnosis and treatment. After that, it had taken me a year to find the proper treatment. Yet PMDD can be treated in a day. What gives? I asked Dr. Tory.

Most medical textbooks don't cover PMDD in great detail, and medical students aren't taught about it, so they are unable to diagnose it, Dr. Tory said. Furthermore, she pointed out, no one wants to be branded as sexist because they suggest a patient's mood might be a result of their menstrual cycle.[34] One clinician mentioned that if she brought up PMDD with a patient, often they were resistant, particularly if they were high-achieving women of color. Today she's working with professors who study race to understand how to communicate the message better.

I had a mixed response to this tidbit. On the one hand, I had not reacted well the first time a therapist suggested my moods and menstrual cycle might be linked. I had a history of being misdiagnosed by doctors and misunderstood in general, an experience I imagine many other women of color share. Great, I thought. Yet one more way in which I was being discriminated against. On the other hand, had I listened, I would have spared myself many years of suffering.

Dr. Tory summarized what I've come to think of as the PMDD problem: we cannot have a nuanced discussion about the menstrual cycle because we live in a society that's steeped in sexism. Conversations about differences in biology quickly become weaponized. In the 1980s, when psychiatrists moved to make PMDD an official diagnosis in the new edition of the *Diagnostic and Statistical Manual of Mental Disorders* (*DSM*), there was an instant backlash. The public conflated PMDD and PMS, and the conversation became one about how all women are crazy, instead of one about how some people need and deserve help.[35]

These attitudes still prevail. In 2015, then presidential candidate Donald Trump said news anchor Megyn Kelly had "blood coming out of her wherever" because she'd called him out for making sexist comments.[36] Trump was censured by his party and disinvited from a major political event, all of which was well deserved. But he was voicing a prevailing and insidious belief: women shouldn't be taken seriously because they menstruate.

As a result, we're simply not having any conversation about PMS, let alone about its more severe cousin, PMDD. We'll talk about why it's sexist to attribute mood symptoms to the menstrual cycle, or we avoid talking about the menstrual cycle at all. Even if we do start talking about PMDD, many people initially have a knee-jerk reaction that PMDD is the imaginary product of a sexist society. After all, many of us are familiar with the

history of the highly gendered diagnosis of hysteria, where doctors blamed the uterus for causing emotional disturbances. Dr. Tory had that reaction when she first learned about PMDD, as did I when a doctor first mentioned that I might have a menstrual mood disorder.

Yet our reluctance to have the conversation about premenstrual mood disorders means that thousands of people suffer every day—and they suffer in silence.

The Periodic Silence
Around Menstruation

When I was twenty-four, I received a Fulbright grant to teach English in Malaysia. My plan had been to teach and write. Instead, I fell in love. It dropped from the sky and wreaked total havoc on my life. Part of me expected this, since I tended to be obsessive in my friendships, but I wasn't prepared for the extent of the damage. Love turned me into someone I didn't recognize: an anxious wreck and a monster.

Malaysia was an accident. I'd actually been aiming for Indonesia, the country where my mother was born and raised. I graduated from college during the Great Recession with a creative writing degree in hand. No one wanted to hire me. After over two hundred applications, I landed a job at the Department of the Treasury writing long reports about financial systems. I knew I was lucky to have a job, and I loved my coworkers, but I did not love my job. I languished in my cubicle. After work, I went home and wrote for hours. Rejections piled up like snowdrifts in my inbox. I felt like somewhere along the way life had stalled. I wanted to be a writer but I had no idea how to make it my career.

When a friend of mine received a Fulbright grant to live in China for a year, I decided to apply for one to Indonesia. I figured I'd park myself on a beach and write a novel. After that,

the plan got fuzzy, but I supposed I'd work it out later. The plan didn't matter anyway, because I was rejected.

In a stroke of luck, the Malaysian Fulbright committee offered me a slot in their program at the very last second. I had to look up Malaysia on a map when I got the offer, but nevertheless I jumped at the opportunity.

Before leaving for Malaysia, all the grantees were required to attend a weeklong orientation at the Grand Hyatt in Washington, D.C. There, I realized I'd made a mistake. My colleagues wore perfectly pressed pants and blouses and polished shoes. They were just as sharp and shiny as their outfits. They mingled during breaks and nibbled on the canapés instead of stuffing their faces in the corner. All of them had stellar résumés, including one woman who had gone to college as a sixteen-year-old. They were star athletes, student council presidents, and premeds: people who knew exactly what they wanted from life and how they were going to get it. None of them seemed as if they'd ever been rejected from anything. Meanwhile, I had a tendency to go silent when I could not think of anything to say, which was often.

During one of the lunches, I bumped into Theo. Theo was tall and thin, with a slight stoop. He had a mop of curly hair and bright brown eyes. He looked like a mad scientist someone had let out of the laboratory: exactly the kind of guy I would have befriended in college at science fiction or anime club. It was easy to picture him twenty years down the road wearing a tweed jacket with elbow patches. I was partially correct: Theo had just escaped from a laboratory. He was in the midst of a Ph.D. program in biology and had originally applied to teach in Taiwan, but was offered a spot in Malaysia instead. We were both there by accident—a coincidence that felt as if fate had conspired to bring us together. He started telling me about his research and then said, "Tell me about you instead."

None of my male friends had ever been interested in my

work before. I liked him immediately. I decided we were friends, and it felt as if we'd already been friends for ages. I relaxed into my chair and started yammering on. I wanted the conversation to continue forever.

When we arrived in Kuala Lumpur for a month of culture and language lessons, Theo and I kept talking. We were placed in towns six hours apart but started texting. In a few weeks, we started dating. I fell for him with a crash and a bang.

I hadn't dated much in college and I'd been unimpressed by many of the men I'd seen my friends date. Most of them expected my female friends and me to form an admiring Greek chorus that cooked and cleaned while they played video games. Many of them assumed I was not a serious student because I was majoring in creative writing. I spent most of college happily revising short stories and poems in the library, assuming I'd spend the rest of my life single in an apartment crammed with books.

Theo struck me as wonderful. He cooked. He cleaned. He was grateful to be in his Ph.D. program, and he worked hard. He could handle my multiethnic background without making insensitive comments. He'd studied Chinese in college and spoke it well enough to joke with my mom. We shared the same quirky sense of humor, and his texts full of truly terrible puns made me laugh. When I decided to apply to graduate school, Theo helped me make flash cards for the GRE and quizzed me at various roadside stalls and coffee shops. Within a few months, I knew I wanted to spend the rest of my life with him.

Yet Theo and I had a problem. Every month, like clockwork, we fought. The fights always had the same pattern. They began with me picking at him for not calling often enough, escalated to both of us screaming at each other, and ended in tears. The fights shook me. I'd never fought with anyone like this before. I didn't know I could fight like this. While I could be moody and anxious, I hated conflict. I'd rarely fought with my previous

boyfriends or my friends. When I did, it usually took the form of making a strategic retreat to my room and avoiding conversation until I felt better. When I fought with my parents as a teenager, which was a more regular occurrence, it also involved hiding in my room. But with Theo, I was a raging, screaming mess.

Once, we fought over a plate of french fries. We'd been traveling all day, motorcycling down long black ribbons of highway and dusty side roads framed by palm trees as the sun beat down overhead. Midafternoon, hungry and tired, we stopped at a roadside stall. Since it was a few days before my period, I was ravenous—in the days before my period, it sometimes feels as if, no matter how much I eat, I'll never be full.

Theo's noodles came first, and he offered me a bite, but no more. In my family, we would have put the plate in the middle of the table and gone after it like lions taking down an antelope. But Theo had only offered me one bite, and though I did not think it was fair to impose my family's social mores on him, I was still ravenous. "Um," I finally said, gathering up my courage, "I know this is kind of inappropriate, but could I have some more noodles?" Theo offered me another bite, but his glance let me know he thought my request *was* inappropriate. I didn't have the courage to ask for more.

When the server set my fries down, Theo dove for them. "There's no way you'd be able to eat all of those," he said, munching happily.

My mind went blank. My appetite vanished. I was furious. Then my brain started up again. *Well,* it reasoned, *maybe you should have asked him for noodles with more confidence. Fries are everyone food,* another part rationalized, *but noodles aren't. This is blatantly unfair,* most of me screamed. All the small irritations that had built up suddenly turned into ticking time bombs. *He's always slow to text. He falls asleep during late-night phone calls.*

He never buys me presents or writes me emails. Now, he's a fry thief. Desperately, I shoved them into a back closet of my mind. *Be a good person. Be the person you want to be.*

"What's wrong?" Theo asked.

"Nothing," I said.

"I can tell something's wrong."

If I opened up, he'd judge me. He'd think I ate too much, I was too needy, I was unreasonable. I shoved the bombs further back. Theo gave up.

I felt my body change temperature: I'd been hot from the sun, but now I was burning up inside, and my skin felt too small. And just like that, the bombs in my mind went off one by one.

"You are so selfish," I hissed—and so it began. For the next hour, I was perfectly free because I finally, truly did not care about what Theo or anyone else thought. I was just cartwheeling helplessly through my rage and there was nothing, nothing at all, that could bring me back to the ground. I was crying and then screaming in public, and I did not care. I was rage, rage was me, and I'd completely lost control.

We spent the next few days completely miserable, not speaking to each other, sleepwalking through life. A few days later, we tearfully made up. After that fight, Theo and I took to eating half of our food and then swapping plates, but the fight left scars. Theo was wary of me. I was wary of me. While I might have started with a valid point, my process was so devastating, it became impossible to respect myself. I had no idea why Theo continued to put up with me.

Perhaps we could have bounced back from one or two, or even a handful, of fights like this, but we fought like this every month: over phone calls that were too short, a lost grocery list, the time he didn't wait with me at the bus station—the list was long, the reasons varied, but the fights remained.

Worse, my memory of what happened would be fuzzy. I don't

remember what I said or did during the french fry fight. Was it the time when I was so incandescent with rage, I flung my shoes into the middle of the road and tried to walk home, the gravel burning my feet? Or the time I got off an auto-rickshaw and started walking on the dark unknown road even though I had no idea where we were? Or was that the day he made me a plate of sandwiches as an apology and I refused to touch them? I remember Theo's face, half hopeful, half woebegone, as he offered up the sandwiches. To this day, I wish I could go back in time and just say "thank you" and eat them. But I can't.

Usually, I have an excellent memory for all the ways I've screwed up. I've lost countless hours of sleep mulling over awkward and embarrassing moments in my life, starting with potty training. (It was traumatic; there are reasons why most people don't remember potty training.) But this memory loss was new. It felt as if I was trying to avoid responsibility, and I hated that. Years later, I would interview dozens of people with PMDD who would tell me about experiencing similar memory loss— including a woman who had lost her best friend from childhood over a fight during a PMDD episode. She cannot remember what she said that ended the friendship, but she does not doubt that her friend had just reason for never speaking to her again. She regrets that she cannot even apologize properly.

I devoted the bulk of my time trying to figure out what was wrong. I talked to my family and friends until they were sick of me. I didn't know how to find a therapist in the small factory town where I'd been placed in Malaysia, but I read countless relationship self-help books. I came up with two primary reasons for our fights.

First was personality. Theo prided himself on being a loner who didn't need people. He was slow to open up to others, and for him work came before relationships. I wanted to be like Theo, but I was the opposite. I believed being a loner meant secretly

wanting a best friend, or five. I felt like the proverbial hopelessly clingy girlfriend. I bought Theo presents whenever I walked into a store, wrote him long emails, and texted him constantly. The only part he reciprocated was the texts.

Second was circumstance. Our grant ended in a year. Theo would go back to school, where, undoubtedly, he'd meet tons of brilliant women who actually understood his research and could discuss it intelligently. Meanwhile, my future as a writer was depressingly unclear. When I'd first told Theo I wanted to be a writer, he'd replied, "Have fun folding clothes at GAP." When I brought up moving in together after the grant ended, Theo was horrified—he wasn't ready for that, he said. It was hard not to see that as a sign that he didn't care about me, which made my anxiety even worse.

In all these cycles of fighting and forgiving, it never occurred to me that there might be a third factor at play: my period. This seems ridiculous in retrospect. I could predict when our bad fights would happen within one or two days of accuracy—they were always right before my period, when my anger had a different quality. During other parts of the month, Theo and I rarely fought, and if we did, it was easily resolved. But during these fights I could not be reasoned with; I could not be appeased.

In my defense, though, no one around me was talking about the emotional aspects of periods. No one was even talking about periods. Characters in books didn't seem to have periods; periods didn't make the headlines. They didn't really make it into music or onto the silver screen, with the exception of *Carrie*, which I'd never watched.

Instead, I drew my own conclusions. I grew up in Minnesota, where being nice is an essential mark of your character. I'd learned early on that if you don't have anything nice to say, you shouldn't say anything at all. Good people don't go nuclear; they

especially don't go nuclear every month; and if they don't like their behavior, they change it. But no matter what I did, I was not able to change. I understood that I was a terrible person. Worse, love—which is supposed to bring out the very best in people— had transformed me into even more of a monster.

MENSTRUAL STIGMA: NOTES ON THE MANAGEMENT OF BLOODIED IDENTITY

Despite the fact menstruation is a normal biological process that three hundred million people worldwide experience on any given day,[1] there's a silence around menstruation that we accept as normal. A 2019 survey reported that 60 percent of menstruators feel uncomfortable talking about their periods at work, and this jumps to 75 percent in male-dominated workplaces.[2] This silence shows up in our public conversations. Over the twentieth century, reporters at *The New York Times* mentioned menstruation only 415 times.[3] It wasn't until 1985 that the word *period* was spoken out loud on TV.[4] As late as 2009, television host Joan Rivers was censored for saying the word *period* on air,[5] even though a few months earlier a *Salon* writer argued that menstruation was no longer taboo.[6]

Menstruation has long been taboo in many parts of the world. The Maya thought menstruation was a punishment for women who had committed adultery—which made nearly all women guilty by default.[7] In several parts of the world, menstruating women are considered unclean and are segregated. In parts of India, Kenya, and Ethiopia, menstruating women are forbidden from cooking, touching livestock or crops, and interacting with men.[8] In Nepal, women are required to stay in a separate hut outside the main household when they menstruate.[9] In some Chinese communities, menstruating women are not allowed to sit on a chair that a man will use, wash clothes, attend public

ceremonies, or go to the temple.[10] Similarly, Orthodox Judaism forbids husbands and their menstruating wives from touching or passing objects to each other. There are some sects of Christianity where women are encouraged not to take communion if they have their period.[11]

While the Buddha thought menstruation was perfectly normal, as Buddhism spread across the globe it could not withstand cultural stigmas around menstruation. In some parts of Thailand and Myanmar, women on their periods aren't allowed to enter temples.[12] Japanese Buddhism is particularly hard on menstruating women. The logic is as follows: when a woman bleeds, she pollutes the ground and waters used to make offerings to the Buddhas and offends them, resulting in bad karma, which results in damnation in Blood Pond Hell, a pool of menstrual blood.[13] In other words, by definition of their biology, women are just damned.

Why have we stigmatized menstruation so consistently across different places and times?

The Canadian sociologist Erving Goffman, considered by some to be one of the most influential sociologists of the twentieth century, wrote the seminal work on stigma. In *Stigma: Notes on the Management of Spoiled Identity*, he notes there are three different types of stigma: abominations of the body, blemishes of character, and tribal associations.[14] Joan Chrisler, a professor emerita of psychology at Connecticut College who specialized in menstruation, among other women's health topics, argues that menstruation fits all three categories of stigma.[15]

The first category, abominations of the body, intuitively makes sense. Menstrual blood comes out of our bodies, and we're not overly fond of discussing bodily excretions. In a 2009 study of fifth- and sixth-grade Taiwanese boys, the boys commented on their disgust over seeing menstrual blood. One stated, "Some girls are truly disgusting. One did not roll up the menstrual

sanitary products and threw it directly in the trash can. You could see the red blood."[16] Just the sight of blood was enough to pass judgment on someone. Theo mentioned once that his ex-girlfriend would occasionally leave blood in his shower during her period, despite her best efforts to be discreet. Although he felt guilty about it, it grossed him out. After that, I started checking the shower too, terrified of grossing him out. The message was very clear: pretend you don't have a period, at all costs.

But our period stigma isn't just a problem with bodies excreting blood. We seem perfectly fine talking about blood from nosebleeds, cuts, and wounds. Many TV shows and movies have no problem showing gory surgeries, gunshot wounds, and people lying in pools of blood. Yet, until 1972, pads and tampons couldn't be advertised on TV, and when the ban was lifted, advertisements used a blue liquid to stand in for blood—and still do today.[17] This squeamishness isn't just in the public domain; it even appears in menstrual educational materials. In an analysis of menstrual hygiene educational booklets published from 1932 to 1997, Chrisler and her student Mindy Erchull found that the books avoided mentioning the biology behind periods and instead highlighted the importance of avoiding accidents or having your pad show.[18] In 2015, when Kiran Gandhi ran the London marathon, freely bleeding from her period, she made headlines. Debates raged over whether she was an activist or disgusting.[19] Gandhi probably wouldn't have made headlines or inspired the same debates if she'd been bleeding from her arm or leg.

You might argue that period blood is different from a cut or a wound because it comes out of a vagina. After all, few people want to talk about what happens when you go to the bathroom. But even those who delight in the fruits of bowel movements are leery of menstruation. The Marquis de Sade, a French nobleman known for his erotic writing, was able to describe amputation, scatology, and the consumption of various body excretions

and body parts for sexual pleasure without blinking, but shied away from menstruation.[20] In his *The 120 Days of Sodom*, the characters describe various sexual fetishes and then try them. Madame Duclos, the novel's first narrator, describes a menstrual fetishist, noting, "I shall lay little emphasis upon the following passions for I realize that there are not many in your midst."[21] Even though menstruation is a routine function of the vagina, the Marquis de Sade and others considered the presence of menstrual blood during sex to be a fetish, and a particularly lurid one. The characters move on with no desire to try menstrual sex. They do, however, try scatological pleasure, mutilation, and murder.[22]

Our stigmatization of periods has to do with more than a mere distaste for bodily fluids. Even when there's no blood, the mere mention of a period can result in backlash. The first reference to PMS on television is considered to be during the third season of *All in the Family*, in 1973.[23] In episode 24, called "The Battle of the Month," the character Gloria marches home in a red dress and complains of a headache because it's that time of the month. When her father tells her he doesn't want to hear about it, they get into a fight over why people don't talk about menstruation.[24] The episode actually presents a nuanced take on women's rights that still hits home fifty years later. Yet it received more mail than any other episode in the show's history, which is notable for a show whose protagonist is known for being a bigot and whose writers didn't shy away from touchy topics. "People wrote in saying things like 'How can you mention menstruation?'" Michael Ross, one of the story editors, told *The New York Times*, even though there's no blood and the only red is Gloria's dress.[25]

Goffman's second criterion for stigma is that it points to a blemish of character. As I mentioned earlier, some Buddhist sects and some cultures consider women damned simply because they bleed. Outside of religious and cultural contexts, this

stigma has a more indirect effect. While we may not go so far as to say that periods are a blemish of character, when we are confronted with evidence of periods, such as stains, or even unused period products, many of us are uncomfortable.

On Reddit's "Am I the Asshole," a popular message board where people post dilemmas and ask the internet to vote on who committed wrongdoing, a sixteen-year-old girl posted about being shamed for using pads to clean up a mess. Over dinner, her mother had dropped her glass and broken it.

> I went into my room, got a sanitary pad and used the adhesive side to pick up the splinters. It worked wonderfully, and after going over the spot with a wet paper towel everything was all cleaned up . . . except for my mom's attitude.
>
> She told me that it was low key gross.[26]

Some on Reddit sided with the teenage girl and celebrated her for being innovative, but her mother's reaction is not an anomaly. In a 2017 study of British schoolgirls, 82 percent had hidden period products and 71 percent felt embarrassed buying them.[27] Our menstrual stigma runs so deep that people with periods stigmatize *ourselves* for a normal biological function.

Yet we have no problem buying and displaying Kleenex or toilet paper in public. While we may hesitate to describe what we do with toilet paper, there's very little shame around purchasing it. A male friend of mine told me when he ran out of Kleenex at work, he grabbed a roll of toilet paper and put it on his desk. No one batted an eyelash.

"What about if someone had pads or tampons sitting on their desk?" I asked. He admitted he wouldn't be comfortable with that. It wasn't just him. In a 2002 study of male and female college students in Colorado, the students were told they would

be partnered with someone else to complete a task. During the task, the partner, who was actually a researcher, dropped either a tampon or a hair clip onto the table while rummaging through her purse searching for lip balm. In the condition where the researcher dropped a tampon, students rated her as less competent and less likable. Moreover, when the researcher dropped a tampon, 53 percent of students made sure to sit with one chair between themselves and the partner. By contrast, only 32 percent of students did this when the researcher dropped a hair clip.[28]

I had hoped that we'd made progress since 2002. I asked my friend's eleven-year-old daughter, Amy, what her peers' attitudes toward menstruation were. Amy mentioned a girl in her class had dropped her purse, spilling the contents on the floor. Everyone had been quick to help the girl gather up her belongings, but they avoided touching her pads. "Those are personal," Amy explained.

The study and these experiences show that people who are presumed to be menstruating, or who are even just carrying menstrual products, are viewed as gross, embarrassing, and less competent than their peers. In addition, the stereotypes that prevail around PMS—that it makes women cranky and depressive—also add to the notion that periods are a blemish of character.

In 1968, Vice President Hubert Humphrey's personal doctor, Edgar Berman, stated that he didn't want women in power because they would be subject to "raging hormonal influences every month." In 1976, Berman further clarified his statement in an interview with journalist Gene Corea: "Menstruation may well affect the ability of these women to hold certain jobs. . . . Take a woman surgeon. If she had premenstrual tension—and people with this frequently wind up in the psychiatrist's office—I wouldn't want her operating on me."[29]

This attitude was echoed in sitcoms, where PMS was depicted

as making women irrational and also harmful. Women who are PMSing, the story goes, are no longer able to do what is best for them or the groups they belong to because they are incapacitated. For example, in *Taxi*, which ran its finale in 1983, the character Simka becomes another person for two weeks every month because of her menstrual cycle. She surrounds herself with bags of chips and keeps canceling appointments with the immigration office, even though she'll be deported.[30] Over a decade and a half later, in 2000, *Everybody Loves Raymond* ran an episode where Debra, Raymond's wife, has epic meltdowns before her period. Raymond eventually convinces Debra to take medication, but the episode ends with Debra having a mood swing and refusing to take them.[31] Essentially, these shows say, PMS makes women selfish and unreliable, an attitude shared by many off-screen. After all, television is merely a reflection of society's values.

Goffman's third category of stigma is tribal affiliation. Goffman was referring to race, nation, or religion, but Chrisler also argues that being a woman is a stigmatized tribal affiliation.[32] Not all women menstruate and not all menstruators identify as women, but many societies see menstruation as the sign that a girl has become a woman. Women are perceived as belonging to a lesser tribe, and we know this because of the many ways they are regularly discriminated against across the world: pay inequity, limited legal protections, and underrepresentation, just to name a few.

We've done such a good job of stigmatizing periods that we're still passing the silence and shame down to younger generations. In the study of fifth- and sixth-grade Taiwanese boys, the boys reported being silenced and then shamed when they asked questions about periods. One boy said: "When I ask questions about menstruation to my mom, then she will make me feel guilty. . . . I am afraid of being blamed for asking. No matter what, I don't want to talk." Another mentioned that teachers forbade boys and

girls to talk about menstruation, and a third said that his mother told him it was an "abnormal topic" when he asked questions.[33] Based on the reactions of the adults around them, the boys concluded that periods were unimportant and not something to be talked about.

The Taiwanese study was published in 2009, but we're not doing much better in the United States today. According to a study published in 2022, only 21 percent of elementary schools provide puberty education,[34] although the average age range for puberty is between eight and thirteen.[35] Meanwhile, there hasn't been funding to launch an in-depth nationwide study, so although researchers know that students aren't receiving puberty education, they aren't sure of what children *are* being taught. There's currently no standard menstrual curriculum in the U.S., so education varies by district and school.[36] According to a 2018 survey of over one thousand youth in the United Kingdom, 72 percent of boys said they had not received any lessons on periods, and 20 percent said they didn't know basic facts about periods such as whether it was safe to exercise while menstruating.[37]

Amy, the girl I spoke to earlier, told me she didn't think periods were anything to be embarrassed about, but because her health teacher kept mentioning how awkward periods are, she learned that periods are indeed awkward. Her health teacher used technical jargon without defining terms or giving the students time to write down the words so they could look them up later. "I really wanted to learn," Amy said. "This is about my body, it impacts me, but she went too fast."

Amy, however, is lucky—at least she is in a health class that covers menstruation. I spoke with thirteen-year-old Darcy, whose school curriculum doesn't cover menstruation at all. Darcy attends a public school in Massachusetts with a progressive curriculum, but her health class has been tiptoeing around puberty. So far, they've discussed the biology of why it hurts if you get a paper

cut, and how as you get older you might get hair in your armpits. Nothing "inappropriate," Darcy told me.

As a result, Darcy had no idea what was happening when she got her first period. "I thought I was going to die. I was vomiting. I thought this was going to be every day for the rest of my life. I was traumatized." At times, Darcy still has trouble saying the word *period*, but she marches on, determined to tell me her story, because she's angry and she wants change. "Sure, it might be awkward, but we need to know this stuff," she says. "I wish I'd known what was happening when I got my period. I don't want this to happen to someone else."

I wished I had more to offer Darcy, including a promise that the stigma was ending, but I didn't. We were both victims of a stigma that had been created long before we were born.

MENSTRUATION IN WESTERN HISTORY

Researchers haven't pinpointed all the causes of stigma: they note it's far easier to understand what is stigmatized than why it is stigmatized.[38] However, one major factor they point to is ignorance.[39] We stigmatize what we do not understand.

For the most part, Western scholars'* take on menstruation seemed similar to religious leaders': periods were occasionally powerful, but mostly profane. It didn't help that most early scholars weren't women, and much of the knowledge about women's bodies often didn't even make it into ancient texts. The few times they wrote about the menstrual cycle, they mainly focused on menstruation itself, while the symptoms associated with other parts of the cycle tended to go unnoticed.

* Since this book discusses the debate around PMDD in America, which was shaped primarily by Western thinking, I've chosen to dive into the Western canon on menstruation rather than the global history of menstrual stigma.

The ancient Greeks believed the womb wandered through the body causing problems. Plato wrote:

> Womb, as it is called,—which is an indwelling creature desirous of child-bearing,—remains without fruit long beyond the due season, it is vexed and takes it ill; and by straying all ways through the body and blocking up the passages of the breath and preventing respiration it casts the body into the uttermost distress, and causes, moreover, all kinds of maladies.[40]

In the early Roman empire, Pliny the Elder, the acclaimed author of *Natural History*, who was seen as a scientific expert until the Middle Ages, had gained no more clarity on menstruation than the Greeks. He did, however, add a healthy side serving of stigma to the literature. On the one hand, he wrote that a menstruating woman who uncovers her body can scare away hailstorms, whirlwinds, and lightning.[41] He also wrote that menstrual blood

> turns new wine sour, crops touched by it become barren, grafts die, seeds in gardens are dried up, the fruit of trees falls off, the edge of steel and gleam of ivory are dulled, hives of bees die, even bronze and iron are at once seized by rust, and a horrible smell fills the air; to taste it drives dogs mad and infects their bites with an incredible poison.[42]

Fast-forward twelve hundred years or so, and not much had changed in attitudes toward menstruation. This is evident in *The Secrets of Women*, written by the thirteenth-century monk Albertus Magnus. Part medical text and part natural philosophy, it records the prevailing ideas about women's bodies and

reproduction at the time. In it, Albertus describes menstruating women as

> so full of venom at the time of their menstruation that they poison animals by their glance; they infect children in the cradle; they spot the cleanest mirror; and when men have sexual intercourse with them they are made leprous and sometimes cancerous.[43]

Albertus Magnus was a prominent and celebrated Christian scholar. To this day, he is lauded as a major thinker who was responsible for curating Aristotle's work and who was Thomas Aquinas's teacher.[44] Albertus's influence has lasted for centuries. *The Secrets of Women* was released in fifty editions in the fifteenth century and over seventy in the sixteenth century, carrying along with it the idea that menstruating women were poisonous.[45]

In the Middle Ages, scholars believed that many functions of a woman's body, such as menstruation and giving birth, were impure and left women vulnerable to demonic possession (particularly young women).[46] Today, some PMDD patients I spoke to found demonic possession a helpful metaphor for their emotions, but during the Middle Ages, demonic possession could lead to accusations of witchcraft.[47] It's estimated that up to eighty thousand people suspected of witchcraft were killed in Europe in the 1500s, and about 80 percent of them were women.[48] Since PMDD only became an official diagnosis in 2013, it's impossible to say for certain if these women had PMDD. However, it seems highly plausible.

In the Renaissance era, doctors started to get a better handle on the menstrual cycle. They considered physical symptoms like fatigue, bloating, and lower back and hip pain before menstruation to be the norm, and a few, including Gian Battista da Monte, noted

the link between menstruation and depressive symptoms. Da Monte, one of the leading physicians of the Renaissance, boasted that doctors could gain the trust of their patients by predicting when someone would menstruate based on these symptoms, which speaks to how little was known at the time.[49]

In later times, the two main misconceptions about menstruation that had persisted for centuries began to build momentum, and both would increase the stigma against menstruation. The first was that menstruation caused madness. The second was that menstrual blood was poisonous.

MENSTRUATION AS MADNESS

As early as the 1780s, Friedrich Hoffman recorded cases of emotional symptoms such as anger and fear related to menstruation. In 1842, the French psychiatrist Alexandre Jacques François Brière de Boismont published a study involving interviews with 223 women and found that 20 percent of them had mood-related menstrual symptoms.[50]

During the Victorian era, women were increasingly diagnosed with "hysteria." Hysteria, like PMS, is difficult to define and included a number of symptoms such as fainting, vomiting, choking, sobbing, convulsions, and seizures. What is certain is that hysteria was believed to be a woman's disease associated with the uterus.

The psychiatrist Henry Maudsley, who practiced in the late 1800s, offered three main hypotheses for the prevalence of hysteria. First, "the influence of the reproductive organs upon the mind." Second, the limited opportunities women had. And third, periods. He wrote:

> The function of menstruation, which begins at puberty in women, brings with it periodical disturbances of the mental

tone which border closely on disease in some cases, while the irregularities and suppressing to which it is liable from a variety of mental and bodily causes may affect the mind seriously at any time.[51]

In her book *The Female Malady*, which explores the connection between gender and insanity, Elaine Showalter points out that during the 1700s madness was culturally associated with men. However, during the Victorian era, the madwoman became a cultural icon, and women and madness became interlinked.[52]

Prior to the Victorian era, asylums had been tantamount to prisons, where patients were locked in tiny cells and treated like animals. The Victorians believed that if the mentally ill were placed in a clean, calm, and controlled environment, they could be cured. They built a new asylum system accordingly.[53] However, as asylums began to professionalize, women were increasingly given less authority in them. While women had been proprietors and caretakers in early asylums, new laws transferred more authority to doctors and locked women out since they couldn't get medical educations. In 1845, the first Victorian asylums had 30 percent more men than women, but fifty years later women outnumbered men.[54]

Women were also kept at home and given fewer educational, career, and social outlets than men, which stifled their intellects and, for some, contributed to their descent into mental illness.[55] Showalter points to Florence Nightingale, whose mother forbade her to be a nurse. Nightingale fell into a deep depression, was at times suicidal, and experienced trances and hallucinations.[56] Later, Nightingale wrote: "The greatest reformers of the world turn into the great misanthropists, if circumstances of organization do not permit them to act. Christ, if he had been a woman, might have been nothing but a great complainer."[57]

While Victorian social mores faded, the link the Victorians

made between women and madness would remain in the social and medical ether. During World War I, psychiatrists had difficulty treating shell-shocked soldiers because they thought mental illness was a women's disease.[58] Instead, they assumed shell shock was a sign of cowardice. The Victorian era had passed, but the concept of hysteria lingered, remaining an official diagnosis until 1980 and continuing to propagate the idea that women are more prone to mental illness.

In fact, the Victorians' influence was so strong they managed to perpetuate the idea that hysteria has a much longer history than it actually does. Much of our current understanding of hysteria in ancient texts can be traced back to the 1965 book *Hysteria: The History of a Disease*, by the German historian Ilza Veith.[59] Veith wrote that the Egyptians were the first to describe hysteria symptoms, while the Greek physician Hippocrates is often cited as the first to use the word *hysteria*.[60]

However, the British classicist Helen King argues that Veith relied too heavily on Victorian-era translators, who imposed their own understanding of hysteria on ancient texts. King argues the notion of hysteria is based on a mistranslation where an adjective used to describe symptoms became an actual disease name.[61]

While the notion of hysteria is overblown, there *was* a hint of truth in the connection between menstruation and mental health. Unfortunately, periods are so stigmatized that the journey toward understanding this connection would be riddled with more missteps.

MENSTRUATION AS POISON

The attitude that menstruation was poisonous may have started with Pliny the Elder and been further reinforced by Albertus Magnus, but it prevailed well into the 1900s. In the 1920s, Béla Schick, a Hungarian American pediatrician and professor at

Columbia University, further reinforced the idea by conducting several different experiments that he believed showed that menstrual blood was full of toxins called "menotoxins" that could kill plants.

Schick made several major contributions to the field of medicine, including playing a key role in virtually eradicating diphtheria. Largely due to Schick's work as well as vaccines, diphtheria cases fell by 80 percent over two decades.[62] Schick was also remarkably progressive for the time and known for providing female doctors with the same opportunities as male doctors.[63]

Yet, in the case of menstruation, Schick's progressivism failed him. As the story goes, Schick received a bouquet of red roses from a grateful patient. He asked his maid to put the roses in water. By the next day, the flowers were drooping. "I was surprised to find out all the roses had wilted and withered," Schick wrote, and questioned his maid. She told him she'd been on her period, and whenever she was on her period flowers died when she touched them.

Schick started experimenting. He gave flowers to a menstruating woman and a nonmenstruating one and told them to walk with them. The first set of flowers wilted; the other stayed fresh for days. Schick followed up with experiments collecting samples of the maid's armpit sweat, blood, and saliva during various parts of her cycle and studying the effect on various plants. He also had a group of women make dough and found that Ms. M, who was menstruating, produced dough that had only risen to 78 percent of the height of the other women's loaves and was ten grams lighter. Overall, his experiments delivered mixed results: at times the body fluids collected during menstruation seemed to inhibit the growth of plants (sweat); other times, it made no difference (saliva) or had mixed results (blood).

Today, Schick's experiments would be considered substandard.

His paper does not provide much detail about his methods, but it's clear there was plenty of room for confirmation bias. Schick knew who was menstruating, which may have influenced how he measured the results. Even if he didn't, the women being studied knew if they were menstruating, which may have subconsciously influenced how they handled the flowers or bread. Furthermore, his sample size was small. Still, Schick concluded that menstrual blood was poisonous, an idea he published in a 1920 paper titled "The Menstrual Poison." He concluded his paper by noting:

> But I say we should be glad that this belief [that menstruating women are unclean] has not been eradicated. We should be grateful to the people that they tenaciously hold on to such facts that have survived through oral tradition. Science often comes to recognize such facts late.[64]

A year later, Hans Saenger, a senior physician in Munich, published a paper refuting Schick's experiment. Saenger carried out experiments injecting mice with the blood and urine of menstruating women. He also soaked flowers in menstrual blood, his own blood, and water and found that only the flowers soaked in water remained fresh. Thanks to his experiments, he concluded: "We are therefore not yet entitled to speak of a specific menstrual toxin."[65]

Yet twenty years later, Schick's experiments stuck with researchers more than Saenger's refutations of them. In 1950, a full thirty years after Schick's work, Harvard University husband and wife researchers George and Olive Watkins Smith further solidified the belief in menotoxins. The pair conducted experiments in which they injected rodents with menstrual blood. When the rodents died, likely from a bacterial infection, the Smiths determined that menstrual blood must be toxic. However, when

Bernhard Zondek, the coinventor of the pregnancy test, re-created the studies in 1953, he added an antibiotic to preclude bacterial infection, and the rodents lived.

Still, support for the existence of menotoxins continued well into the 1970s. In 1977, a trio of researchers based in the United Kingdom wrote a letter published in the internationally acclaimed medical journal *The Lancet* calling for more research on menotoxins. They noted "the possibility of there being substances capable of interacting with both plant and human metabolism in a manner relevant to mood changes in the menstrual phase."[66] More depressingly, I found a 1998 review in German that lauded Béla Schick for "providing the key to finding the cause of many menstrual problems." The writer, Frank von Krogmann, included his own personal biases in the review, mentioning a butcher shop employee who told him menstruating women who touched sausage made it go sour.[67]

After wading through so many papers on menstrual toxins, I became curious about how the concept had managed to linger for so many years. Even a brief Google search can tell you that menstrual blood is not toxic; it is merely regular human blood mixed with the shed lining of the uterus. But then how were so many doctors and researchers in the past able to get at least some results pointing to menotoxins? I contacted Jamie Hittman, a pathologist who trained at the University of Maryland and a friend of mine, to ask her what was going on.[68]

Dr. Hittman confirmed that while blood does have the ability to transmit diseases such as HIV, "menstrual blood is no more toxic than regular human blood." She noted that the method for collecting blood for the experiments likely had effects on the results. "There's a lot of flora in people's vaginas, some of which can cause diseases," she said, in line with Zondek's findings of infected vaginal blood. Indeed, Zondek was able to reduce the death rate of mice injected with menstrual blood from 95 percent to

5 percent simply by changing his method of collecting menstrual blood. The Smiths had collected menstrual blood by using a balloon that was left in the vagina for up to a day, whereas Zondek used a sterile tube.[69] In addition, Hittman also pointed out that poor study design more than likely influenced the results.

While the idea of menotoxins has been pushed to the fringe, the effects of menstrual stigma on how we as a society think about periods and how that impacts people who menstruate are very real. Menstrual stigma has meant that whatever little conversation there is around menstruation has focused on validating or debunking myths such as menstrual poison, while more substantive questions like how menstruation impacts people continue to be underresearched.

There are enormous gaps in our understanding of how menstruating bodies work. First, there's a gap in understanding how menstruation impacts people. From 1977 to 1993, the FDA excluded women of "child-bearing potential" from medical studies.[70] (Today, many studies still exclude the pregnant.)[71] The FDA reasoned that male and female bodies were generally the same, except the hormone fluctuations from menstruation made women's bodies too complicated to study.[72] Second, there's a gap in understanding how menstruating impacts how we respond to other medical events. Research on women's bodies is criminally underfunded: in the U.S., only about 12 percent of the NIH's budget is for women's health,[73] and in the U.K., less than 2.5 percent of publicly funded research is for women's reproductive health, while there's five times as much funding for erectile dysfunction.[74]

We also have a pipeline problem when it comes to menstruation. Male health-care providers have a more difficult time bringing up menstruation with patients and are less knowledgeable about it than female health-care providers,[75] yet according to a 2019 study, 64 percent of doctors in the U.S. are male.[76]

As a result, menstrual disorders are often underdiagnosed,

misunderstood, and subject to variable treatment quality. Endometriosis can result in infertility and put patients through excruciating amounts of pain, yet on average it can take ten years to diagnose, because symptoms are frequently dismissed as bad periods.[77] PMDD only became an official diagnosis in 2013, and it can also take a decade to get a diagnosis.[78]

This silence in research and medicine is also present at a cultural level. A survey published in 2018 found that 42 percent of women have been period shamed at some point in their life and that 58 percent of women have felt embarrassed when they are on their period.[79] In fact, there's so much stigma around periods that we're uncomfortable with the word itself. The German company Clue, which runs a period-tracking app, documented five thousand different euphemisms in 190 different countries for being on your period.[80]

Consider the boys in the Taiwanese study who were shamed for asking questions about menstruation and learned not to talk about it. They are our future researchers, doctors, and policymakers: how will they be able to research, treat, and talk about periods when they've been told it's abnormal to talk about them? Given that historically men have had more power and say in what society looks like, it makes sense that they've built a society that doesn't have the infrastructure to handle menstruation. However, even as our attitudes around gender roles are changing and we're making more space for women in positions of power, we are still passing along period stigma.

In my early twenties, before I went to Malaysia, I decided I was on a mission to openly talk about menstruation with the men in my life. Overall, I was appalled by their menstrual IQ. One friend thought the adhesive side of pads goes on your labia. Another was surprised to learn about the existence of cramps. "Ah, so that's why women always carry Advil," he said. I grandly told a third friend to "ask me anything" when I purchased my

first menstrual cup. "There's a difference between 'ask me anything' and you telling me things I don't want to know," he replied. Chastened, I changed the subject.

Even as a menstrual advocate, my courage only went so far. Once, a male boss who was an avid runner challenged me to a 5k. I managed to duck out of all races for most of running season, until finally I ran out of excuses and signed up for the last one of the season. The night before the race, I got my period—a particularly bad one. I spent the night vomiting. In the morning, I was still dry heaving.

My mother happened to be in town, visiting. "You can't run like this," she said, and made me stay home.

I called in sick. The day after, I came back to work.

My boss looked me up and down. "You seem perfectly fine to me," he said.

As a woman who believed about talking about menstruation openly, I should have been able to say something. In fact, since my boss clearly believed I blew him off for no reason, it might have benefited me professionally to tell him the truth.

But I was silent. I had no idea what to say. Later, Theo joked I should have said it was a *periodic* ailment. It was far easier to retreat into silence than to fess up. This silence is indicative of our larger attitude toward menstruation.

But what does the public discourse become when you combine one stigmatized condition—menstrual health—with another stigmatized condition—mental health?

Bloody hell.

The Brief, Sensational History of PMS

When I returned from Malaysia to go to graduate school in New York City, the first thing I did was take advantage of the very expensive health insurance that came with tuition to talk to a therapist. I did not like my therapist, Susan, because I thought she did not like me.

Sessions would go like this: I would sit in Susan's office in the middle of a couch and Susan would crouch in a swivel chair facing me. Susan had a long, solemn face, and her eyebrows would climb up her forehead as I described my fights with Theo. Her eyebrows would stay up by her hairline until I was done talking. Then she would swivel back and forth while she thought. The swiveling sounded angry to me, and she spoke in staccato drumbeats.

"How did you end up staying up the whole night fighting about his ex-girlfriend's teapot?" she cried after I walked her through yet another labyrinthine tale of "he said, she said." I'd just explained to her how. The real question was *why* the fight was that bad, I thought. That's why I was in her office. I left sessions with my tail tucked between my legs and no answers, writhing in shame.

I didn't want to be a person who screamed, or fought with my

boyfriend over a teapot, who couldn't focus on work or school. I'd had panic attacks before, but they'd usually been about school or my career, and they'd never lasted for long or been so constant. Now, I couldn't focus on anything except Theo. I'd never felt this out of control before, and I hated it. Out of sheer desperation, I'd started reading Corinthians and repeating "love is patient, love is kind" in my head whenever I talked to Theo. It did not work. I was not patient and I was not kind.

At the same time, Theo was also seeing a therapist. Theo's therapist sounded lovely. He told Theo that he needed space from everything in his life: his family, graduate school, and me.

Susan probably would have agreed with Theo's therapist. "Why can't you see that you keep escalating fights?" she said during another session. She sounded angry again. "You tell him you want an apology, he apologizes, and then you're still angry."

I had several explanations for my anger, but I had gone through all of them with Susan before. Well, Theo hadn't apologized properly or at the right time or—

"I don't want to be like this," I burst out. "I always get like this before my period."

Susan frowned at me. "I think you need help."

Right, I thought. Isn't that why I'm here? Then I realized Susan meant medication help, not therapy help.

Since Susan was a therapist, she couldn't prescribe medication, so she referred me to a psychiatrist for rage-related menstrual problems. Later, I would realize that while Susan had made some good points, we were a terrible fit.

Look at how sexist the medical system is, I'd tell my friends for years afterward. Theo's therapist tells him he deserves space for his needs; mine refers me to a psychiatrist for medication.

I hated Susan, but I loved my psychiatrist, "Dr. Parr." Dr. Parr sat me down in a swivel chair like hers. She treated me like an

intelligent and thoughtful person—the person I wanted to be instead of the person I was.

"Before we begin, I need to ask, how do you feel about medication?" she asked.

"Not great," I said. When I was a teenager, my doctor suggested birth control for my painful cramps. My parents had advised me against it, warning me that we weren't sure of what side effects birth control had. That attitude pretty much described the Gupta philosophy toward medication: skeptical unless utterly convinced, and at that moment I was not convinced. Since I had refused birth control, the doctor had given up and told me to live with the pain, which I'd done.

"Great," Dr. Parr said. "I'm conservative about prescribing medication too. Tell me about what's going on."

I walked her through the recent past—long-distance-relationship issues, culture shock after returning from Malaysia, and graduate school stress. Dr. Parr nodded sympathetically. "Anyone would be struggling in your shoes," she said. I left her office and switched therapists.

What I didn't realize, and would not for years, was that the disagreement between Susan and Dr. Parr—whether I needed medicine or therapy—was a microcosm of a similar debate that had occurred in the 1980s between feminists and psychiatrists. Was PMDD a real condition or yet another case of science weaponizing women's bodies?

PMS: SYNDROME OR SITUATION?

At the heart of the debate in the 1980s were these questions: At what point does a disorder become a diagnosis? At what point does the benefit of treatment outweigh the negative impacts of stigma or side effects? Who gets to decide? The answers are

surprisingly subjective, reflecting the social mores of the time, even when they are theoretically backed by science. And science, which is the supposed gold standard for objectivity, has a distressing tendency to be subject to bias and error as well.

One of the earliest papers about menstruation and mood appeared in 1931. It was written by Robert Frank, a gynecologist from New York who graduated from Harvard University and became the chief of gynecology at Mount Sinai Hospital.[1] The paper is laced with sexist language. Frank wrote about "premenstrual tension," which he described as "indescribable tension from ten to seven days preceding menstruation" that results in "many reckless and sometimes reprehensible actions." He listed effects such as "husband to be pitied," "shrew," "impossible to live with," and chalked up premenstrual tension to excess estrogen. Frank treated patients by irradiating their ovaries with X-rays, and their symptoms vanished.[2]

I asked Dr. Hittman what she thought about treating PMDD with X-rays. She was not a fan. She thought it sounded similar to how high doses of X-rays can be used to treat cancer. Radiation damages the DNA of cancer cells, causing these cells to die. Unfortunately, X-rays can also damage the DNA of healthy cells, which can result in secondary cancers. "Irradiating the ovaries with X-rays would likely kill the cells responsible for making hormones," she said. "I'd also be worried about cancer developing there later on, as well as the impact on fertility."[3] I was grateful that today we have better treatments for PMDD, with less serious side effects.

The same year Frank published his paper, the German psychoanalyst Karen Horney also released a paper describing the same phenomenon. Her take was more sympathetic than Frank's. She wrote:

> It is remarkable that so little attention has been paid to the fact that disturbances occur not only during menstruation

but even more frequently, though less obtrusively, in the days before the onset of the menstrual flow. These disturbances are generally known; they consist of varying degrees of tension, ranging from a feeling that everything is too much, a sense of listlessness or of being slowed down, and intensities of feelings of self-depreciation.[4]

Horney also attributed these symptoms to estrogen, but believed that women had to cope with both the irritation estrogen caused as well as the cultural restrictions of society.[5] She analyzed the impact of her patients' environments and well-being, noting that women who were unhappy with some aspect of their life had more severe symptoms. She also noted that "menstrual disturbances" disappeared when women were fulfilled in their love lives.[6] Horney's take describes a reality that I and many of the people I spoke to found to be true: just as one's environment can impact a chronic physical disease, PMDD symptoms can vary depending on how stressful one's life is.

Research on menstrual symptoms didn't really take off until the 1950s, led by the British doctor Katharina Dalton. Dalton is one of the pioneers of PMS research, thought to have invented the phrase *premenstrual syndrome*. She originally trained as a podiatrist and even published a textbook on the subject before she enrolled in medical school. After graduating in 1948, she started working in a general practice in North London. At the time, she was pregnant and realized that the migraines she'd always had before her period had disappeared. She also noticed a similar pattern of monthly recurring medical complaints in her patients that ranged from asthma to vertigo.[7]

Unlike Frank and Horney, Dalton theorized that premenstrual syndromes were caused by low levels of progesterone. In fairness to Frank and Horney, progesterone was only discovered in 1933, two years after they published their work. Dalton and

her former instructor Raymond Greene (brother of the English novelist Graham Greene) published their first study together in 1953. They asked eighty-four women to track symptoms related to their periods, including asthma, depression, epilepsy, lethargy, migraines, skin lesions, and vertigo, to name a few. When the women got pregnant, their symptoms vanished, but they returned after the women gave birth. When the researchers gave women progesterone shots, in over 80 percent of the cases, the symptoms improved.[8]

Dalton and Greene dubbed these symptoms "premenstrual syndrome." They eschewed Frank's phrase *premenstrual tension*, noting:

> The term "premenstrual tension" is unsatisfactory for tension is only one of the many components of the syndrome. Its use has commonly led to a failure to recognize the disorder when tension is absent or overshadowed by a more serious complaint.[9]

They felt that *premenstrual syndrome* was also unsatisfactory because symptoms do occasionally occur during ovulation, during menstruation, and at times even after menstruation has stopped. Still, they thought "premenstrual" was preferable to "menstrual syndrome," which suggests symptoms only occur during bleeding. They hoped that someone else would later suggest a better name—but the name has stuck for decades and continues to lead to confusion.[10]

The paper kicked off Dalton's career as a PMS researcher. Four years later, she opened the first PMS clinic, at University College Hospital in London. She would run it for forty years without pay.[11] In her later years, Dalton studied how PMS impacted behavior. In a 1960 paper, she analyzed over 350 schoolgirls' grades during the course of their menstrual cycle. For about a quarter of

students, grades fell during their premenstrual week. For another quarter, grades fell during their menstrual week. However, almost 20 percent saw their grades improve during their premenstrual week, and another 20 percent during their menstrual week.[12] Dalton's work indicated that the menstrual cycle does have an impact on performance, though this impact varies depending on the person. The wide variation makes it difficult to pinpoint specific symptoms. Later, this would cause problems as psychiatrists struggled to define the diagnostic criteria for PMDD.

Dalton expanded her research on menstruation and behavior to women's prisons. In her 1961 paper "Menstruation and Crime," she interviewed 386 prisoners and found 49 percent of their crimes were committed during a few days before menstruation or during menstruation.[13] Ultimately, Dalton's work with prisoners would move her and the concept of PMS into the public spotlight.

In 1980 Dalton served as an expert witness for two women accused of murder: Sandie Craddock and Christine English. Craddock had a troubled history—she had attempted suicide multiple times and had more than thirty convictions for criminal damage and assault. Eventually, she stabbed a coworker to death. Craddock's attorney reviewed her diary and realized each of the suicide attempts or offenses occurred around the same point of her menstrual cycle. The attorney pleaded PMS as a defense, and Dalton served as a medical expert in the case. Dalton prescribed progesterone to Craddock, and her symptoms stabilized.[14] Craddock was given a lighter sentence because she was seen as acting with diminished capacity. She was ultimately released and given three years' probation provided she continued her progesterone treatment.[15] Two years later, Craddock appeared in court again. She'd been charged with threatening to kill a police officer. Dalton testified that she'd been reducing Craddock's medication. This time Craddock was found guilty, but again she was released on

probation as the court recognized her severe PMS.[16] In the case of Christine English, the thirty-seven-year-old drove a car into her boyfriend after a fight, pinning him to a streetlamp and killing him.[17] Dalton was able to diagnose English with extremely severe PMS, and the court reduced English's charge as well.[18]

The court cases resulted in a media boom around PMS. *The New York Times* published eight pieces on the subject. *Glamour* polled readers about the validity of using PMS as a legal defense (71 percent against, 24 percent for, 5 percent unsure), and *People* profiled Craddock, English, and Dalton.[19]

The growing awareness of the syndrome also spilled over to the medical community. In 1983, a panel of physicians and researchers met to discuss whether severe PMS, the kind that allegedly led English and Craddock to commit their crimes, should be added to the *Diagnostic and Statistical Manual of Mental Disorders (DSM).*[20]

The *DSM* is published by the American Psychiatric Association (APA), and is one of two leading manuals used by healthcare professionals to diagnose mental disorders. (The other is the International Classification of Diseases, published by the World Health Organization.)[21] Listing PMDD* in the *DSM* would elevate it from observed anecdotes and the fringes of research to a recognized disorder. This had major implications: researchers would study PMDD, more people would be diagnosed, and pharmaceutical companies would market treatments for it.

The debate over PMDD wasn't unique to PMDD but, rather, is one that experts have had every time a new disorder is discovered:

* PMDD went through several name changes as psychiatrists struggled to come up with a name that would separate PMDD from PMS and underscore the psychiatric nature of its symptoms. Some of the names included late luteal phase dysphoric disorder and periluteal phase dysphoric disorder. For the sake of simplicity, I shall continue to use PMDD or severe PMS.

where should the medical community draw the line between personal experience and diagnosis?

The first edition of the *DSM* was published in 1952, in the wake of World War II, because psychiatrists realized they needed better tools to diagnose and treat an influx of veterans. At the time, there wasn't much information available to help clinicians understand how to diagnose patients, so diagnoses could vary widely from doctor to doctor.[22] Yet crafting a reference book for mental disorders was a moving target. In the first two editions of the *DSM*, each disorder had a brief two- to three-sentence description, making the diagnosis process highly subjective.[23] Furthermore, the *DSM* was still susceptible to bias and error: homosexuality was listed as a disorder in the first edition of the *DSM* and was only removed in the second.[24]

For the third edition, published in 1980, psychiatrists pushed for basing the *DSM*'s diagnoses in scientific data and including specific diagnostic criteria, in hopes of having the field of psychiatry taken more seriously. The first brain scans were already being performed,[25] and psychiatrists hoped they would be able to unlock the biological reasons for mental illness.[26] *DSM-III* contained a systematic list of diagnoses and criteria for over 250 disorders,[27] and it went from a little-known manual to the gold standard of psychiatric diagnosis.[28] However, there were several inconsistencies in it, and the APA wanted to publish a revision with corrections.[29]

Robert Spitzer, a Columbia University professor and psychiatrist, was nominated to lead the revision. He was the obvious choice: he had served as chair of the *DSM-III* working group. He received enormous kudos for the success of *DSM-III* and for his ability to wrangle an agreement out of a group of experts—sometimes by plying them with lunch and introducing a compromise while they were digesting.[30] (Spitzer also played a key role in removing "homosexuality disorder" from *DSM-II* in

1973. Yet, surprisingly, in 2001 he published a paper on how to "cure" homosexuality, which he later apologized for a few years before his death.)[31]

To revise *DSM-III*, Spitzer formed twenty-six committees to help decide which disorders should be listed in the revision, including one to decide whether PMDD should be a diagnosis. In an interview, Spitzer discussed the inspiration behind asking a working group to evaluate PMDD as a potential diagnosis:

> I would get invitations to conferences on PMS. And [it] just occurred to me at some point, "Hey here's all this interest in this condition. . . . It seems as if the symptoms of the conditions are primarily behavioral and mood changes. And if this really is a syndrome and affects women and it causes distress in some of them, how come this isn't being presented as a mental disorder?"[32]

The working group had fourteen members, including Spitzer and Janet Williams, the text editor of *DSM-III-R*, a future professor of psychiatry and neurology at Columbia University and Spitzer's wife. They had to determine if PMDD met the following criteria:[33]

1. If it fell within *DSM-III*'s definition of a mental disorder: "a discrete entity with sharp boundaries (discontinuity) between it and other mental disorders, or between it and no mental disorder."[34]
2. If there was compelling research or clinical need for a diagnosis.

Ira Glick, who was a professor of psychiatry at Cornell Medical College and would later become a professor at Stanford, was one of the members of the working group. He had published a seminal review on how birth control could be associated with

depressive symptoms. As a medical student on a gynecology rotation, Glick had noticed that some of his patients had psychiatric symptoms such as anxiety and depression, and those with psychosis saw it worsen before their period. He noticed the same thing later as a psychiatry resident.[35] The main concern, Glick said, was sorting out anecdotal evidence from controlled research data as they sifted through the existing literature, much of it focused on Dalton's work. "It was a very early literature," Glick recalls. The process of combing through it gave him an appreciation for the rigor of science and the importance of controlled research.[36]

On the whole, Glick was on board with PMDD as a diagnosis. "People were suffering. Why not treat them? We didn't know if we could help them, but we wanted to try."[37]

However, not all the working group members felt the same way. Jean Hamilton, who had done work on gender differences in responses to clinical drugs,[38] was firmly anti-inclusion. Hamilton thought "the deck was stacked" from the get-go because so many members of the working group were pro-inclusion even before they began considering the criteria.[39] She asked the APA's Committee on Women to attend the group's meetings and present their objections to the diagnosis, which were twofold.

First, a diagnosis would stigmatize all women. The Committee on Women was concerned that the diagnosis would pathologize menstruation and turn a regular biological event into a mental disorder, especially given that at the time it was not clear who, exactly, was impacted by PMDD.

Second, there wasn't enough scientific data to substantiate a diagnosis.[40] A 1989 commentary on the existing research literature, published four years after the APA Committee on Women presented its objections to the diagnosis, sums up the problem: "We do not know if patients complaining of premenstrual

syndrome are at one extreme of a spectrum disorder or if they are a 'specific group.'"[41] The review examined a range of papers on PMS, published between 1953 and 1982, that used widely different criteria for PMS. Estimates for the population with PMS ranged from 21 percent to 85 percent.[42]

Yet, in June 1985, the *DSM* working group reached a consensus. All but two of the members wanted the diagnosis to be listed in the revised *DSM-III*.[43] They voted for inclusion, unleashing a firestorm.

Hamilton was quick to react. She and her colleagues spearheaded a campaign that included compiling briefing books and publicizing Spitzer's home address so the public could write him letters of protest.[44] They also mobilized other groups such as the National Coalition for Women's Mental Health and the American Psychological Association's Committee on Women.[45] For the sake of simplicity and following the tradition of earlier researchers who have written about this debate, I've chosen to refer to these groups collectively as "the feminists."

The feminists campaigned against PMDD and two other controversial diagnoses that were being considered for inclusion in *DSM-III-R*: paraphilic rapism and masochistic personality disorder. Paraphilic rapism was the idea that some people are unable to get sexually aroused unless they rape others. Masochistic personality disorder was loosely a martyr complex, where the patient encouraged others to exploit them.

Feminists feared the first diagnosis would be used to decriminalize rape, turning violent offenders into innocent people who could not control their impulses. In a context where women were already victim-blamed for being raped, the feminists argued paraphilic rapism would add to a culture of absolving rapists.[46] The second diagnosis, masochistic personality disorder, could have been used to claim that abuse victims intentionally encouraged the people who abused them.[47] It was easy to see

why feminists thought the *DSM* was mired in sexism given this trifecta of diagnoses that seemed to say rapists are not morally culpable, women want to be abused, and women are crazy because they menstruate.

By fall, Spitzer realized that the opposition to PMDD was serious and growing. He offered to meet with the Committee on Women, which did not go well. He later described the meeting in a letter:

> As they say in diplomacy, we had a "frank exchange of views," which means that we had some very serious differences. . . . Their main concern is with Premenstrual Dysphoric Disorder, which they feel will only stigmatize women, and in no way encourage attention to women's special health needs. The fact that nine of the eleven experts on our Advisory Committee strongly supported the inclusion . . . does not impress them.[48]

The campaign was just the beginning. In November, the Association of Women Psychiatrists registered a formal complaint against all three diagnoses.[49] For the next year, the feminists and the APA would go back and forth. Spitzer finally asked the APA to give him an extra year for public debate about the three diagnoses. When he got the extra year, Spitzer promptly organized a symposium in Washington, D.C., to discuss the diagnoses on May 13, 1986.

On May 12, protesters from several women's mental health professionals' organizations picketed outside the convention center where the symposium was being held. Spitzer invited them to have a joint press conference and debate PMDD. Among them was the psychologist Paula Caplan, who would devote a large part of her career to leading the charge against PMDD. Spitzer asked Caplan to deliver a statement.[50] Caplan and Janet Williams

have different interpretations of the press conference. Caplan remembered it as sprung on her with little warning:

> I had been scheduled to speak briefly. However, APA press room chief John Blamphin announced as I entered the room that the conference would begin with a ten-minute statement by Spitzer, followed—to my astonishment—by a ten-minute statement by me.[51]

Williams remembers the conference as Spitzer's attempt to give both sides an equal opportunity to say their piece. "He was a great negotiator. He confronted controversy head-on," she said. "He always wanted to hear all sides of the argument to give people a chance to arrive at a compromise. That's how he got homosexuality disorder out of the DSM."[52]

The compromise was as follows: in December 1986, the APA decided they would include all three disorders in the appendix under the heading "proposed diagnostic categories requiring further study" (see Appendix A).[53] PMDD was given the name late luteal phase dysphoric disorder (LLPDD) in hopes of further distinguishing it from PMS. Yet the debate was far from over.

THE CASE AGAINST PMDD

The feminists had argued against including PMDD in the *DSM* for two main reasons: first, it would stigmatize all women; second, there wasn't enough scientific data to substantiate a diagnosis.[54] Both of these arguments proved to be valid, at least at the time.

The research around PMDD was so nascent that experts themselves weren't quite sure what PMDD was or how many people it impacted. A 1984 *Washington Post* article by the reporter Molly Sinclair illustrates the confusion:

PMS, as the experts call it, shouldn't be confused with men-
strual discomfort. It is more severe and disabling than the
occasional headache or slight irritability that many women
experience just before the start of their cycle which can be
relieved with traditional medications. PMS afflicts its victims
with powerful mood swings and sometimes painful physical
symptoms. . . . Yet no one knows exactly how many women
have PMS. Some experts estimate 3 to 5 percent of women
are affected so seriously that it sometimes interferes with
their lives. . . . But other experts say that up to 90 percent of
women experience PMS symptoms occasionally but not so
seriously that it interrupts work and social routines.[55]

Sinclair is seemingly describing PMDD—debilitating mood
swings—that impacts 3 to 8 percent of the population. However,
the statistics she gives show experts conflating the numbers from
PMDD and PMS. This confusion terrified the feminists.

Menstrual stigma was already a social force holding women
back, and this debate provided more reasons for the public to
stigmatize menstruation. Joan Chrisler is one of the many fem-
inists who didn't believe PMDD belonged in the *DSM*. Her
personal experience illustrated precisely what was at stake.
Early in her career, in the 1970s, she attended a lecture at Cor-
nell delivered by an eminent male professor. The topic was
the question: why are there no great women artists or novel-
ists? The conclusion: a woman's creativity declines when she's
menstruating. In response, Chrisler wrote a dissertation on a
study she conducted showing that women are just as compe-
tent and creative during their periods as at any other time of
the month.

Chrisler and other feminists made the case that PMS was in-
vented by a sexist society rather than based on biological reali-
ties. When Chrisler first read about PMS, she surveyed women

of various ages to see if they suffered from PMS. "Everyone knew about cramps, but no one knew about PMS," she said.

She and Caplan later wrote a paper explaining that PMS was thought to be a culture-bound syndrome—which is to say, a syndrome that exists in some places but not in others. They pointed out that only women in Western societies mentioned having emotional symptoms associated with PMS. They also cited two studies from Hong Kong and China where women reported PMS symptoms like fatigue, water retention, pain, and an increased sensitivity to cold (a symptom people in Western countries don't associate with PMS) but were very unlikely to report negative mood symptoms.[56] In essence, they were saying, the cultural narratives we hear about PMS shape our perceptions of what our bodies experience.

Certainly, awareness of PMS, particularly as a psychiatric condition, was spreading across the U.S., for better or worse. When Chrisler analyzed the frequency of references to PMS in popular magazines, she found three references between 1976 and 1980, forty-five articles between 1983 and 1987, and thirty articles between 1988 and 1992.[57]

As PMS became more widely written about, a stereotype of the premenstrual woman began to form in popular culture. Sexist jokes abounded, such as this one: "What's the difference between a pit bull and a woman with PMS? Answer: a pit bull doesn't wear lipstick." Through the late '80s and '90s, there was a booming industry of merchandise like greeting cards and mugs printed with similar jokes; nail polish that changed color depending on the wearer's mood, including "pouty pink" and "bloated blue"; and jokebooks and calendars with comics of people going through severe PMS (in one, Melinda rearranges her furniture by hacking it with an axe).[58]

This pattern was echoed in TV shows and movies. *Married . . . with Children*, which came out in 1987, the year

PMDD was added to *DSM-III-R*'s appendix, was particularly harsh. The show aired an episode where the characters go on a camping trip. All three women have PMS. They growl and demand chocolate. The main character, Al, tells his friend Steve that PMS stands for "pummel men's scrotums." At one point, Steve tells Al you have to treat women with love and respect during their time of the month. He asks his wife, Marcy, how she's doing, only for Marcy to bring up an old fight, and then burst into tears a few seconds later because she's bloated.[59] In 2003 hormones were still used as a synonym for crazy in the Mormon remake of *Pride and Prejudice*. In the trailer, Darcy declares he loves Elizabeth because "she's crazy." In the next scene, Wickham asks, "What's up with Elizabeth?" "Probably hormones," Lydia responds.[60]

I had mixed feelings about these portrayals. On the one hand, I couldn't deny that after many of my PMDD episodes, I'd laughed over my behavior. Laughter was the gilt paint I poured over the battered edges of my life to put a shine and sparkle on suffering. Laughter gave me dignity. It let me say to the world: look, I might be unstable some of the time, but at least I have the honesty to acknowledge it. If every month I rode straight to hell in a handcart and had no choice about getting on or off, I could at least make one choice: I could laugh instead of cry.

On the other hand, the entire industry of PMS caricatures didn't strike me as the same type of laughter. Watching *Married . . . with Children* was painful. I pictured the writers and producers witnessing one of my PMDD episodes—perhaps a bad one, where I cried, and raged, and then punched myself in the face. I did not think they would sympathize. Rather, I thought they would see me as an animal—to be pitied, to be put down, and to be made the butt of a joke in the process. This entire industry felt as if it existed to undermine the credibility not only of women with PMDD but also all women, and it did.

These portrayals of PMS had major implications for how society thought about women in positions of power. When Walter Mondale chose Geraldine Ferraro to be his running mate for the 1984 presidential election, many people questioned whether Ferraro was capable of handling political power because of her menstrual cycle.[61] Paula Caplan wrote about how a Canadian editor killed a story interviewing her about PMS because he thought no one would be interested. When it seemed likely that Kim Campbell would become the first female prime minister of Canada, Caplan noted that the editor was suddenly interested in running the interview in order to imply that women couldn't be trusted with power.[62] The 1984 *Washington Post* article by Molly Sinclair that informs readers PMS is a real problem also urges the public to have more empathy for people with PMS but ends with this kicker:

> Anyone with serious PMS problems isn't likely to have the energy or the inclination to run for president, or any other competitive position. For one or two weeks a month, women with serious PMS prefer to be at home resting rather than be out soliciting votes, shaping public opinion and debating the state of the economy and the possibility of nuclear war.[63]

PMS might be a problem, the article says, but don't worry; only *some* women, not all women, aren't fit for power. Of all the qualities that could make a candidate unsuitable for the presidency (many of which we've since seen in the election of Donald Trump), it's hard to see why PMDD, which is predictable and treatable, is so bad.

Paula Caplan and Joan Chrisler chalked up the emergence of PMS discourse to a pattern of female oppression in history. In an academic paper, they wrote that "each time women make substantial gains in political, economic, or social power, medical

or scientific experts step forward to warn that women cannot go any farther without risking damage to their delicate physical and mental health."[64]

Today, we're seeing a similar pattern. On the one hand, we're in the midst of a deeper conversation about sexism and how to create more gender equity. The gender pay gap is the narrowest it's ever been, although these gaps are wider for women of color.[65] The #MeToo movement has led to a clampdown on harassment, with twenty-two states passing laws to make the workplace safer,[66] and we're having more conversations that push for gender equality. On the other hand, the Supreme Court overturned *Roe v. Wade*, which had protected the national right to abortion since 1973. Two steps forward, one step back, Caplan and Chrisler said.

THE *DSM* TRIES ONCE MORE

In 1988 the APA decided to revisit the inclusion of PMDD in its revision of the *DSM*. This time, they were determined to avoid controversy. Allen Frances replaced Robert Spitzer as chair. While Spitzer had focused on getting expert consensus, Frances decided to focus on evidence.[67] "In *DSM-III-R*, experts could succeed in having their pet diagnoses included with very little supporting evidence," he said. "In preparing *DSM-IV*, we were much more aware of the potential harmful unintended consequences of including a diagnosis. Experts always have a strong tendency to expand the manual—to see only the benefits of new diagnoses, while being blind to the risks."[68]

This time the PMDD working group was made up of all women, including three members of the original working group, one of whom was Sally Severino. Severino is measured and cautious when she speaks—she was careful to tell me she had retired in 2000 and had not kept up with PMDD since

then. Her first preference was to refer to papers she'd already written. Failing that, she answered me by email, with a phone call as a last resort.

Severino grew up in Wichita, Kansas. Her father had a high school education; her mother completed eighth grade. "My goal was to complete high school and get married just like Mom," she wrote. However, a high school teacher advised her to prepare for college, and since she hadn't found a husband, she went to Wichita State University.

In college, Severino spent a year abroad in the Philippines. On her way back home, she stopped in Thailand, where she met her future husband. When the marriage ended after a few years, she became interested in the unconscious forces at work that may have caused the relationship to fall apart and enrolled in a child psychology course at Columbia University. Then she decided to attend medical school at Columbia, where she was one of 9 women in a class of 123.[69]

When Severino joined the full-time faculty of New York Hospital–Cornell Medical Center, she became interested in PMDD. She wrote:

> At the time that I was wondering what research I would do, a friend called me in a rage. "I shattered the full-length mirror in the principal's office today," she told me. "And she deserved it! She treats my daughter unfairly, but she totally denies it." That evening her menstrual period started. The next day she seemed a different person, relaxed and with a sense of humor. "How could I have done such a thing?" she asked me. "The principal probably thinks I'm crazy!" Month after month I watched her.
>
> There was my research question: What unseen forces cause Premenstrual Syndrome?[70]

Originally, Severino had been in favor of including PMDD in *DSM-III-R*. However, during her time on the working group for *DSM-IV* she began reading about the history of American women in the late twentieth century and grew increasingly concerned about how women had been marginalized by the medical system.[71] She'd been trained at Columbia, mostly by men, and while she hadn't experienced much sexism herself at Columbia, her readings made her realize how patriarchal the medical establishment was. This spurred her to ask a colleague to educate her in using more female-centric language. For example, while speaking about women who take care of others, men would say *caretaker*, but women would say *caregiver*.[72] "It didn't change my opinion on PMDD, but it changed the way I talked about women," she said.[73]

The *DSM-IV* working group spent five years deliberating over whether to include PMDD as a diagnosis. This time, they focused on an exhaustive review of the literature and combined data on 670 women from five research sites to reanalyze the data. At the end of the process, depending on the assessment method used, 14 to 45 percent of women met the criteria for PMDD.[74] This was more accurate than the range of 5 to 90 percent that *The Washington Post* had quoted, but it was still a wide range. The lack of consistency concerned Severino.

She concluded it was too early to create a PMDD diagnosis. "We knew a lot about what PMS *is not*. We do not know what it *is*. The diagnosis should remain in the research appendix of the manual," she wrote.[75]

While the APA had hoped that the decision would be backed by data instead of expert consensus or politics, the working group was so divided that the APA ultimately had to call in two outsiders to make the final decision: Nancy Andreasen and A. John Rush. Critics pointed out both were specialists in depression and

schizophrenia, not in PMS.[76] Caplan speculated they had been chosen because they were close to Spitzer.[77]

When *DSM-IV* came out in 1994, PMDD was listed in the main text under "Depressive Disorder Not Otherwise Specified," while its criteria stayed in the appendix, a move Caplan blamed on Andreasen and Rush and their research proclivities.[78] There were a few other changes: this edition dropped the term LLPDD in favor of PMDD. Some of the language in the criteria was tightened in an attempt to make it more specific and sensitive (see Appendix B).

However, the decision to list PMDD as a depressive disorder caused the most consternation. "Such a classification, I believed, reflected the power of political persuasion. It did not reflect what our scientific research and what women with PMS told us," Severino wrote me in an email.[79] In a follow-up interview, she clarified: "If you put something under a category like depression, people automatically slant the diagnosis a certain way, for certain treatments and pharmacological interventions. And I just felt there was no research ground for it."[80]

Once again, the feminists were not happy. This time, Paula Caplan spearheaded the campaign against PMDD's inclusion and categorization in the new *DSM*. Caplan had been invited to be an advisor to the PMDD working group but eventually left, saying: "I resigned in 1990 as a consultant and an advisor because of my concern about the *DSM* Task Force's false claims to base their decisions on science and their distortions and lies."[81] Caplan created email blasts even though it was still the early days of the internet, organized petitions, and wrote articles debating the inclusion of PMDD in *DSM-IV*.[82]

I was lucky enough to interview Caplan once on the phone. In photographs, she has wavy silver hair, dimples, and, often, bright clothing and accessories. She was wonderfully kind to me. Eight minutes after I emailed her, telling her about my PMDD

diagnosis and how much I worried about whether that would affect my credibility, she replied back eager to talk, even though she was ill. Five months later, she would pass away.

I could see immediately why she was the perfect person to spearhead an opposition campaign. In conversation she was clever and funny, able to respond to any question instantly, and staunch in her beliefs, even though she was ill when we spoke. At times, I struggled to get my questions in because she had so much to say. Our fact-checking session gave me a headache, because she questioned everything, even quotes I had tape-recorded her saying or passages I'd pulled from her earlier work.

I admired and envied Caplan's ability to stick to her guns and fight. By nature, I'm indecisive. I sympathized with the PMDD working group members who had gone back and even changed their minds. When there isn't much awareness of a condition, and research is nascent, how do you make the call that it should be called a disorder—especially if you risk stigmatizing a group that's already vulnerable? I had no idea.

Caplan was the opposite of indecisive. When I sent her some of the latest papers on PMDD, she ripped them apart, convinced they were bad science, artifacts of a deeply sexist society. I wish she were still here to crusade for abortion rights or protection for contraception.

I realized that the feminists and psychiatrists on either side of this debate had different answers to the same problem of how best to protect women's interests. The psychiatrists who wanted PMDD in the *DSM* thought diagnosing and medicating the roughly 8 percent of women who suffer from its symptoms promoted the greater good. The feminists thought including PMDD in the *DSM* would stigmatize the other 92 percent—and it did.

I was curious about what both Paula Caplan and Joan Chrisler thought about this conundrum, given they'd spent a good part of their careers fighting against PMDD as a diagnosis: how

did they square the campaign against PMDD with the small per-
centage of us who are suicidal and angry once a month and find
it helpful to have treatment?

When I spoke with Chrisler, I had been diagnosed very re-
cently. I was so ashamed of my episodes and so in awe of Chris-
ler's work that I told her "a friend" had PMDD. Even though
she disagreed with PMDD as a construct, Chrisler was full of
compassion for people like my "friend." "People often get mad
at me because they think I'm saying there's no such thing as
PMS," she said. "I question the constructs, but I don't question
women's experience. I care that women who need support and
might need medication . . . get what they need. Of course they
should get what they need. Sometimes what they need is a di-
vorce. Sometimes it's an antidepressant or to go to bed early. But
as someone who has studied the menstrual cycle for decades, I
worry a little bit about everything that goes wrong being con-
nected to it."[83]

Chrisler was so kind that I grew braver, and when I spoke to
Caplan a few months later, I dropped the friend pretense and
asked her point-blank what she thought about people like me
who had PMDD. Caplan fired a question back at me: "Are those
symptoms, or are those feelings?" She pointed out that society is
full of sexism and that everything from relationships to work-
places is constructed to place women at a disadvantage. Worse,
we're told we must patiently suffer through our pain, and even
our pain is seen as less important. PMS, she thought, was soci-
ety's convenient way of giving women permission to be angry
while calling them crazy, instead of letting them just be angry.
Caplan did not question me, or my experience, or my belief in
PMDD. Instead, she questioned the society that, in her view,
made me think I had PMDD.

There's a joke out there about getting diagnosed, she told me.
Women will say, "Oh, thank goodness I'm not crazy, I'm just

mentally ill." However, mental illness comes with real stigma, she warned me. "Anything you say gets explained away, minimized, dismissed."[84] Her warning echoes in my ears to this day.

After talking to Caplan, I felt horribly guilty. I felt as if I'd let down the team and my desire for a diagnosis and treatment would undermine the credibility of women as a group. I wondered, if I tried harder to control my temper or ate more vegetables, maybe I wouldn't need to hide behind a PMDD diagnosis and would be able to live my life without treatment.

I am grateful to feminists like Caplan and Chrisler. Caplan's early work on female assertiveness overturned the work of the famous German American psychologist Erik Erikson, who believed boys are naturally more assertive than girls. Caplan showed that gendered socialization, not biology, was at work by studying how young children behaved when adults weren't in the room.[85] Chrisler painstakingly documented menstrual stigma and worked to break it down, including teaching about menstruation during a time when the subject was deeply taboo.

It's thanks to them that we're able to have a conversation about menstruation and that it's considered a faux pas to write off someone's mood because they are nearing their period. Still, at the same time, Tory Eisenlohr-Moul estimates that the controversy over PMDD set back care by ten to fifteen years.[86] Had there been less controversy over whether PMDD was real, we could have spent more time treating people—to say nothing of the thousands of people who went untreated and go untreated today because they've never heard of PMDD.

In May 2013, PMDD finally became an official diagnosis, in *DSM-5*. Roughly five months later, I would walk into Dr. Parr's office and tell her about my period-related rage. Dr. Parr and I would chalk this up to difficult personal circumstances. She would tell me I didn't need medication, and with a few more therapy sessions and a little bit of time, life would get better. I

would walk out happy. Happy that Dr. Parr believed me, happy that I wasn't mentally ill, and happy with her promise that once the dust settled in my life, I would be just fine. Unfortunately, Dr. Parr was wrong.

The Diagnosis Blind Spot

I was not fine. Or, maybe I was fine, if fine means learning to keep going despite the raging trainwreck that is your life. Theo and I limped along as I changed jobs and moved from city to city, but after three years I decided I couldn't handle long distance anymore. I quit my job in San Francisco and moved to Boston to live with Theo and try my hand at freelancing and writing a book.

Like clockwork, Theo and I fought each month—brutal, nasty fights that left us sleepless and giving each other the silent treatment for a week. But after a while, the fights began to lose their edge, or maybe we just got used to them and began to accept that this was our life together. Sometimes I thought the two of us were pushing a pendulum of resentment back and forth between us. This month, Theo resented me because of last month's fight. Next month, I'd explode at him because he hated me the previous month. Still, we carried on.

Shortly after our six-year anniversary, we began to talk about marriage. Something small and low-key. I went to visit my parents in Minnesota and told them all about our plans. A few days into the trip, Theo called me up. Lately, he'd seemed spacey when we talked, as if he were hiding in a cave in his head. I began to

pick at him for being distant—a week later, I would get my period and understand why I'd been picking at him.

"I can't do it," he said suddenly as we talked. "I can't see a future with you."

"What do you mean?" I seethed. "We've been dating for six years. If you don't want to marry me, you should break up with me."

Theo went silent. We ended the phone call. He stopped responding to texts and didn't call for the next few days. We'll be fine, I thought. I would fly home to Boston soon, we'd talk, and we'd sort this out. We'd survived worse.

When I arrived back in the apartment, Theo was lying on the couch, an arm flung over his face. "It's over," he said as soon as I walked in the door.

Like that, life as I knew it fell apart.

While Theo slept, I began to pack. The next day, I called leasing offices. I signed the first lease someone offered me even though I couldn't really afford it. I moved out two days later.

Moving was relatively easy. Moving on was another story entirely. For months I existed in a fog. Usually, I was a night owl, but now I jolted awake at 6:00 AM. For a moment, I wouldn't remember where I was and I'd look around for Theo. Then I'd remember all over again: Theo wasn't part of my life. I would never get to see him again. I'd bolt out the door and run. Running left me sane enough to get showered and dressed, but after that waves of anxiety and grief would crash over me throughout the day with no warning. I found myself bumping into strange walls and unexpected corners or reaching for mugs or bowls, only to remember Theo had kept them. Other times, I'd burst into tears at the kitchen table, remembering the day I bought it with Theo. Whenever I tried to picture the future, it was blank. All I could focus on was the next half hour.

At night, my sleep was fitful and shallow. When I did manage

to sleep, I dreamed about Theo. The dreams were variations on the same theme: I apologized. I vowed to do better. Sometimes, Theo forgave me; mostly, he didn't. The next morning, I'd wake up and have to face the day all over again. It didn't help that I worked from home and lived alone.

I signed up for a marathon; booked therapy appointments, even though my experience with Susan had left me suspicious of therapists; and checked out piles of books about grief and re-silience from the library. One of my friends suggested I make an online dating account just to remind myself that Theo wasn't the only man in the world. I started going through profiles with the same fervor I'd applied to job hunting during the 2009 recession.

Within a few months, I met Usheer. Usheer was a Buddhist who was vegetarian by choice and air-dried his clothes to re-duce his carbon footprint. On one of our early dates, a drunk man who looked and smelled as if he hadn't showered for days swayed and stumbled as he tried to get off the subway. The other passengers steered away. Usheer walked up to him and held him up until they found a bench. Usheer doesn't kill insects; he res-cues them and releases them into the wild. This includes cock-roaches. "I like to think cockroaches are just nature's warriors and deserve our love too," he told me as he showed me a picture he'd taken of one of his cockroach rescues.

"You're so well behaved it's nauseating," I replied, which was code for *I love you, never change*, but also, *you're so well behaved it's nauseating*. Then I poked him hard just to make him squeal.

When we visited one of his friends for dinner, her mother appeared in the doorway. "Usheer?" she cried and folded him in her arms. "He is the sweetest man," she said, and then glared at me over his shoulder. I got that reaction a lot from Usheer's inner circle, and I didn't blame them.

I was suspicious of me too. If the world can be divided up into cockroaches and cockroach rescuers, I was definitely the roach

in the relationship. My roach-like qualities weren't just limited to scuttling away from inebriated strangers on the subway. I knew I had a history of erupting into loud, explosive rages, and I was terrified I'd repeat my past mistakes.

From the get-go, I gave Usheer lists of reasons why I'd make a bad partner, including all the things Theo hadn't liked about me: my ridiculous number of allergies, my hatred of *Lord of the Rings*, and my inability to sit through movies, TV shows, and podcasts. And, oh yes, I had berserk-like rages. I could promise him one thing, I told him. We'd fight, and we'd fight again, and it would be over something completely stupid.

Despite the red flags, Usheer decided it was worth sticking around. Even if we didn't work out long-term, he told me, he would have had the pleasure of my company for a few months. Plus, Usheer was confident we wouldn't fight. He didn't do rage. If he got angry, the emotion soon evaporated, leaving behind a wellspring of compassion. "We'll be fine," he told me.

It was easy to believe him. Theo had loved me, but Usheer made me feel treasured. For example, Theo had a habit of moving his trash to my desk: used Kleenex, books, junk mail. His desk, meanwhile, was immaculate. I tried several strategies, ranging from asking nicely to nagging, but after they all failed, I lost my temper during a PMDD episode. I cannot remember exactly what I did, but it definitely involved screaming, nasty comments about hypocrisy, and more than likely I threw some books at the wall. Afterward, Theo made a few comments about how I wasn't good at sharing because I was an only child, though he did keep my desk mercifully clear. Love, as I understood it, meant trying your best to let go of little things, failing utterly, and then being grateful that your partner was willing to forgive you month after month.

Usheer and I didn't have that problem. Usheer didn't leave trash on my desk. If I asked him to do something, he did it,

and most of the time I didn't even have to ask. For my birthday, Usheer bought me an ergonomic chair that cost almost as much as a laptop because he noticed I'd been complaining about back pain. "You spend ten hours a day at your desk," he told me. "You should be comfortable." Love, I was realizing, could be easy.

For a while, Usheer was right: we didn't fight. My breakup had been so awful that for months afterward I didn't have any emotions other than panic. When my ability for anger returned, I panicked even more anytime I started to feel an inkling of irritation. Angry was why Theo had left me. Angry meant I wasn't lovable.

Yet every month or so, I'd get an itchy, crawling feeling under my skin. I was spoiling for a fight. After about six months of dating, Usheer and I began to fight regularly, mostly because I was afraid he was going to leave me. At first, they were small arguments that were easily settled since the ghost of Theo was always at the back of my mind. Gradually, our fights became worse and started to echo the pattern I'd been in with Theo: me screaming, time apart, tearful reconciliation.

From my perspective, the fights were mild compared to what I'd gone through with Theo. They had the same out-of-control flavor, where my body changed temperature and I felt like I was imploding inside, but it was easier to calm down. While Theo had fought back, feeding the flames of my anger until I burned us both to the ground, Usheer stared at me bewildered. Our fights were usually doused in a day or two, much shorter than the weeklong arguments I was used to. Still, Usheer was traumatized. He'd curl into himself during the fights, and even after we'd made up, he would walk around on eggshells. I knew I was hurting him and I didn't know how to stop.

Something in my brain felt broken. Before I'd met Theo, I'd managed to keep my temper on a leash whenever I felt irritable.

With Theo, leashing my rage felt impossible: we both managed to pick at each other until our fights spiraled out of control. Now, even though I only felt a milder version of the rage Theo inspired in me, I couldn't manage to keep myself in check. I had no idea if Theo had brought out a specific type of rage in me and anything Usheer did that reminded me of Theo reignited it, or if I'd always been capable of this rage and it lurked within me, waiting for a reason to explode at the world.

Then, one day, in late spring, when the COVID pandemic had just started and the blossoms on the trees had just begun to fade, Usheer and I had another fight. This time, he sat me down afterward. "I don't think I can do this anymore," he said.

I went to the bathroom and vomited. Then I stared at the ceiling for a long time. There was always some elaborate explanation for why Theo and I fought: long-distance stress, different priorities. None of these reasons was present anymore. Something else was wrong. If I didn't fix it, Usheer was going to break up with me and I would deserve it. If I couldn't make it work with Usheer, I would probably never be able to make any relationship work. Theo had tried—really tried with everything he had. Usheer, who was so pathologically patient it was obscene, and who was so compassionate he could even find something to love in cockroaches, was now telling me he couldn't try anymore. I went to the computer and googled "severe PMS." I stumbled upon the Massachusetts General Hospital Center for Women's Mental Health's website, which had the following description:

> Normally you're a pretty chill person . . . But . . . It is a week before your period . . . You burst into tears when someone tells you that you look tired . . . you yell at your best friend for no reason. The world sucks and everything is going wrong.
> **Does this sound like you?**

If this happens to you every month, the week before your
period, you may have PMDD.[1]

I called my doctor.

THE ROCKY ROAD TO DIAGNOSIS GETS ROCKIER

DSM-IV came out in 1994 with PMDD listed in the main text as
a "Depressive Disorder Not Otherwise Specified," while its cri-
teria stayed in the appendix as a condition for further study. Six
years later, the APA published an update, *DSM-IV-TR*. PMDD's
updates were relatively minor, such as rephrasing sentences for
clarity and noting that symptoms were comparable to general-
ized anxiety as well as depression. While the *DSM-IV* revision
didn't stir up much drama, the controversy around PMDD was
far from over. It was about to get spicier because the drug man-
ufacturer Eli Lilly was pushing the Food and Drug Administra-
tion to approve its best-selling drug Prozac as a treatment for
PMDD.

In 1998 the Society for Women's Health Research organized
a roundtable of experts to discuss Prozac as a treatment for
PMDD. Jean Endicott, a Columbia University professor who
had been in the PMDD working groups for the third and fourth
editions of the *DSM*, led the discussion, which included repre-
sentatives from Eli Lilly and FDA officials.[2] The group ultimately
released a paper that cited evidence from old and new studies,
concluding there was sufficient evidence to use fluoxetine, the
generic name for Prozac, to treat PMDD.[3]

In July 2000, the FDA approved Prozac to treat PMDD. Eli
Lilly repackaged Prozac, swapping out the green-and-yellow
capsules for pink and lavender ones, and sold it under the name
Sarafem. Sarafem was a play on the word *seraphim*, the angels

who guard the throne of God. Eli Lilly provided an altruistic reason for the rebrand: they wanted to help women. "Women told us they wanted treatment that would differentiate PMDD from depression," a spokesperson for Eli Lilly explained.[4]

It's hard to see Eli Lilly's motives as purely altruistic. Its patent on Prozac expired in 2001.[5] This was disastrous news for the company since Prozac was its top-selling drug.[6] Prozac had been a blockbuster ever since Eli Lilly introduced it to the market in 1988,[7] and by 1996 Prozac accounted for 34 percent of Eli Lilly's sales.[8] The patent's expiration would mean Prozac's sales would decline from $2.51 billion in 2000 to an estimated $625 million in 2003.[9] Eli Lilly fought against the patent expiration in a six-year court case that made it all the way to the Supreme Court, but ultimately lost.[10]

Executives at Eli Lilly knew they would have to come up with new ways of making revenue. By March 2000, Eli Lilly's stock price had fallen over 40 percent in anticipation of the patent expiration.[11] In its annual financial report in 2000, CEO Sidney Taurel wrote:

> We remain opportunistic; therefore, we selectively pursue promising leads in other therapeutic areas. . . . In addition to discovering and developing new chemical entities, we look for ways to expand the value of existing products through new uses and formulations.[12]

New uses of Prozac included a version that could be taken once a week,[13] as well as Sarafem.[14] Since Sarafem was a new application of fluoxetine, it would be protected until 2007.[15]

Eli Lilly took the opportunity and ran with it. The company went on an extensive marketing campaign, spending an estimated $17 million advertising Sarafem to the public and $16 million marketing it to doctors and in scientific journals during the

latter part of 2000.[16] In one Sarafem commercial, a woman yanks at a grocery cart that's stuck. A soothing voice-over explains:

Think about the week before your period. Do you feel irritability? Tension? Tiredness? Think it's PMS? Think again. It could be PMDD: premenstrual dysphoric disorder. You know, those intense mood and physical symptoms the week before your period. Sound familiar?[17]

Another, with a similar voice-over, showed a woman digging through a bowl looking for her keys. While the commercials did note that symptoms were "intense," they did not explicitly lay out the differences between PMS and PMDD. Rather, they seemed to imply that anyone who menstruated should think about medication.

Paula Caplan blasted the commercials in a paper: "Feminist and other women's Internet discussion lists have been buzzing with messages from women who feel insulted by ads that depict women as shrews."[18] I agreed. The ads were insulting—only I thought they were insulting because they didn't go far enough. If my PMDD episodes were confined to yanking on a shopping cart or digging through a bowl of keys, instead of fights that erode or end relationships, I would have been thrilled. I wouldn't have talked to a therapist in grad school or called my doctor during the pandemic. If Eli Lilly had shown someone ramming their car into another one (a story one spouse told me about their partner with PMDD), that would have been more accurate. Worse, the commercials seemed to suggest that ordinary irritation in women— who hasn't tugged at a shopping cart that's stuck?—was a sign of a disorder that should be medicated with pink-and-purple pills.

In some ways, the commercials worked. Sarafem was launched in the U.S. in August 2000, and by the end of the year sales had reached $14.6 million.[19] In other ways, the commercials backfired

spectacularly. In November, the FDA chastised Eli Lilly for marketing Sarafem too aggressively and targeting women who had PMS, rather than the more severe PMDD. Eli Lilly ended up pulling the ads.[20] However, the damage was done.

The media had a field day over the FDA's approval process. The story practically wrote itself. At best, Eli Lilly looked overeager to sell Sarafem. At worst, there was plenty to fuel conspiracy theories about inventing a new audience for a drug. A *Village Voice* investigation pointed out that two members of the roundtable conducted research funded by Eli Lilly, and a third had received speaking fees from Lilly. Moreover, the Society for Women's Health Research, which had organized the Eli Lilly roundtable, had an "unrestricted educational grant from Eli Lilly and Company." It had used the grant to conduct a national survey about awareness of PMDD treatment—specifically Sarafem.[21] The media complained that the consensus around using SSRIs had only been substantiated by two papers, one of which was paid for by Eli Lilly Canada. The second, which was written by researchers at the National Institute of Mental Health—a government entity that could not accept private donations to conduct its research—only examined the effects of fluoxetine on seventeen women with PMDD.[22]

Allen Frances, the head of *DSM-IV*, was not happy about the FDA's approval of Sarafem. He told reporters it was "absolutely absurd for the FDA, in secret meetings with drug companies, to make a decision that would be contrary" to what the psychiatric community had decided about PMDD. "That's not the way regulators are supposed to work," he said. "It's the fox guarding the hen house."[23]

Paula Caplan wrote a paper on how therapists could gently educate patients who thought they had PMDD. A belief in PMDD could hamper someone's recovery process, she pointed out:

If she rejects your offer of information . . . continues to main-
tain that she has "PMDD" and continues to take Sarafem,
what do you do? If you believe that this will seriously impede
her progress in therapy—for instance, if she sticks with the
belief that all of the "unfeminine" feelings she has, such as
anger, result from her "PMDD"—you are obligated to tell her
that, just as you would with any other major impediment to
therapy.[24]

She provided an alternative explanation for PMDD symp-
toms. Researchers had found that PMDD was prevalent in
women who had traumatic pasts. "To label these women men-
tally disordered—and send the message that their problems are
individual, psychological ones—hides the real, external sources
of their trouble," she wrote.[25]

Reading Caplan's paper was difficult. I felt crushed, as if
someone I respected greatly had accused me of being a liar.
When I'd spoken to Caplan on the phone, she had wondered if I
was unhappy in my job or relationship. She did not ask if I had
a history of sexual abuse or trauma, but now I wondered if she'd
wanted to. I had a safe, sheltered childhood, and I loved my job
and my relationship with Usheer, but I had the feeling Caplan
wouldn't have believed me. I did not know how to explain that
my jobs had changed, the men in my life had changed, but the
one constant was always my monthly breakdowns.

Even more neutral articles expressed doubt. In 2002 the
American Psychological Association (a different organization
than the American Psychiatric Association that releases the *DSM*)
ran a cover story titled "Is PMDD Real?" It contained quotes
from Jean Endicott, the head of the roundtable discussions, as
well as Paula Caplan and Joan Chrisler, who were against the
idea of PMDD as a disorder. The article was inconclusive about
the existence of PMDD but stated: "Whether PMDD is a mental

disorder or not, the most important thing is to give women who seek help validation."[26]

Two years later, the European drug regulator ruled that "PMDD is not a well-established disease entity across Europe," pointing out that the disorder was listed only as meriting further research in *DSM-IV*.[27] Eli Lilly was forced to drop PMDD from the list of disorders Prozac treated.

Despite Eli Lilly's mixed motives, a tragedy lies behind all this: fluoxetine actually *is* an effective way to treat PMDD. About a decade later, research would come out demonstrating that while SSRIs take two to three weeks to work for depression or anxiety, treatments like fluoxetine can alleviate irritability in some people with PMDD within hours.[28] I'd had no idea of the history behind fluoxetine, yet somehow I managed to absorb the stigma against antidepressants. I refused them when Dr. Parr asked me if I wanted medication, and years later I would refuse them, instead opting for medications that were less effective with dangerous side effects.

DSM-5: DIAGNOSIS AT LAST

Despite the controversy, the idea of PMDD as a diagnosis and thus a disorder that could be treated gained momentum. The Sarafem approval seemed to open the floodgates for additional drugs to treat PMDD. The FDA approved Zoloft, another SSRI, in 2002 and then Paxil in 2003 to treat PMDD. In 2006, the FDA followed up by approving YAZ, an oral contraceptive. The same year GlaxoSmithKline, which manufactured Paxil, paid researchers to write up guidelines for how to treat PMDD, even though such guidelines are usually created by medical groups. In the guidelines, SSRIs were one of the first-line treatments for PMDD.[29] Around the same time, preparations were underway

for the next version of the *DSM*: *DSM-5*, given the Arabic numeral to set it apart from previous versions.[30]

In 2009 a group of experts met to review the existing literature around PMDD and decide whether there was sufficient evidence to include PMDD in *DSM-5*.

Among them was Peter Schmidt. A psychiatrist by training, Schmidt was one of the authors of the National Institute of Mental Health paper on fluoxetine that was discussed at the Eli Lilly roundtable on PMDD, as well as of the paper that demonstrated fluoxetine can relieve PMDD symptoms in a matter of hours. In fact, much of the foundational research on PMDD can be traced back to Schmidt or his coauthors, since Schmidt is one of the very few researchers who study the impact of sex hormones on the brain.

I spoke to Schmidt over a series of interviews that culminated in a visit to his office in Bethesda, Maryland. Schmidt's office at the NIMH building floats above the arched grand foyer, nestled behind a labyrinth of corridors. It sits in a hallway just behind the clinical waiting room where patients come in to participate in his experiments. His office is lined with bookshelves filled with stacks and stacks of papers.

Schmidt is easy to talk to. He has a low, gravelly voice and blinks owlishly over his glasses to punctuate his sentences. He likes to take his time with explanations, easing into them by providing the backstory to the backstory. At times it seems like his answers are tangential to the question, but then he wraps it up and all the tangents fold into a cohesive and detailed whole. While waiting for the next question, he'll slide into stories about his dog, who likes to chew up *The Economist* but leaves the store catalogs alone.

Schmidt recalls a well-run *DSM* committee that didn't debate much about whether PMDD existed. "The evidence was

brought in and reviewed. . . . It was pretty clear from a population standpoint that there's PMDD. We also had international studies pointing to the same thing."

By this point, research around PMDD had evolved. There was a body of work showing that when people with PMDD stop ovulating, their symptoms disappear. Schmidt authored a key paper that described a study where he medically suppressed ovulation in people with PMDD and people without PMDD. People who had no symptoms to begin with saw no changes. However, people with PMDD saw their mood symptoms of anxiety, depression, and/or irritability go away once they stopped ovulating.

Schmidt and his team then tested the effects of progesterone, estrogen, or a combination of both. People without PMDD continued not to have symptoms. However, some people with PMDD had psychiatric symptoms when progesterone was added back, others when estrogen was added, and still others when both were added.[31] In other words, despite concern that PMDD was the result of scientists' medicalizing of emotions and trauma, there was biological evidence that people with PMDD reacted differently to changes in hormone levels. Moreover, Schmidt's paper overturned another long-standing hypothesis, that PMDD was the result of abnormal hormone levels. The experiments showed that hormone levels didn't matter: it was the *change* in hormone levels.

Instead of debating whether PMDD existed, the working group focused on the finer points of PMDD, such as whether irritability should be the primary symptom of PMDD and whether people should track how impairing their symptoms are. Irritability ultimately made it into the *DSM-5* criteria for PMDD but remains alongside sadness and anxiety as core mood symptoms. Its primacy is still being debated today.[32] Meanwhile, *DSM-5* requires tracking mood and behavioral symptoms for two months,

but does not require tracking the accompanying "significant distress" or interference with someone's life for two months.[33]

DSM-5 was published in 2013, with PMDD listed in the main text as an official diagnosis (see Appendix C). In a paper explaining the rationale for including PMDD in the new edition, the working group members added the following: "The Food and Drug Administration and similar authorities in other countries have approved several pharmacological agents for the treatment of premenstrual dysphoric disorder, making it a de facto diagnosis regardless of its position within DSM."[34] (In 2022 the APA released an update to *DSM-5*, *DSM-5-TR*, but the entry for PMDD did not go through any changes.)[35]

Once again, there was an outpouring of articles debating the validity of PMDD. In 2014 the *Journal of Bioethical Inquiry* published a paper arguing PMDD was a culture-bound syndrome.[36] In 2016 the *Milwaukee Journal Sentinel* published an investigation of PMDD, finding "evidence of drug company influence—and money—at virtually every step of the way." In fact, it would take the World Health Organization until 2019 to formally recognize PMDD as a diagnosis in its International Classification of Diseases.[37]

One of the members of the roundtable that had kick-started the FDA approval of Sarafem told me they believe that the roundtable paper was ghostwritten by Eli Lilly representatives. They declined to answer specific questions, citing a fear that "old ghosts would come back to haunt [them]," but did send me a copy of *The Illusion of Evidence-Based Medicine* by Jon Jureidini, a pediatric psychiatrist, and Leemon B. McHenry, a professor of philosophy and bioethics. In it, Jureidini and McHenry detail the ways in which Big Pharma is corrupt, from paying off academics to endorse papers with dubious results to hiding evidence of side effects during clinical trials. They list PMDD as one of the most "questionable indications for psychiatric drugs."[38]

Critics argue that PMDD was included in the *DSM-5* because of politics, not science. Ironically, proponents of PMDD argue that the disorder had been kept out of previous versions of the *DSM* for the same reason. Schmidt mentioned attending an earlier meeting of experts discussing PMDD at the *DSM-IV* working group meetings. "One of my colleagues asked everyone around the table to raise their hand if they'd actually met someone with PMDD," he said. "People at the lower end of the table did, but the people who were in charge of the discussions didn't. We weren't asked back."

When I asked Schmidt about the media's narrative that the FDA had approved Sarafem on the strength of two papers, he pointed out that this was an oversimplification. While two main papers were cited, they rested on a bedrock of several papers that had studied fluoxetine as well as other treatments for PMDD. "There were lots of treatments people studied for PMDD," he said, and rattled off a string of treatments from magnesium to thyroid hormones. "Fluoxetine worked the best."

He explained that the first paper studied four hundred people, which probably would not have been affordable without funds from Eli Lilly. The NIMH paper discussed a much smaller pilot study that went through extensive FDA audits. It compared the effects of fluoxetine versus a placebo on PMDD and examined how quickly PMDD would respond to SSRIs, since much of the research at the time on PMDD and SSRIs did not use placebos.[39] Furthermore, he added, we don't require that other disorders have a formal diagnosis before we treat them. Postpartum depression isn't a stand-alone diagnosis in the *DSM*, but no one questions whether it's real, and there's no controversy around treating it.

I found it telling that Jean Endicott, who led the Eli Lilly roundtable and was part of the *DSM-III-R*, *DSM-IV*, and *DSM-IV-R* working groups, told interviewers she was not intimidated

by the campaign against PMDD because she and her mother had PMS-like symptoms.[40] Given that PMDD only appears in 5 to 8 percent of the population, and how much social pressure there is not to talk about mental and menstrual health, it's not surprising there's very little awareness of PMDD. Theo and Usheer had seen the full extent of my PMDD episodes, but no one else had. At work, I had a reputation for being calm—coworkers had occasionally told me they couldn't picture me angry. My friends and family knew I struggled at times, but they'd never seen how much. After all, how do you explain monthly rage or suicidal ideation that passes as suddenly as it appears?

PMDD AS A DIAGNOSIS IN PRACTICE

As I pieced together PMDD's history, I was struck by how critics of PMDD were so vigilant about protecting women from being victimized that they never stopped to ask if they themselves were part of the problem. Reading through the arguments against PMDD felt like looking through a trick mirror depicting an alternate reality. The logic was sound and internally consistent. After hours reading about Sarafem's history, sometimes I would find myself wondering if PMDD was real, despite how real it has been to me for years.

My self-doubt was tied up in the controversy over PMDD as a diagnosis. The *DSM* experts had spent a great deal of time discussing how PMDD should work as a diagnosis, what counted as symptoms, and what patients should and shouldn't track. One of their major concerns was the lack of consistency in diagnosis. The point of tracking, according to Dr. Tory, is to make sure that patients do actually have PMDD. "It's a disorder with some false positives, but false negatives are rare," she said.

A false positive is when someone thinks they have PMDD but they don't. Dr. Tory mentioned that occasionally she would see

women whose partners had told them so many times that they were irritable and moody that they believed they had PMDD when their partners were just gaslighting them. A false negative is when someone doesn't think they have PMDD but they actually do have it. Most people tend not to find a PMDD diagnosis surprising. Instead, it feels like finally learning the answer to an impossible riddle.

However, the reality of getting diagnosed looks far different from the process outlined by the *DSM*. Many of the people I interviewed had been diagnosed the same way I had: by googling symptoms and then speaking to a doctor. Most had to see more than one doctor before they could get a diagnosis. Some had given up and just told the doctor they had depression so they could get antidepressants. None of them had been asked to track symptoms for two months. According to a survey of PMDD patients about their experience getting diagnosed and treated, over a third said their general practitioners had no knowledge of premenstrual disorders, and about 40 percent said their mental-health-care providers had no knowledge of premenstrual disorders.[41] Less than 12 percent of survey respondents said their clinicians asked them to track their symptoms.[42]

Tanya Valor is a twenty-nine-year-old Welsh woman who is reminiscent of a 1950s Hollywood starlet. She has wavy blond hair, perfect eyebrows that are arched like commas, and an air of effortless confidence. Tanya has known she needed help ever since she was fourteen, but getting a diagnosis was a long, rocky road. The first doctor she visited thought she had depression. "Avoid being alone," he told her. "Terrible advice," she said, especially given that one of her major symptoms was irritability. Her twenties were a roller coaster of highs and lows. "I left so many jobs because I got so angry, I needed to quit or fell out with colleagues or upset customers. Or I broke up with friends," she said.

About a year and a half before we spoke, the roller coaster

became too much for her. "I was driving home from work and I was so tired of it: one moment I'm the best salesperson and other times I want to die." Tanya nearly drove her car off a bridge, but managed to get home and started googling depression related to menstruation. She came across a blog post by the International Association for Premenstrual Disorders (IAPMD). "It just hit me," she said. "I went through my life and so many moments made sense." The next day, she called her doctor. The doctor sent her to get tested for diabetes.

When her doctor insisted on more blood work, Tanya broke down crying and insisted on speaking to someone with expertise in women's health and mental health. The new doctor believed her, but Tanya's relief was short-lived. She spiraled into a depression. "Why has this gone on for so long? Why didn't someone hand me a booklet and have me track my period in my teens? It would have changed my life."

Tanya's story made me realize how lucky I was. When I told my own doctor I thought I had PMDD, she instantly believed me. She didn't make me track symptoms for two months. At the time I was grateful. I'd spent over fifteen years without treatment for a problem I knew I had. I didn't want to waste time proving to a doctor that my experience was real. But now, as I conducted interviews for this book, I began to wish I had done symptom tracking, because not everyone I spoke to believed that I had PMDD, while others didn't believe PMDD existed.

One sociologist told me PMDD is really undiagnosed depression or anxiety, and people use PMDD to avoid the stigma of a mental health label and instead blame their hormones. I found this surprising, given that I would have much rather been diagnosed with depression or anxiety. People are familiar with both, and neither one requires mentioning your period.

The sociologist ended by saying people with PMDD should consider ibuprofen, exercise, and magnesium to relieve their

symptoms. I thought about all the moments when I'd taken ibu-
profen to manage my cramps and then a few hours later spiraled
out of control during a PMDD episode, pouring ibuprofen down
my throat in an attempt to overdose.

Some of the experts I interviewed asked me how I was diag-
nosed and if it involved two months of symptom tracking. Per-
haps I had PME, they suggested. I'd tracked my period for a long
time, and occasionally my mood, but not both together. I began
to worry about whether I actually had PMDD or if PMDD was
even real—especially since, thanks to fluoxetine, it had been a
while since I'd had a major episode. Sure, I was grumpy before
my period, but it was mild: easily appeased by an apology, choc-
olate cake, a head rub, or, better yet, all three.

The curse, or perhaps gift, of PMDD is that you feel perfectly
fine during the follicular phase of your period. It's easy to imag-
ine you simply didn't try hard enough to control yourself during
the luteal phase and next month will be better. To make matters
even more confusing, you are treated to a good month every
once in a while. It's easy to stop believing in PMDD until your
life falls apart.

Time and time again, the people I interviewed mentioned
that the worst part about PMDD is the gaslighting. There's the
gaslighting from medical professionals who simply don't believe
it exists, but there's also the gaslighting from your own mind.

At one point I got so spun around, I asked Schmidt to debunk
everything I'd heard about how PMDD wasn't a real diagnosis.
By now, I was taking fluoxetine, and I hadn't had a PMDD epi-
sode for months. It was easy to believe PMDD was a bad dream,
and reading through stacks of papers arguing it didn't exist didn't
help. "It's real, isn't it?" I asked.

"Are giraffes real?" he countered. He made the point that we've
decided to give a cluster of symptoms the name PMDD, much
in the way that we decided to one day name a tall, long-legged

animal that roams the savanna *giraffe*. (Giraffes, it turns out, should be subdivided into at least four separate species.)[43] While there's much we're still trying to find out, the symptoms certainly exist. "Of course PMDD symptoms are real," he said. "So are giraffes."

I was relieved—learning giraffes are a lie would have been too much to handle on top of finding out PMDD isn't real. Still, despite these reassurances, I decided to go off fluoxetine and track my symptoms. Jean Endicott had developed a clinical symptom tracker for PMDD, the DRSP (Daily Record of Severity of Problems). The official DRSP has twenty-one items listing symptoms associated with PMDD and the impact on work, school, daily routine, and relationships.[44] I used a modified version that I found on IAPMD's website, which condensed the questions down to eleven symptoms and their impact on productivity, daily routine, and relationships.[45] Every day for two months, I scored how much each symptom was impacting me on a scale of 1 to 6.[46]

After the first two days of tracking my period, I realized I was in a good news–bad news situation. Good news: no symptoms. I didn't have PMDD. Bad news: I needed to tell my family and friends I was deluded about my diagnosis. The third day, everything started to crumble. Usheer and I had a talk about the future, which resulted in a fight, which culminated with me punching myself in the face. I wondered if that might be a sign PMDD was back, but dismissed it. After all, don't we all indulge in some light self-harm when we get frustrated?

The next day, a friend texted me, upset. I'd thought she'd said I could tell my family about her pregnancy. She'd meant Usheer. I thought she'd meant Usheer and my parents, and she was furious that my parents had congratulated her.

I promptly descended into a pit of self-loathing filled with *I shouldn't have, why did I, why am I so dumb, why can't I be a normal person?* I spent the day locked in the bathroom crying. When

the tears ran out, I just sat on the couch inventing new reasons to feel guilty and worthless. My friend was mad at me, I'd gotten my parents into trouble, I'd ruined what should have been a perfect moment for my friend, and I was a self-absorbed narcissist because I couldn't stop hating myself. Usheer took me running and then for ice cream. Nothing made me feel better. I cried through the run, I cried through ice cream, I kept crying even though I was dehydrated and tired of crying. I did not know how to feel better. I'd forgotten how to feel better. When my period came a day later, the despair lifted. I was still unhappy, but it was no longer all-consuming. Thanks to medication, breakdowns like this had become a rarity in my life instead of a constant. I'd forgotten how bad PMDD episodes could get.

During the second month of symptom tracking, I had to travel for a wedding and would be staying with my friends Chao and Jeremy. I debated putting symptom tracking on hold. On the one hand, I couldn't face restarting the process when I came back and going through two more months without medication. On the other hand, the last time I'd seen Chao and Jeremy a few months ago, I'd forgotten to pack my meds. I ended up having a PMDD episode where I cried for hours. Even though Chao ordered all the cakes on the menu at dinner, I still couldn't stop crying. I was terrified of having another breakdown in front of them.

Still, I decided I'd stay the course, skip meds, and symptom track. Moreover, I thought, with a fierce twisted logic that was wrapped up in shame and insecurity—a lot of intelligent people were telling me with great confidence PMDD didn't exist. Very well, then. I should believe them. Maintaining my dignity in front of Chao and Jeremy would be an excellent reason to stop me from having a meltdown if PMDD was under my control.

At the wedding, Chao and Jeremy and I stuffed our faces and tore up the dance floor. All was well until I stepped out to buy

lunch the next day. In line, I read a *New York Times* article about two immigrants who met at a homeless shelter and developed a deep friendship. Then one dies, leaving the other to wander alone through the streets of New York.[47] I burst into tears and had to step out of the line. I hid behind a large bush in front of Jeremy's apartment and wept over friendship, the ways in which it makes our lives worth living and the ways in which so many friendships end, whether a slow decomposition over time or abruptly because of a fight that never gets resolved. Then I wept some more because I was ashamed that I couldn't stop.

I called Usheer, thinking of studies Paula Caplan had cited that say PMDD patients see symptoms decrease by 40 to 50 percent through talk therapy.[48] Granted, Usheer isn't a therapist, but he is a good listener with a soothing voice. Then I texted my friend Garvi, who can usually talk me out of anything. It didn't help. I couldn't stop crying. I wanted to go upstairs and hang out with my friends on our last day together. I wanted lunch. But I was crying too hard to make any of these things happen. None of this was under my control. I did not want to be this person. I wanted to stop crying. I wanted fluoxetine. I wondered what it would take for the world to believe the name and shape of this pain.

The Treatment Void

When I called my primary care provider after learning about PMDD through Google, I was terrified. It was April, we were one month into the COVID lockdown, and I couldn't imagine delaying treatment any longer while stuck in my apartment with Usheer. I wanted help now, but I was sure she was going to follow my therapist Susan's footsteps and get angry at me for being too much or tell me I was imagining my symptoms.

None of these things happened. My doctor believed me the moment I described my symptoms. Moreover, she was compassionate. "You sound like a wonderful person," she said. "I can't believe you've been living like this for over a decade. We're going to get you help immediately."

With that, she had my undying devotion. I had visions of a new magical me who practiced Zen Buddhism and was full of compassion, a friend to all small furry animals and chirping birds. Perhaps I, too, would now rescue cockroaches. However, I was wary of antidepressants. I'd heard horror stories about getting addicted and gaining weight. No one had ever told me anything good about them. My doctor also said she didn't much like prescribing antidepressants, so she put me on Nikki, the generic

version of YAZ, the only birth control the FDA has approved to treat PMDD.

I had read one of the side effects of birth control was mood swings. "What if YAZ makes everything worse?" I asked. "I'm barely hanging on." That was code for, *I haven't gone over the edge yet, but it won't take much to send me there.*

"You'll be fine," she said. "If something happens, we'll get you into therapy. I'm here for you."

The memory of Susan still stung, but I figured nothing could be worse than what I'd already been going through and went off to the pharmacy to get birth control. Typically, birth control comes with a week of placebo pills, which allow you to get your period, but in my case, the doctor recommended skipping the placebo.

Since PMDD is cyclical, I had to wait a few weeks to see if YAZ made a difference. It did. Not getting a period was life-changing. Instead of spending a week on the couch curled up in pain, I could run, I could focus on work, and I didn't feel sleepy or sluggish. I was so happy that I didn't have a period that it took me nearly four months to realize that my mood swings were getting worse.

A few months before I'd found out PMDD existed, Usheer and I had fought about one of his ex-girlfriends. Out of pure stupidity, I'd asked if he thought she was better looking than me. At first Usheer refused to answer, which confirmed my deepest fears. I pushed and I pushed, and finally Usheer gave in. In a moment of ill-considered honesty—and Usheer is honest to a fault—Usheer said yes, she was prettier.

"Well, what does that mean?" I raged. "Break it down for me."

And Usheer, panicking in the face of my rage, did. Now I could draw a diagram of my body and label everything that was wrong: my abs weren't flat, my hair was frizzy, and my face just didn't measure up, whatever that meant.

For the most part, we'd put the fight to bed, but during my PMDD week, the fight came back and so did the jackhammer pain of Usheer explaining what was wrong with me.

On birth control, I thought my anger would go away entirely. It didn't. Instead, it blazed in the back of my mind, often pushing itself forward until it consumed all my thoughts. I no longer had the peace that came with non-PMDD weeks: almost every day seemed to be a PMDD day.

In September Usheer and I went on a road trip to the Berkshires. I'd never been to the Berkshires, and Usheer had booked a tour of Edith Wharton's house. I was deeply excited. COVID had reduced my world to whatever was within walking distance of my apartment, and I couldn't wait to go somewhere new.

But that morning I woke up with a storm brewing in my head. As we drove down the highway lined with scarlet and orange trees, the storm grew worse. I couldn't calm down.

All I could think about was our fight. Usheer's ex-girlfriend loomed large in my imagination. I wondered if he'd leave me, if prettier was code for "saner" or "a better partner." I wondered why I could never manage to lose weight. If I was ugly, did that mean Usheer loved me less? I wanted to take a razor to my face and cut away my imperfections so I could leave my cheeks, my nose, and my extra pounds littered on the highway. None of this came out cleanly. Instead, I alternated between sobbing and yelling, "Why would you say those things to me?"

Nothing Usheer said could calm me down. Instead, his assurances made me spin like a top. I loved him; I didn't want to go through another breakup. But I hated him because he didn't think I was beautiful, which meant he probably didn't love me. I hated myself for not having a body worthy of love. I hated my flab, my hair, my everything. I didn't want to live anymore because I didn't deserve to.

Then I popped open the car door and tried to jump out onto the highway.

Usheer grabbed my seat belt and slammed the door shut. Then he pulled over to the side of the road. We sat staring at each other. Usheer clutched the steering wheel, gulping air, too stunned to cry.

After that, the day blurs into a patchwork of hazy images: Usheer driving white-knuckled the rest of the way to the Berkshires with one hand on my seat belt. Screaming at him to stop until he let me out on the side of the road because I knew I was going to jump again. Running in an unknown neighborhood while Usheer tailed me, my lungs burning and my calves aching. Collapsing in the car too exhausted to run, my mind still being thrown to and fro by waves of depression and anger like a ship caught in a storm. Calling the Edith Wharton museum and saying very politely we'd run into trouble on the road, could we possibly reschedule our tickets? Of course, we're fine, thank you for asking. We're just fine.

Although the day was blurry, two things became very clear to me. First, I did not want to die. I just wanted the pain to end so I could explore the Berkshires, eat pancakes, and acquire a deluxe version of Edith Wharton's collected works. Second, I needed to call my doctor. YAZ wasn't working.

"EASY TO TREAT FOR MOST PEOPLE"

PMDD treatments are fairly straightforward on paper. According to Ruta Nonacs, a psychiatrist who treats PMDD at the Massachusetts General Hospital Center for Women's Mental Health, the disorder is relatively easy to treat for most people. "I would say there's about 10 percent that's very hard to treat, but a lot of people respond so beautifully to the medication," she said.[1] Once

someone has been diagnosed with PMDD, first-line options for treatment are birth control, SSRIs, or a combination of both. Studies have found that SSRIs can be used intermittently—only during someone's luteal phase—to treat PMDD.[2]

In more severe cases, doctors will use gonadotropin-releasing hormone (GnRH) analogs, a monthly injection that suppresses ovulation and creates a chemical menopause. However, this can cause a loss of bone density and requires patients to undergo hormone replacement therapy at the same time. Most doctors will only recommend doing this for six months, which means most people with severe cases of PMDD will have to turn to the last line of treatment: surgery to remove the uterus and/or ovaries.

After speaking with Nonacs, I assumed my difficulty getting the right treatment was an anomaly. As I understood it, diagnosis was the hard part and treatment would be a matter of popping a few pills. I assumed wrong. There was a gap between the best practices articulated by the experts I interviewed who specialized in PMDD and what people experienced at the doctor's office. For example, C. Neill Epperson, who was part of the *DSM-5* committee on PMDD, said she never starts with birth control. "I always start with antidepressants," she said. "Then if someone is stable, I'll add in birth control, but rarely vice versa."[3] She was appalled it had taken me so long to get diagnosed. She also added that YAZ would not have been her first choice for someone like me, with a long and clear history of PMDD symptoms.

For almost everyone I spoke to, finding a treatment that worked was its own hill to climb. Most of the people I interviewed who had trouble with treatment fell into one of three buckets: they lacked access to treatment, treatment was ineffective, or they found the prospect of treatment as unpleasant as the disorder.

Namrata Menon, a twenty-four-year-old videographer living

in Mumbai, fell in the first category. Namrata is slight, with elfin ears. At first, they seem shy, but as they speak a quiet intensity builds in their voice. Their Instagram is a medley of dog close-ups, wide landscape shots from purple evening skies over mountains to fog-shrouded forests, and selfies—either glamour shots or quieter shots filled with shadows, with the occasional meditative reel about life with PMDD or gender dynamics in India.

PMDD would make Namrata feel anxious and suicidal each month, but they would deal by retreating into their room. "Tantrums were a big no-no in our house, so I knew whatever I was feeling I had to deal with within the four walls of my bedroom. I couldn't show it to others," they said.[4] They knew they wanted treatment.

Namrata said it's uncommon for Indian doctors to prescribe birth control to anyone in their early twenties with PMDD. They also worried about taking birth control since their sister had experienced several side effects, including a rise in blood pressure, anxiety, depression, and weight gain. Namrata wanted antidepressants, but obtaining them required seeing a psychiatrist to get a prescription. Psychiatrists are difficult to come by in India: there are only about 9,000 for a country of 1.4 billion people, or .75 per 100,000. (The Indian government estimates it needs 3 per 100,000.[5] By comparison, the U.S. has 16.6 psychiatrists per 100,000 people.)[6]

When I checked back a few months later, Namrata had finally found someone willing to prescribe antidepressants—but even so, they had to visit over fifteen pharmacies to get the prescription filled. "There's a hesitancy in general in India with respect to psychiatric drugs," they wrote in an email.[7]

Namrata's story points to an overall problem with a system that isn't built to treat PMDD, and this problem isn't unique to India. People I interviewed in Australia, the U.K., and the U.S. all had stories about doctors who wouldn't diagnose them or who

didn't believe their symptoms and wouldn't provide treatment. One woman told me she gets SSRIs by telling her psychiatrist she's depressed, because PMDD was a nonstarter.

Vonda Burris, thirty-five, who currently lives in North Carolina, was originally diagnosed with PMDD by their gynecologist in 2021, but when they moved, they had to change doctors. Vonda Burris is Black and genderqueer and has autism. Vonda has a mellow voice and a soothing presence; even though their journey was harrowing, when we spoke they projected an unflappable calm.

Vonda had an IUD inserted but realized the IUD was making their PMDD symptoms worse. "It made me nauseous; I couldn't get off of the couch. I lay there for five days. I went back to the doctor and said, 'I want to take this out. I think it's making me sick.'" The doctor refused. Vonda didn't push—they'd had bad experiences with medical professionals when standing their ground. Instead, Vonda went home and burst into tears. Their husband ended up removing the IUD himself. It took him an hour.[8]

Twenty-nine-year-old Anna Metzler is in the second category of people for whom first-line treatments didn't work. Anna is a cardiothoracic nurse who travels from location to location. She has curly brown hair, a clear steady voice, and a radiant smile. When she speaks, she's able to break down complex history and medical terms into bite-size pieces that are easy to follow. She's the kind of nurse I would want if I had open heart surgery.

As a teen, Anna struggled with anxiety, depression, and an eating disorder, all of which her PMDD exacerbated. When she was going through a PMDD episode, dropping shampoo in the shower would make her cry. She struggled with memory loss; she'd go to the grocery store and get lost. She'd get headaches, and her eating disorder would worsen. She would cut her legs and envisioned avenues for suicide everywhere. To manage her PMDD, she tried everything: different combinations of antidepressants

and oral contraceptives as well as lifestyle changes such as cutting out caffeine and alcohol. Nothing worked.

Anna decided she wanted a hysterectomy in her early twenties, but her doctors were dismissive. A psychiatrist told her to have children to cure her PMDD. "I was twenty-one, in college, and didn't want children. What do you mean you want me to have a baby? I'm clearly mentally unstable and am in no way fit to be mothering," Anna recalls thinking. Another doctor called her a raging lunatic when she told him about her symptoms. Anna knew she would not survive if she didn't get the hysterectomy to treat her PMDD and told her doctors as much. "I had a plan, a means, a date. I would keep fighting until this date," she said. Even then, doctors were reluctant.

After a year and five doctors, Anna eventually found someone willing to approve a hysterectomy. Still, she had to undergo a six-month course of hormone suppressants before the doctor would do the surgery. During this time, the doctor also had her on YAZ. Anna's reaction was similar to my own. She was on YAZ for three weeks and experienced the strongest suicidal ideation she'd ever had. "I'd drive and see an option to drive into a wall, walking through the house I'd think about knives. I was just tortured by these means of killing myself," she said.

However, what stings most is not the memory of her pain but the enormous amount of work she had to do to get treated. "I saw some of the best doctors, including a couple at the Mayo Clinic," she said. "I was treated like a liability. My reproductive ability was valued more than my desire to live."

Anna points out that she had the educational background to conduct her own research and walk into her appointments armed with data and studies. She also had the social know-how to be her own advocate. Even then, the process was grueling. She can't imagine how it'd go down for someone who is less equipped to battle the system for their own life.

For Anna, the battle was entirely worth it. Anna lights up when she talks about life post-hysterectomy. "Life is amazing. I used to plan according to my menstrual cycle. I had ten days where I could maybe do things but I wouldn't be able to plan things in advance," she said. She feels like a different person. She can travel now and, because of her job, spends thirteen weeks a year in a new city, usually one that she can choose. "Looking back, I'm like . . . how was I able to graduate school? I should have been hospitalized at some points. I don't know how I didn't end up killing myself."[9] Her TikTok account features a series of travel montages set to upbeat music. In one, taken in Belize, her first solo trip, she bounces on a diving board, and then flips backward into the blue-green water in a move of pure joy.[10]

Watching Anna's TikTok made me feel like she'd finally achieved what most people with PMDD want: not to end our lives, but to end the pain in our lives. The tears, the rage—all these are attempts to release our pain. In the moment they may seem futile, but at the end of the day I like to think of them as signs of how deeply we wish to live.

There's a third category of people who worry that treatment will be worse than the condition—those who want to avoid medications entirely. Tanya Valor falls into that category, and she is focusing on exercise, nutrition, and meditation. She's already using a hormone implant as birth control and is considering taking it out so she can fully understand her menstrual cycle. She doesn't want to take antidepressants, which she thinks are overprescribed in the U.K. "I don't want to have to take a pill every day," she said. "Sometimes PMDD comes by and I don't even notice it. Part of me being able to manage is being aware of it."[11]

Tanya isn't alone in her desire to avoid antidepressants and birth control. I spoke to Sarah Nowell, a thirty-nine-year-old mother of two who lives in the U.K. Sarah has straight brown hair and glasses. When she speaks, her words are carefully

chosen, her tone self-reflective. She runs an Instagram account that documents her journey with PMDD. In one photograph, she's smiling slightly at the camera, washed in clear daylight. It's the kind of photograph that conjures up visions of autumn days spent at a café or a library sipping tea and reading. The caption reads: "Just because I look like this on the outside it doesn't mean I'm OK."[12]

Sarah was diagnosed with PMDD when she was thirty-eight. Prior to having children, she was an elementary school teacher. Every month she ended up taking sick leave, and when she gave birth to her first child, she decided to become a stay-at-home mother. Before being diagnosed, she and her husband had split up multiple times. Sarah steered away from medication because she was breastfeeding her son. Once he was weaned off breast milk, she decided she wanted to try more natural methods. She has a "PMDD toolbox" full of coping mechanisms, which she read to me from a sticky note. It includes iron supplements, probiotics, magnesium, a clean and balanced diet, very little sugar, no caffeine or alcohol, time for herself, exercise, a regular bedtime, practices to heal her wounded inner child, aromatherapy, and crystal therapy.

I had never heard of crystal therapy, so Sarah explained. She collects different crystals and has paired them up with different PMDD symptoms. As Sarah talked about reiki and chakra points, and how she'd just started charting moon phases, I began to wonder what distinguished natural methods from unnatural.[13] Natural often included magnesium and calcium supplements but never birth control or antidepressants—especially antidepressants, which were stigmatized.

I was torn. If you aren't able to have a career or a relationship, then what do you have to lose by trying birth control or antidepressants? Studies show they work for a majority of people.

On the other hand, I understood deeply. We know so little

about birth control and antidepressants it's hard to know if the cure will be worse than the disease. My first round with birth control had nearly killed me. My second round went better— sort of. After YAZ, my doctor thought it was best to refer me to a gynecologist, someone who knew more about birth control options. The gynecologist put me on Seasonique, an extended birth control that meant I'd have a period once every three months. On Seasonique I entered the state of Zen calm I'd been dreaming about. I didn't have cramps. I didn't have mood swings. There was just a beautiful silence in my head. PMDD felt like a bad dream. Gradually, I began to forget what it felt like.

Seasonique also had side effects. First, it killed my libido. Second, it made me ravenous. Within three months I put on ten pounds. I wanted to spend the rest of my life as a Zen Buddhist monk at an all-you-can-eat buffet. Choosing between my sanity and my sexuality didn't seem like a winning situation. Moreover, I was terrified of gaining more weight and becoming even less attractive to Usheer.

Later, when I was conducting interviews, I asked Nonacs what the biggest barriers to treatment were for patients, since she specializes in treating people with PMDD. She said weight gain, followed by sexual dysfunction.[14] I was shocked. I expected the order to be reversed. I knew I was unduly preoccupied with my weight, but I'd hoped that other people had escaped that trap. After all, isn't it preferable that someone is happy and stable rather than skinny and miserable?

None of the people with PMDD I interviewed flat out said they were afraid of gaining weight, but when I brought up my own weight gain, some of them mentioned it as a reason for not trying medication. When I told an especially svelte friend with PMDD that I gained weight on Seasonique, she told me she'd point-blank refused birth control because she didn't want to lose

her figure, even though PMDD had ended one of her relationships. Instead, she took fluoxetine, which is known for being weight neutral—something I hadn't realized until she told me.

I felt horrible about my obsession with my weight, and somehow it felt even worse to know that I wasn't alone—many other women were also trying to choose between their stability and their waistlines, and their waistlines were winning. Studies show that for women, but not for men, weight can impact their earnings and their romantic prospects. Research shows that very thin women make $22,000 more than their counterparts, and while half of male CEOs are overweight, only 5 percent of female CEOs are.[15] Other studies show that college students with a higher BMI tend not to be in relationships—if they are women, that is. No difference was found for men based on their bodies.[16] It's not surprising that this pressure has led 56 percent of women to try to lose weight, according to a 2016 study.[17] Women face weight discrimination that men don't. Not only do we face this, we also have to carry the cognitive dissonance of being told our minds and characters matter more than our waistlines when society constantly signals just the opposite. Like so many others, despite knowing all this, I still fell into the trap of wanting to be thinner.

I was reminded of Anna Metzler, whose doctors were reluctant to remove her uterus even after she'd told them that she would kill herself if they didn't. I thought the issue actually goes one step further: society valued my reproductive ability and my perceived attractiveness more than my desire to live. Because I'd heard this so often, I'd internalized this view until it became my own reality. I reached a point where even though Seasonique was working, the trade-off wasn't worth it.

When I went to my gynecologist and asked for a treatment that wasn't YAZ or Seasonique, she told me she didn't have another birth control recommendation. She prescribed fluoxetine. I was

still wary of antidepressants, so I asked to take the minimum dose possible, which meant taking antidepressants a few days before my period, instead of every day, or even just during my luteal phase. Fluoxetine worked but not as beautifully as Seasonique. It felt like putting a leash on my emotions. I still felt them, but now they didn't control me. I could still go about my day even if anger, depression, and anxiety howled and bayed by the sidelines. Fluoxetine dampened my sex drive slightly but did not completely obliterate it the way Seasonique had, and it gave me the occasional headache, but the trade-off felt well worth it.

But now I had a different worry. I'd heard that you could get addicted to SSRIs, something several people had brought up during interviews. When I visited the National Institute of Mental Health, I sat down with Pedro Martinez, the head of the Reproductive Psychiatry Clinic. Martinez had spent over two decades at NIMH, running the clinical side of studies on the intersection between hormones and mood disorders with Peter Schmidt, before retiring in 2022.

I asked Martinez for his thoughts on the most common fears around using SSRIs: they cause weight gain, they are addictive, and they can stop working. To begin with, he said that SSRIs such as fluoxetine usually don't cause weight gain. Some are even known for decreasing appetite. He had no idea where the notion SSRIs cause weight gain comes from, but he said it was a common misperception. "Everyone I saw would claim SSRIs were making them gain weight, but we measured people's weight and it didn't change."

Next, Martinez nixed the idea that SSRIs are addictive. Addiction, medically defined, is the inability to stop using a substance even though using it causes physical or psychological harm.[18] Martinez explained that people don't end up craving SSRIs but that suddenly going without them can feel terrible. SSRIs provide the nervous system with an extra dose of serotonin, a neurotrans-

mitter that impacts mood. Low levels of serotonin are associated with depression.[19] If you suddenly stop taking SSRIs, you can have serotonin withdrawal, which manifests as twitches or feeling electric-shock sensations, which is why doctors recommend coming off them slowly.[20]

Finally, I asked him about whether SSRIs lose their efficacy. A few people I interviewed mentioned that SSRIs had stopped working for them and that their symptoms came back worse than before. In general, studies suggest that antidepressants lose their efficacy for 25 percent of people with depression, though this varies by drug.[21] Martinez said we don't know much about why this happens, but he's seen several patients need to switch medications after a year while others can continue on the same medication. While some people theorize that intermittent dosing (such as using SSRIs only during the luteal phase) may prevent antidepressants from losing their efficacy, as of yet we don't have much research on this, he said.[22]

I asked Dr. Tory why it was that some people said their symptoms were worse if they stopped using SSRIs after a period of time. "PMDD is a chronic disease," she said. "You have to continue treatment to manage symptoms, otherwise they'll come back." She did note that people can form a psychological dependence on antidepressants, which means we associate the drug with feeling better, and that we might be afraid of stopping or feel anxious if we do. However, she added, in her experience most people with PMDD had the opposite reaction: they felt better so they wanted to stop using medication.

She also pointed out we accept addictive substances in our lives such as caffeine or sugar without batting an eye. "As a population we tend to be suspicious of antidepressants and I think the root of that is stigmatizing mental health disorders," she said. "We need to get to a point where getting treatment for a mental disorder is just as accepted as getting treatment for a physical one."

PMDD eliminates choices: the choice to remain calm in the face of your emotions, the choice to stop crying or screaming, and the choice to be your best self. While I found medication helpful, given how painful this disorder is it seems clear that at least one aspect of PMDD should remain sacrosanct: the right to choose how you want to treat it, if you want to treat it at all.

THE UNANSWERED QUESTIONS

PMDD has only been in the *DSM* for a decade, and there's still much we don't know, including why certain treatments don't work for some people. According to Nonacs, PMDD treatments don't work for about 10 percent of patients.[23] The unanswered questions around PMDD fall into three main groups.

First, we don't have a clear understanding of the distinction between PMDD and premenstrual exacerbation (PME), which is when symptoms of an existing mental health condition worsen during the latter half of the menstrual cycle. While the public is starting to grow more aware of PMDD as a disorder, very little is still known about PME. *DSM-5-TR* does not delineate clearly between the two. Rather, it shoehorns PME into PMDD's diagnostic criteria, providing very little diagnostic information on PME. *DSM-5-TR* merely notes:

A wide range of medical conditions (e.g. migraine, asthma, allergies, seizure disorder) or other mental disorders (e.g. depressive and bipolar disorders, anxiety disorders, bulimia nervosa, substance use disorders) may worsen in the premenstrual phase; however the absence of a symptom-free period during the post menstrual interval obviates the diagnosis of premenstrual dysphoric disorder. These conditions are better considered premenstrual exacerbation of a current mental or medical disorder.[24]

As of yet, there's no commonly accepted definition for how much symptoms of a mental disorder need to worsen during the luteal phase in order for someone to have premenstrual exacerbation. Yet an estimated 60 percent of women with existing mood disorders have PME.[25] While there's scant research on PME, many researchers believe that most women whose PMDD doesn't respond to treatment may have PME and another mental health condition, typically depression. Studies have shown that in some cases oral contraceptives actually worsen mood disorders and can lead to increased suicidality, but these studies didn't distinguish between PMDD, PME with depression, and depression that is not exacerbated by the menstrual cycle.[26]

Dr. Tory pointed out that PMDD is complicated and varies from person to person. Identifying and defining textbook PMDD was a thirty-year battle, but PMDD rarely presents in its textbook format. It can often be comingled with other disorders like depression and anxiety, and we still don't have good ways to understand what is going on.

The second unanswered question is whether there are different subtypes of PMDD that respond differently to treatment. Dr. Tory hypothesizes there are at least three different types of hormone sensitivity. First, she proposes, there are people who are sensitive to progesterone surges. This tends to be the typical PMDD pattern. After ovulation, progesterone levels rise and PMDD symptoms such as irritability, anxiety, and mood swings appear. Next, she thinks, some people have estrogen-surge sensitivity. This means that when estrogen levels are increasing, some people might experience emotional highs or even mania and a tendency toward impulsivity such as binge drinking or risky sexual encounters. Finally, there's sensitivity to estrogen withdrawal around the onset of menses, which leads to increased depression and stress. Yet, as of now, we have no way of identifying different types of PMDD.

Furthermore, studies estimate that 18 to 20 percent of women have "subthreshold PMDD," where they have symptoms that disrupt their lives but don't meet the *DSM-5-TR* diagnostic criteria because they have fewer than five of the eleven symptoms.[27] "The PMDD diagnosis is incredibly rigid," Dr. Tory said. "It's imperfect and many people have more complex patterns. Part of this is in response to reasonable concerns from feminists who were against including it in the *DSM*. The PMDD criteria needed to be specific enough to be meaningful and not overdiagnose, but then that also leaves a lot of people locked out. They might not fit the definition even though they might need treatment."

Dr. Tory compared PMDD and PME research to breast cancer research in its early days. "It took decades to identify the different subtypes and start treating them accordingly," she said.

She thinks the next big wave of research for PMDD will involve identifying the types of PMDD in order to predict how effective various treatments are. "We need to stop running away from the complexity of real patients and find better ways of subtyping them in order to predict treatment results," she said.[28]

At the National Institute of Mental Health, Peter Schmidt and his colleague Shau-Ming Wei are working on a study where they use machine learning to identify different PMDD symptom profiles in order to understand if different types of PMDD exist and if people might respond differently to treatments.

The third unanswered question is what physiological responses occur when taking birth control and antidepressants. Most birth control studies focus on their effectiveness at preventing pregnancy, as well as their long-term health effects for women and babies. There's very little research on how people's hormonal profiles affect the side effects they experience on birth control. One clinician told me, "I'd love to see that research, but it's not a moneymaker so it doesn't get funded."[29]

Peter Schmidt is calling for more research on isolating PMDD biomarkers—that is, a biological signature that can be used to identify disease or measure how the body reacts to treatment.[30] The hope is that PMDD biomarkers could identify how people will respond to different medications and which side effects to expect. "This would mean there's less of a trial and error and more of an empirical approach to treatment," Schmidt said.[31] *Trial and error* struck me as exactly the right phrase. Right now, the lack of research means anyone getting treatment for PMDD or PME goes through an experimental phase. It's better than nothing, but the stakes are high: in some cases, error means death.

THE QUEST FOR A MIRACLE CURE

There have been attempts to develop a PMDD-specific treatment. In 2010 the Swedish pharmaceutical company Asarina Pharma patented Sepranolone after investing forty years of research and development into it.[32] As you may recall, allopregnanolone is produced by progesterone. Typically, it soothes and calms people, but people with PMDD react poorly to it.[33] Sepranolone blocks the effects of allopregnanolone.

Sepranolone was developed for PMDD treatment by Torbjörn Bäckström, a professor of obstetrics and gynecology and Asarina Pharma's chief science officer.[34] Bäckström became interested in PMDD in 1972, when he was a medical student working weekends in the local psychiatric hospital. He was fascinated by a patient who was constantly getting arrested at the same time of the month for violent outbursts, such as punching a police officer. When her period arrived, the outbursts stopped and she was left feeling guilty. Bäckström began studying hormones in an effort to understand what had happened to her.

A few years later, he set up experiments measuring hormones

in blood and tissues and realized that for some people seizures were correlated with hormone levels, which caused him to dive deeper into understanding the nature of neurosteroids and how women with PMDD have an atypical reaction to allopregnano-lone.[35]

In 1998 he identified a naturally occurring substance in the body that inhibits allopregnanolone, which he dubbed Sepranolone. He began to develop it as a treatment for PMDD. In 2014 the first trial for Sepranolone started. In the sample of 120 people, PMDD symptoms decreased by 80 percent, with very few side effects. Four years later, Asarina Pharma rolled out a second trial, with over two hundred people across Europe. Thousands applied, hoping to get a chance to try the new treatment.[36]

There was a crucial problem with the second trial: researchers could not find a statistical difference between Sepranolone and a placebo. On average, people with PMDD had a baseline score of 85 on the DRSP, the daily record of PMDD symptoms.[37] Sepranolone dropped the symptoms' scores by 30.3 points. However, patients on the placebo saw their symptoms' scores drop by 27.9 points.[38]

Asarina Pharma discontinued further work on Sepranolone as a treatment for PMDD, to the disappointment of many. The company released a statement in which its CEO, Peter Nordkild, apologized: "To all women living with PMDD I can only express my shared disappointment about the study outcome. Maybe more than most we understand the enormity of the need for a treatment for PMDD, but also the incredibly complex symptomatology. We hope that our research around allopregnanolone will play an important part in the collective understanding of PMDD, and that this study has been valuable in raising awareness of and attention to this devastating condition."[39]

The ensuing disappointment was so great that IAPMD also released a statement and devoted a page on its website to

keeping track of updates.[40] In IAPMD's last update, in September 2021, Asarina Pharma and leading PMDD experts dove further into the trial data and found that Sepranolone actually had an impact on some but not all PMDD symptoms.[41] Furthermore, when the researchers extended the analysis to look at nine days of symptom data instead of five days, they learned that patients on Sepranolone experienced few or minimal PMDD symptoms, markedly different from patients on the placebo.[42]

I asked Dr. Tory why the placebo responses were so high. She pointed out that a lot of people with severe PMDD who aren't responding to treatment are desperate. A new medication could easily create a placebo effect, especially given that PMDD has psychiatric symptoms that are self-reported. If you're feeling hopeful about a new treatment, it's plausible you'll be less depressed and stressed in the following months.[43] I remembered my own experience on YAZ: it took me about four months to realize that I was doing worse mentally, because I was so happy to see my cramps gone and so happy to finally be doing something about my PMDD after decades of being enmeshed in a vicious cycle. As of yet, Asarina Pharma has no plans for moving forward with Sepranolone as a treatment for PMDD—which would require another lengthy and expensive trial.

This news might be disappointing to some, but at some level it's heartening that Sepranolone is being tested so carefully. There's an endless string of people hawking PMDD treatments that are based on shaky science or haven't gone through rigorous testing.

One controversial example is the brainchild of Chilean gynecologist Jorge Lolas Talhami. Lolas Talhami believes PMDD is caused by inflammation of the cervix. To treat it, he recommends injecting the cervix with anti-inflammatories. He conducted a study on 148 PMDD patients and published the findings in the *Open Journal of Obstetrics and Gynecology* in 2015.[44]

First, he injected their cervixes with a mix of gentamicin, an antibiotic, and lidocaine, an anesthetic, followed by diclofenac, an anti-inflammatory. Diclofenac is usually used to manage arthritis and menstrual cramps,[45] but it is also associated with heart attacks and strokes.[46] Next, he administered three rounds of cryotherapy for up to twenty minutes.[47] Cryotherapy is a treatment for precancerous cells in which doctors use liquid nitrogen or argon gas to freeze abnormal cells or tumors to kill them.[48] He followed up with another few injections. If the patient showed no improvement, he tried a second round of cryotherapy. Prior to the treatment, he wrote, patients' symptoms were severe for an average of about thirteen days; afterward, this dropped to two days. In addition, symptom severity improved by at least 70 percent.[49]

There's a lot to love about the promise of a treatment that makes symptoms shorter and milder. Yet I could not find other papers replicating Lolas Talhami's treatment. Meanwhile, as of yet the research is inconclusive about the connection between inflammation and PMDD. IAPMD has issued a warning about Lolas Talhami's treatment, writing: "The treatment is not a rational approach to addressing the existing known causes of PMDD."[50] I emailed Lolas Talhami. He asked for questions in advance and then responded by sending me news articles, interviews, a book (mostly in Spanish, which I cannot read), and a patient testimonial in English. He did not directly answer my questions about safety records, the costs of treatment, or how he felt about IAPMD's warning. I got the articles translated, but they did not cover these topics either.

I did some digging into the *Open Journal of Obstetrics and Gynecology*, which had published Lolas Talhami's paper, and was not impressed. The journal is one of many owned by SCIRP, Scientific Research Publishing. In 2010, the prominent scientific journal *Nature* conducted an investigation of SCIRP and found

it had not only published papers that had already been published elsewhere but also listed several experts on their editorial board without their permission.[51] Though the investigation was over a decade old, I found several of the experts listed on the *Open Journal of Obstetrics and Gynecology* editorial board who did not mention the journal in their own biographies and CVs. One doctor I emailed told me she'd never heard of them and promptly cc'd her hospital's attorney asking for her biography to be taken down from their website. As of this writing, it was still up.

Adriana, the author of the testimonial Lolas Talhami emailed me, agreed to chat after initially declining since she was still recovering from her treatment. Adriana is forty-two and is a translator who speaks Spanish, English, French, and Chinese and lives in Mexico City. She had what she called normal PMS—anger, irritability, heavy bleeding, abdominal cramps. In her thirties she had a massive PMDD episode, which she believes was triggered by a number of personal crises. In the wake of this, she took antidepressants for two years, but they did not help. She did not want to try birth control—she didn't want to overwhelm her system by adding more hormones to the mix. She was still hoping to have a child one day, so chemical menopause and surgery weren't options.

By 2020, Adriana's symptoms had worsened to the point that she was spending whole months in bed sleeping. Adriana's mother, a psychologist, diagnosed Adriana with PMDD. Adriana consulted a PMDD specialist from Spain who had trained under Lolas Talhami. The specialist thought she didn't have PMDD. "She was not kind, she was not attentive or a good listener," Adriana said. In the meantime, doctors also checked her for tumors and thyroid problems and put her through a battery of other tests, but nothing came up.

Adriana decided to work with Lolas Talhami directly. Since Lolas Talhami screens patients to make sure they are good

candidates for treatment, she had to write him a letter explaining her symptoms and history. In September 2022, she flew to Chile and spent five weeks with Lolas Talhami. He gave her the treatment, which involved various shots and injections in her cervix in order to reduce inflammation. Then, she went through a two-and-a-half-hour procedure, during which he injected her with "frozen medicines," a process, she says, he filmed. "He has cabinets full of films of his patients," she said. The whole process cost $10,000. "If you can't afford the operation, he sends you home with a cream that you can apply," she said. "It provides relief but it doesn't reduce inflammation."

Immediately after the first shot, Adriana felt more energetic. Her hair had been falling out, but now it stopped. She was leaking medication and had to wear pads to absorb them. The process didn't hurt, she said. What did hurt was a postoperation checkup, where Lolas Talhami pushed on her cervix to make sure it was properly aligned. Adriana flew home but had a PMDD episode afterward, which she chalked up to the stress of the long flight. In December and January, she lost three people close to her and had more symptoms. She realized something was wrong.

Adriana did more digging on PMDD and found a nutritionist who claimed to have a special diet for people with PMDD. When I chatted with Adriana, she'd been working with the nutritionist for twelve days, and she was hopeful. She'd seen therapists and doctors who'd said her problem was needing a new man, or that she was lazy, or that she was too smart to be so depressed. She was tired of it all. She wanted her life back; she wanted to get back to her students and authors. We took a several-minute detour to discuss Mo Yan and the intricacies of translating literature before returning to her PMDD journey.

When I checked back in, a month later, Adriana had fired

her nutritionist and was crafting her own regimen of supplements and workouts in hopes of gradually getting back to her previous routine. Overall, she was grateful to Lolas Talhami but felt his procedure was far too expensive and incomplete. "This should be available to everyone," she said. She pointed out that for many Latin American women, conventional treatments were out of reach because they were expensive. "Women spend their entire salaries on it," she said. Meanwhile, most information on PMDD is only available in English. She was full of advice for me on reducing processed food and incorporating more exercise. "There's hope," she told me, and we wished each other well, fervently and with great affection.

I also asked Peter Schmidt for his thoughts on Lolas Talhami's method. Schmidt gave me a flat-eyed look. Inflammation, he pointed out, was associated with several different conditions, from COVID to diabetes and heart disease, as well as several different kinds of mental disorders, since many are seen as neuroinflammatory. "There might be an underlying inflammatory response with PMDD," he said, "and if there is, show me the evidence. We're looking for it." On the whole, he was skeptical of Lolas Talhami's treatment. "There's no evidence biologically for it. I would be cautious about doing it if I were a patient," he said. "It's easy to hear about the successes but not the trauma the cure could have caused some people."[52]

It's easy to get lost in what is and isn't true, especially when so much remains unknown regarding PMDD. We haven't reached a point where PMDD appears in mainstream discussion, and there's even less understanding of the biology behind PMDD. Yet the suffering PMDD creates can be a breeding ground for misinformation and false hope. This makes it easy for pseudoscience and myth to sneak into the discourse. Reddit abounds with tales of people who found a new cure for PMDD: a nutritionist

promising the right diet will fix everything, doctors offering synthetic hormones to fix hormone imbalances. But PMDD cannot be cured as of yet. It is not caused by hormone imbalances; it's caused by a reaction to changes in hormone levels. There are no extensive studies on whether diet can alleviate symptoms. It's easy to forget all this in the face of chronic suffering, especially when the treatments doctors offer aren't working. Worse, understanding PMDD research requires wading through dense academic papers filled with complex scientific language. One Reddit user with PMDD asked if others had tried a doctor who was hawking hormone replacements at an anti-aging clinic. According to the user, half the clients claimed it "cured" their PMDD; the other half said it was a scam.[53] The Redditor wrote: "I am sick of doctors telling me to take yaz and then not giving me a solution when I say that Yaz makes me have all sorts of issues."

Another Reddit user, Laura Beckman, a freelance artist in New York, posted joyfully: "Huge victory for me—found out I actually do have a hormonal imbalance!" She went on to write that while she knew that hormone imbalances aren't usually the cause of PMDD, she had tried everything from supplements to eliminating dairy, antihistamines, and antidepressants. Finally, she found a naturopath who ran a test and said her progesterone was low and her estrogen was high. "I'm so happy I found the root cause," she wrote, adding that she encouraged everyone to get their hormones tested.

She later updated to say the naturopath charged her for several expensive supplements. When she went to her endocrinologist, the endocrinologist said her hormone levels were actually normal. Laura decided the naturopath who said she had imbalanced hormones was a scammer. "Be wary of any functional medicine doctor," she wrote. "Desperation makes us gullible."

In a later post, she wrote that she was on YAZ, which was

making her symptoms worse, but her doctor advised her to stay on it for six months. Finally, she updated once more to say she was trying a chemical menopause in preparation for a hysterectomy.

Laura and I spoke four months into her chemical menopause treatment. It was easy to see why she was excited by a solution that was off the beaten path. Time and time again, mainstream doctors had let her down. Laura had suspected she had PMDD since 2019. However, her therapist told her she didn't because people with PMDD have rages and destroy their relationships. Instead, Laura was avoidant. She hid in her room and wondered if she should break up with her partner. Laura then visited a psychiatrist who misdiagnosed her with bipolar disorder and put her on medication. She tried to get an appointment at Massachusetts General Hospital, which has a PMDD clinic, but was told Massachusetts General didn't treat New York residents. When she asked for a recommendation, they directed her to a New York psychiatrist. The psychiatrist found out she had an eating disorder in her teens and fixated on her past rather than her menstrual cycle, then charged her five hundred dollars.

Laura was stunned by how difficult it was for her to find treatment, especially since her father is a doctor and researcher who has connections at MGH. "It's crazy to me that I have all this privilege—my dad was trying to research this and help me," she said. "I realized the people at the cutting edge don't know any more than the people who are in the PMDD support groups. I realized I just need a gynecologist who listens to me." She ended up visiting several naturopaths before meeting the doctor who put her on chemical menopause in preparation for a hysterectomy.

Chemical menopause has reduced her symptoms by 60 percent. However, part of the reason she thinks the doctor was willing to give her the treatment is that she wrote a statement and

asked to read it to him first. "I wanted to preempt all the stupid questions," she said. "Which always starts with, are you sure you have PMDD?"[54]

It feels particularly unfair that people with PMDD have to be their own advocates, because PMDD makes it difficult to advocate—try being taken seriously when you're suffering from crippling anxiety or when you're on the brink of tears or screaming. Because there's so little general awareness about PMDD and PME in the medical community, patients are forced to do their own research. Those who are not well versed in science, who don't have the know-how to wade through research, or who are simply desperate are particularly at risk of believing in a miracle cure when, as of yet, there are no miracle cures.

It's no wonder that people turn to the internet for answers, and the internet does have answers. The only problem is the answers vary in quality. I found nutritionists, relationship coaches, and naturopaths all touting PMDD expertise. While some of them have a PMDD diagnosis themselves and many are well intentioned, much of what they sold had little to no scientific backing. One PMDD coach had a "PMDD survival" kit, which listed a bidet, a Himalayan rock salt lamp, electrolytes, and a smart light bulb—all with links to where you could purchase them on Amazon. I can see where focusing on mood lighting, hydrating, and sniffing a pleasant aroma could make someone feel better in general, but that's not the same as actually treating PMDD symptoms.

Worse were the PMDD nutritionists talking up the benefits of "eating right." To me this seemed like yet another way to police women's waistlines. I spoke to a range of people with PMDD whose opinions on treatment varied from trying all of them to trying none of them, but there was one treatment everyone had tried: eating "healthy."

Before I took medication, during PMDD episodes I binge ate junk food at a terrifying rate. Even if I was full and my stomach was bulging, I would crouch in front of the fridge stuffing chocolate into my face like a raccoon who'd just found a new trash can. These binges terrified me so much I tried to clean up my eating by skipping processed foods and quitting sugar. The first time, I tried to stop eating all sugar for a year, including foods that contained sugar like ketchup and bread. A few months into my no-sugar diet, I met Theo and went on to have some of the worst PMDD episodes of my entire life.

Other than my desperate attempts to quit sugar, my diets never lasted very long—I would always do well during my follicular phase, but the closer I came to my period, the more overpowering my desire for chips and chocolate. Usheer was usually able to predict when my period would come because my cravings were so overpowering I'd drag him to the nearest grocery store, even if it was midnight, and emerge with the same trifecta: caramel chocolate bars, chocolate cake, and chips.

However, once I began taking fluoxetine, all these cravings melted away and I stopped my traditional monthly grocery store runs. I still enjoyed pastries and chocolate but found I only needed a few bites. I no longer felt like my appetite was out of control. Later, I wondered if part of my frenzied feeding was because my body desperately craved serotonin.

PMDD is a disorder that already leaves people feeling guilty about not having enough control over their mood. It is particularly cruel that many of these regimens that "PMDD experts" tout imply that failure to control your mood is due to failure to control your diet. This is yet another manifestation of diet culture telling people that their illnesses are their fault. While everyone I spoke to mentioned eating healthy, and some said it helped, no one said it made their symptoms go away.

Yet as dismaying as it was to find so many pseudotreatments for PMDD online, it was easy to see why people are drawn to them. Monitoring your diet or sniffing essential oils can make you feel as if you're at least doing something, and neither will lead to unexpected side effects like jumping out of a car. Meanwhile, the medical community doesn't make it easy to get treatment and a diagnosis or to feel heard. Even with a diagnosis and treatment, I was surprised by how much I've had to manage my PMDD treatment compared to my other medical problems. I have asthma, and all I have to do is tell my doctor and they prescribe me an inhaler. No one has ever asked me if I'm sure that I have asthma, and if I change doctors or revisit my doctor, my prescription gets renewed without question. My doctors educate me about asthma, not the other way around. PMDD, on the other hand, has required educating my doctors and reeducating them every time I see them.

A year after my gynecologist gave me Seasonique and then fluoxetine, I went back for my annual exam. The nurse was a jolly woman who instantly had my heart because she called me "my love." When I told her I needed my fluoxetine prescription renewed, she did a double take.

"That can't be right," she said. "We don't really prescribe that." I explained PMDD, and as she ushered me into the gynecologist's room, we chatted about mental health and the kinds of medications she usually saw prescribed at the office. She promised to renew my prescription.

Yet there was more to come. At the end of my exam, my gynecologist asked me if I was on birth control. "Nope," I told her.

She was the same gynecologist who had helped me find a PMDD treatment that worked. I'd been in and out of her office a year earlier when she'd put me on Seasonique and then finally on fluoxetine. When I first met her, I'd given her a sanitized version

of what happened with YAZ because I was afraid she would institutionalize me if she knew I'd tried to jump out of a car. I did my best to project calm and stability, and I paused meaningfully a great deal to let her fill in the blanks rather than get into the gory details. She seemed to get the picture, though—before I left, she cleared her throat. "Keep me updated," she said. "I want to know you're doing well."

Now, I had a feeling she didn't remember me, which was fair—it had been a year since I'd seen her, after all, and I imagine she saw dozens of patients every day. She was not happy I wasn't on birth control and immediately recommended one, starting with YAZ.

"I can't take that," I reminded her.

She walked me through other types, including an IUD.

"What would it do to my moods?" I ask.

"I couldn't promise your moods wouldn't get worse," she said. "You might also get more cramps."

My cramps already left me unable to walk for a few days. I'd been so preoccupied with PMDD that getting them taken care of was the least of my problems, but I certainly didn't want them to be worse. I held my ground. Finally, I told her I was in a long-term relationship and had never been pregnant before. She blushed and told me she wasn't trying to judge me.

"I just want you to know your options," she said before she finally let me go.

I did, I thought. My options seemed pretty simple: suicide risk or no suicide risk. I left her office exhausted. I couldn't understand why she was so insistent on birth control. My stint on YAZ had had long-term effects: Usheer was still twitchy whenever we got into a car; I was wary of new medications and of my doctors who didn't seem to understand what was at stake if I ended up on the wrong pills. I was tired of having to package my

life in a neatly sanitized story while projecting stability and calm, all with a smile on my face.

Shortly after, I switched gynecologists in hopes that I wouldn't have to have this conversation again. My new gynecologist came highly recommended by a friend, since he'd ushered her safely through a complicated pregnancy. "I call him Dr. Xanax," she gushed. Dr. Xanax had a string of credentials from the top medical schools in the country.

I adored Dr. Xanax the moment I met him. Not only were his credentials impeccable, he had the bedside manner of a therapist. "Sit down across from me," he said. "The examination table is much too scary and formal of a place for a first meeting." I'd never had a gynecologist try to set me at ease in the same way.

I told him all about my medical history, and he listened intently. Then I told him I had PMDD.

"Are you sure?" he asked. "That one's a pretty squirrely disorder and often gets misdiagnosed. It's usually anxiety or depression."

"I'm sure," I said. I'd just finished my two-month symptom-tracking experiment so I was extra sure: my symptoms had a very clear on-off pattern. Luteal phase: depression, anxiety, rage. Follicular phase: all clear.

"Well, let's say you do have PMDD," he said. With great patience and good humor, he continued to listen to me, doing his best to validate my experiences while also respectfully pointing out that, in all probability, he didn't think I had PMDD and I should get help for anxiety or depression. I left his office rattled. I realized that perhaps I was better off sticking to my old gynecologist, who at least believed I had PMDD, even if she was trying to pressure me into taking the birth control that had almost killed me.

I wondered how many more times I would have to have this conversation and what would happen if I moved or had to see another gynecologist. Would I be able to get my fluoxetine

prescription renewed if I couldn't find a gynecologist who believed I had PMDD? Yet, overall, I knew I was very lucky. I had a diagnosis, and I had a treatment that was working. I had tried to kill myself, but I was still alive. That was a lot more than many people with PMDD could say.

Making Work Work

One morning the month after I'd started taking fluoxetine, I woke up in an excellent mood. My period had just ended, which meant my cramps had vanished and I was at the height of my follicular phase. Moreover, I'd just made it through a month without any severe PMDD symptoms. I had a mug of chai, birds were chirping outside my window (or at least inside my head, which is basically the same thing), and all was well.

Even better, my friend Colin texted me to say hello. Colin is one of my favorite people—he's side-splittingly funny and throws the best parties. In college, whenever I needed a pick-me-up, I'd read his Facebook page and laugh myself into an asthma attack. He made me laugh, and in return I lectured him about books and feminism, which, of course, included periods and making him learn about PMDD.

Colin told me he'd just recovered from COVID. "Honestly, anytime I have a sinus headache, I think about how the patriarchy was a foregone conclusion for early humanity," he wrote.

I had a bad feeling about where this was going. "Tell me more," I texted back, because sometimes I like to play with fire.

"When I'm sick, I find it difficult to concentrate on tasks that I am not already deeply familiar with or passionate about," he

texted. "I can be there 90 percent for playing games, but for work I'm only 10 percent there."

I had a feeling we were not talking about sinus headaches anymore, but I let him go on.

"Women have built-in headache machines," he continued. "That's enough of a difference to guarantee systemic oppression. Menstruation means you feel less than 100 percent a few days a month, and then you factor in pregnancy." Part of me wondered if I'd failed to lecture Colin properly on period stigma if he was still using sinus headaches as a euphemism for menstruation.

I stopped responding to Colin. Was he really suggesting that misogyny is the natural result of menstruation and biology? Or was he trying to have a nuanced discussion on the reasons behind the historic oppression of women and how we could do better moving forward? I couldn't say, all I knew was that Colin had touched a raw nerve. The conversation around women's bodies and women's rights has been so fraught that I was terrified educating people about PMDD would mean we would be back to square one: people would start using PMDD as an excuse for misogyny.

No one had questioned my performance or my ability before I was diagnosed with PMDD. I pushed myself to finish college in three years with two majors. When I worked in the government and could see no clear path to becoming a writer, I wrote for two or three hours a night and on weekends. Before I left my full-time job, I usually juggled it with a freelance gig or two and a book project. I often struggled to figure out where I was going and how to get there, so I zigzagged from job to job and industry to industry, but the common thread was that I worked.

With a diagnosis and treatment, I was the same person I was before—if not more functional. The only difference was my public acknowledgment of how much I struggled. Before, I just assumed everyone felt the same way I did, so there wasn't much

point saying anything out loud. Now, I realized most people didn't spend half the month hiding the emotional equivalent of pneumonia.

I wanted to give Colin an earful, and then I realized that, if anything, I would just solidify his existing stereotypes about PMDD. I wondered how many other people shared his stereotypes, and how they might be used against me.

When I interviewed Allen Frances, the chair of *DSM-IV*, he emphasized that his biggest concern with including PMDD in the *DSM* was stigmatizing women, especially in the workplace: "We didn't want society discriminating against women because a small number of them have this condition."[1]

I thought it went one step further. I didn't want anyone to think I, or anyone else with PMDD, shouldn't be working.

GRIN AND BEAR IT

On the whole, I've been lucky: PMDD has been rough on my romantic relationships, but I find it much easier to maintain control at work. For the most part, I can mask my feelings in front of colleagues or bosses. I might feel more anxious than usual during the luteal phase, but in general that's spurred me to work harder and make sure my work is high-quality. When I do get angry, it's possible to bite my tongue, take a step back, cool down, and then strategize. I run through a decision tree in my head: Is the problem fixable? If yes, think about how to have a conversation to get what I need; otherwise, the resulting frustration will build until I end up wanting to leave. If no, time to move on.

Two of the biggest symptoms people with PMDD face that affect their work are meltdowns and brain fog. People who struggled at work told me about either arguing with coworkers or having trouble concentrating because they felt so sleepy. The latter has been most challenging for me, as well as the physical

pain of cramps. PMDD means that for a few days a month, I'm so exhausted, I'll sleep for twelve hours a night and nap in the afternoon. Years of PMDD had trained me to work ahead of schedule, so I could often handle having a slow day without anyone noticing. But when I worked in an office, sitting at a desk, pretending to work, was frustrating when I just needed a nap. Similarly, when I had cramps during my period, having to wear pants with tight waistbands instead of sweats seemed like an unnecessary struggle. Feigning positivity when I felt like a piranha was swimming around eating my organs felt like a waste of energy. I did it because I had to, but it seemed pointless.

Once I quit my office job to become a full-time writer, I never wanted to go back. Now, I could schedule meetings around my health, take a nap on bad days, or work in my pajamas with a hot compress tucked between my lap and my laptop.

However, not everyone can fake good health. Danielle Lenhard, a clinical social worker, told me she struggled while earning her Ph.D. in art history and criticism. During the beginning of her luteal phase, she would often end up sleeping for an entire day. She scheduled exams, conferences, and presentations around that time and was able to complete her Ph.D. Danielle was lucky. More than one person told me about dropping out of school, or taking years to complete their education.[2]

Jessie, a freelance writer, hasn't been able to hold down a job because two weeks of the month she's too sleepy and distracted. At her first job, she got fired for having an attitude problem, even though she wasn't aware that she had one. In person, Jessie struck me as quiet and thoughtful. Her work has been published in international outlets like *The Guardian*. I'd been hopelessly intimidated before speaking to her because her writing is so funny and elegant. Jessie told me she was living on disability and relying on her partner, Chris, to support her—which had taken a toll on her confidence.[3]

Learning that Jessie, a wildly talented writer, requires disability benefits and the support of her partner to meet all her needs made me wonder what resources were available to people with PMDD. I consulted Heidi Liu at George Washington University. (Liu also happens to be a friend of mine.) Among other topics, Professor Liu researches the barriers marginalized people face at work. She received her law degree and a Ph.D. in public policy from Harvard, which means she combines a social scientist's understanding of theory with a lawyer's practical thinking. She designed a minicourse for me on how people with PMDD should think about their rights as employees.

I quickly learned that employees have more right to accommodation than they might imagine. For people in the United States, the Americans with Disabilities Act (ADA) prohibits employment discrimination for people with disabilities. This covers the world of hiring, treatment on the job, promotion, and dismissal. The ADA applies to people who have "a physical or mental impairment that substantially limits one or more major life activities, a person who has a history or record of such an impairment, or a person who is perceived by others as having such an impairment."[4] In other words, as Liu pointed out, disabilities are broadly defined and cover anything that impacts your ability to function, which can include PMDD.

Under the ADA, employees must meet the requirements for the job and be able to perform essential functions. Employers must provide reasonable accommodations,[5] which essentially means changes to the job that are minimally challenging to implement financially and logistically. Depending on the job, flexible hours or working remotely might be considered reasonable, but employers do have significant leeway to define what accommodations are reasonable. Furthermore, they are not required to eliminate any part of the job that's considered essential, lower standards, or provide

personal items that are also needed off the job (e.g., eyeglasses and wheelchairs).[6]

But how do you get accommodations without exposing yourself to discrimination? Does getting the accommodations you need to do your job well require disclosing PMDD to your boss and colleagues and dealing with all the biases and misconceptions they have about menstruation?

Professor Liu pointed out you do not necessarily have to tell your employer the exact diagnosis to get accommodations—you only have to tell them you have a medical condition that impedes your ability to do work and explain the kind of accommodation you need. She explained that the law is structured to assume and enable a good-faith dialogue between employer and employee so that this process can begin swiftly. She also added that it's generally advisable to tell your employer you have a disability if it's likely you'll run into a problem. The law cannot protect you if you haven't let anyone know you have a disability. "Knowing your rights is one of the most powerful advantages an employee has," Liu said.

Liu pointed out there's an inherent tension between disclosing to raise awareness and protecting yourself from backlash. Some scholars argue people with disabilities have an inherent duty to disclose because it helps end stigma. In addition, Liu noted that disclosing before you get the job offer has a major upside.[7] If you get hired, it's usually a good sign the employer will be supportive of your diagnosis and you'll weed out anyone who would have a problem with a PMDD diagnosis. On the other hand, just because something is good for society doesn't mean it's good for your career. There's what the law says and then there's how people behave. The gap between the two can be insurmountable if you have an employer who acts in bad faith, or if you and your employer disagree on what a reasonable accommodation looks

like. A lawsuit can be a drain of time and resources, especially if you're suing an employer with deep pockets. Managing your career proactively, rather than suing, struck me as the more practical road to follow.

For brass tacks on how to do this, I turned to Alison Green, who runs the popular work advice blog *Ask a Manager*. People write in with a thorny work problem, and Green answers using a combination of diplomacy and office smarts, all underlaid with a strong sense of fairness. On the whole, Green isn't a fan of disclosure. She worries disclosing any health information for accommodations sets a precedent where everyone is expected to disclose their diagnosis. Furthermore, she warned, oftentimes biases come into play when managers dole out promotions or assign high-profile projects because they might worry an employee with a diagnosis can't handle the stress. "Even people with the best of intentions might have unconscious bias," she said. "If you talk about a mental health condition and then you have an off day, people might wonder if it's because of your condition, when in reality everyone has an occasional off day."

Rather than disclosing PMDD as a diagnosis when asking for accommodations, she recommends the following script: "I have a medical condition that increases my stress levels and irritability X days of the month. I'm working with my doctor to get it under control but in the meanwhile I'd like to ask for [accommodation]."

If possible, she advises asking for accommodations at least one or two months after you've established yourself at a new job. "By then you're more of a known quantity," she said. If you need the accommodations immediately, the soonest she recommended asking for them is after you have an offer in hand, to eliminate the chance of getting rejected because of conscious or unconscious bias. In addition, Green pointed out disclosing when you apply puts the employer in an awkward spot because if

they reject you it brings up the question of discrimination even if the rejection is for other reasons.

I also asked Green what to do in the event of brain fog or a meltdown. Green didn't think brain fog warranted a disclosure unless it was a repeated pattern. "Everyone has off days, and if you have a diagnosis, you're probably more aware of your off days than other people are," she said. If it is a repeated pattern, she recommended a variation of the earlier script while asking for appropriate accommodations: "I have a medical condition that [makes me forgetful/exhausted] X days of the month. I'm working with my doctor to get it under control but in the meanwhile I'd like to ask for [accommodation]."

If you have a meltdown—either from anxiety or rage—Green said the best thing to do is address it: "People are going to wonder, can this person handle feedback? Do I have to tiptoe around them?" Green gets mail about meltdowns that have nothing to do with PMDD, and she says that people are often tempted not to address them because it's embarrassing, but that's actually the worst thing you can do. "You want to signal that you understand what happened is a problem and you're working to make sure it doesn't happen again," she said. She recommended the following script: "I know I had a strong reaction and I'm embarrassed. How I handled [the situation] wasn't okay. I have some medical issues/stress going on and I'm working on it. I'm sorry about my reaction."

She pointed out that when you mention feeling embarrassed or mortified, you're showing vulnerability and that, in a reasonably healthy office, people will respond to that. If you know outbursts are a problem, you can ask for the flexibility to work from home or to avoid scheduling meetings on certain days.

She left me with one last thought. Employees at companies that have resource groups should consider bringing up PMDD with group leaders. "If about 8 percent of the population has

PMDD, there's probably other people at the office who have it, and this is something employers need to figure out," Green said. However, if you are worried about being stigmatized for having PMDD but do want to talk to a resource group, she recommended asking the resource groups what their confidentiality rules are before sharing your diagnosis.[8]

Because PMDD isn't well known and we live in a world rife with sexism, the onus is on employees to figure out how to manage PMDD in the workplace. Some researchers and clinicians mentioned stories about women with PMDD at high-level jobs who scheduled important meetings during their follicular phase, when PMDD symptoms are less likely to occur. This included a lawyer who would attempt to deliberately schedule trial dates according to her menstrual cycle to avoid appearing in court when she was symptomatic. In order to maintain their jobs and their professional reputations, all these people managed elaborate schedules, mostly in secret.

Rose is the associate manager of clinical development for a biotech firm in Massachusetts and is in her late twenties. She's the youngest person in the history of her company and in the industry to hold such a senior position. She makes $200,000 a year, and her next goal is to make $300,000.

She's opted not to tell her employer about her PMDD. "I take advantage of my 'good days' during the follicular phase and work as much as possible, often twelve- to fourteen-hour days," she said. "On a bad week, I might only work four to five hours a day. I've learned to accept that. I just tell myself I'll make it up during my follicular phase. Early in my career, I was terrified someone would catch on that there's two weeks where I'm not functioning well, but no one has noticed." When she gets irritated at work, she gives herself one cycle before acting. If she's still upset after a month, it's probably time to do something. If she's not, she chalks up the irritation to PMDD.

However, she's afraid that as she climbs up the ladder, PMDD will hold her back, as her work will require more people management and less scientific knowledge. "PMDD impacts my ability to effectively communicate and I worry it will be a lot more difficult to manage people on a daily basis when I have anxiety and depression," she said, particularly because she has an expressive face. She even got baby Botox so she can't move her face as much. "It mutes my facial expressions," she said. She's thinking about taking a course on communication to prepare herself for the future.

I asked her if she'd ever consider telling her coworkers she had PMDD. She shook her head. She's already faced sexism on the job and is afraid of more. One supervisor told Rose she didn't come across as professional because Rose fiddles with hair when she's thinking. Rose hasn't even told her friends she has PMDD. "I don't want to be the chick with the period issues," she said.[9]

On the flip side, Annika Waheed, a lecturer at a hospital in the U.K., chose to disclose. (In the U.K., in order to receive accommodations, your employer must know about your disability, the employment lawyer Moira Campbell told me.)[10] After undergoing a weight-loss surgery in 2017 that regulated her hormones, Annika began to experience debilitating PMDD, which turned her daily life into a roller coaster. "I would be crying uncontrollably at my desk and I wouldn't know why," she said.

In December 2020, after a suicide attempt where she overdosed, Annika told her team she had PMDD. In some ways, she had no choice: she had to let her boss know she wouldn't be coming into work the next day. "People were relieved when I disclosed," she said. "They felt like they could manage expectations."

"Did it hurt your career?" I asked.

"It definitely hurt my career," she said. When COVID hit and most of the staff ended up sick and out of the office, Annika took

over understaffed projects, even though she was still managing symptoms and recovering from her suicide attempt. At the same time, she began hormone replacement therapy that brought most of her symptoms under control. "I was running projects . . . and implementing training like a carousel on steroids," she wrote to me in a follow-up email.[11] Yet as spring tapered off into summer, Annika wasn't put on key projects because her managers were worried about her. "People kept taking away projects, they didn't feel comfortable giving me projects, it was soul destroying. I'd hear, 'You've got so much potential . . .' They didn't intentionally hold me back; it was their mindset. The narrative took a negative turn. No one was thinking: 'Annika is a superhero who skyrocketed while living with a chronic illness.' All they could say was, 'Annika has PMDD,'" she said.[12]

Technically, Annika had protections and accommodations, and yet her career had taken a hit. While she was able to eventually get her accommodations and her career back on track, Annika's story epitomized my greatest fears around disclosure.

Prior to diagnosis, I'd always made an effort not to show my emotions at work. Yet once or twice, when a boss was being unfair and I didn't know what to do, I cried. Once, a manager got angry at me because she'd forgotten her talking points during a meeting, and I'd jumped in.

"You could have passed me notes," she said.

I had. She just hadn't looked at them.

"Well, I can't break eye contact," she said.

I was being berated because she was unhappy about forgetting, not because I'd done anything wrong, and the unfairness rankled. On a different day, I might have been able to reroute the conversation, or laugh it off, or keep my cool. But I was tired. The meeting had been grueling, and the conversation was unfair. I may or may not have been PMDDing—I cannot remember. What I do remember is that when I started crying,

the manager apologized and we talked about what to do in a similar situation going forward. My tears weren't calculated. They were the best option available to me at the time, but they also achieved what I wanted: for my manager to stop yelling and take accountability for her actions.

Shortly after I got diagnosed, I did tell my boss at the time I had PMDD. By then, I'd worked with her for several years and had a track record for being diligent. To her credit, she handled the news well, and even praised me for my hard work. Later, when we occasionally disagreed, she never once brought up PMDD.

However, I did worry one day that she might chalk up one of my reactions to PMDD. After being diagnosed, I began to worry every time I had an emotional reaction. If I cried, would people think I was too sensitive? If I was irritable, would people blame my period instead of thinking about how their behavior might have also played a role in the situation? Alison Green's warning about unconscious bias resonated with me. Sometimes I couldn't even tell if I was having an off day because of PMDD or external circumstances. If I didn't know the difference myself, how could I expect anyone else around me to figure it out?

Women already face discrimination at work, particularly at the top, where competition is frenetic. In 2020, women in America earned 84 percent of what men earned.[13] At the highest levels, we still have trouble getting in the door, even though we make up over half the college-educated workforce.[14] According to a 2019 McKinsey report, for every one hundred men who are promoted to manager, only seventy-two women are promoted or hired for the same role, and this figure dips to sixty-eight for Latina women and fifty-eight for Black women.[15] Only 20 percent of the C suite is made up of women,[16] and only 4.8 percent of Fortune 500 global CEOs are women.[17]

I thought about Rose. Given her career trajectory, she should have a shot at the C suite one day. But Rose is already running

into unconscious bias *without* disclosing her PMDD. Given the world today, I cannot picture any way that disclosing would help her as senior managers decide which employees will be promoted and given bonuses behind closed doors.

And yet I might be too cynical. Anuhya Korrapati, a health economist who lives in Bangalore, gave me much reason to hope. I met Anuhya through IAPMD, since she was one of their youth advisors who'd also started a nonprofit PMDD advocacy group in India. When Anuhya was interviewing for jobs, she told her employer that she had PMDD and would need flexibility. She got it, and she used the opportunity to educate her colleagues about PMDD.

Anuhya is wiry and birdlike, with a luminous intelligence that instantly made me understand why an employer would give her grace. I chatted with her several times over a period of two years, culminating with lunch in Bangalore. I was fascinated by her advocacy work and her practical take on how to make life with PMDD work.

A year or so before we met up, Anuhya had received the COVID vaccine. Afterward, Anuhya's period failed to come and she got stuck with over three months of continuous PMDD symptoms. Her symptoms were so bad that she struggled to get out of bed much of the time. Moreover, thanks to supply chain disruptions and lockdown, she couldn't get her antidepressants or see a doctor.

I assumed that Anuhya hadn't done much since our first conversation several months earlier, since she'd spent so much time ill.

"Oh no," Anuhya told me. She'd written a chapter of a book, started an audiovisual art project for people with a spectrum of menstrual health experiences that had been a finalist for a grant, produced a paper on PMDD in India, spoke to fourteen hundred students about PMDD, and was part of a patient insight

panel. Probably the only reason she hadn't taken over the world yet was because she wasn't interested in doing so.

Anuhya is currently completing her dissertation on health economics and teaching. After lunch, we walked through Bangalore, dodging rickshaws and talking about writer's block. Anuhya kvetched about her thesis. "My thesis advisor told me not to blame PMDD," Anuhya wailed. "She said, 'I know you're in your follicular phase, so no excuses for not writing.'" We doubled over laughing, but I was in awe. Her advisors respected her so much that Anuhya wasn't caught in the trap of appearing superhuman to make up for her PMDD. She could afford to joke about using PMDD as an excuse because her competence was never up for debate.

WORK REIMAGINED

After speaking with so many people with PMDD about the sheer amount of effort they put into navigating their careers, I started dreaming about what the ideal workplace for someone with PMDD would look like. What would employers need to change so that people with PMDD could really shine? First, we need flexibility. By flexibility I mean the ability to work from home (if that is an option), set one's own hours, and determine the size of one's workload. Not everyone can work a full-time job, but that doesn't mean they should be locked out of the workplace or that employers can't benefit from part-time employees. During a brief stint at a nonprofit, I had to write a job description for a part-time position. I was shocked by the glut of applications we got. Part-time work often pays less than full-time work and does not usually include health insurance, but for many people who cannot work full-time jobs, it's a better option than not working at all, and we simply don't use it enough.

While COVID has made asking for work flexibility more

of a norm, workplace policies still have a long way to go. For example, in the U.K., HR professionals use the Bradford factor to keep track of employee absenteeism, which penalizes cyclical absences. Under the Bradford factor, an employee who is gone a few days a month for a cyclical condition will get flagged, while an employee who disappears for ten days would get a pass.[18]

Meanwhile, 15 to 20 percent of women report having moderate to severe cramps, which may make working difficult.[19] Yet the average private company in the U.S. only provides seven days of sick leave per year, and the government twelve days.[20]

Countries like Japan, China, Indonesia, and Zambia offer period leave for employees, and Spain started offering it in 2022, but the policy isn't a cure-all.[21] In college, I spent a summer working in Indonesia. My aunt told me not to worry about my periods. "There's period leave here," she said. "But no one uses it because no one wants to talk about having a period," she added. I ended up not using the period leave and gritting my teeth through cramps. This isn't a problem unique to Indonesia. In Japan, period leave was introduced in 1947, and initially about a quarter of women used it. However, in 2017 less than 1 percent of women took period leave. Similarly, in South Korea, period-leave use has dropped over time.[22] Alison Green of *Ask a Manager* worries that period leave will have the same effect as potentially disclosing PMDD. It will be used by employers as an excuse not to hire and promote women. There's little research available on whether period leave is helpful, but Green's concerns struck me as very reasonable.[23]

Instead of period leave, let's offer flexibility to everyone. We can take pointers from the U.K., where the government is working on allowing employees the ability to request flexibility—working from home, and the right to figure out their hours—from the get-go.[24] More flexible policies would serve everyone: people with PMDD, people without PMDD who have painful periods,

people with mental health issues, people with physical health is-
sues, parents taking care of children, employees taking care of
aging parents—the list goes on.

This may not seem possible for all jobs, but then again it's
surprising what you can accomplish when trust is in the pic-
ture. I spoke with Bree Inkson, an Australian who works in auto
insurance. Bree has severe PMDD that might be complicated
by other disorders, including schizophrenia and autism—she's
not sure. What she does know is that she still struggles despite
treatment. She raved about her job. "They truly put employees
first," she said. "I wouldn't be working if it weren't for them."
Bree started working in 2015, the worst year of her life, as she
recalls: her PMDD was out of control, and her brother-in-law
passed away a few months later. She got two months off work for
bereavement. When she went on maternity leave, her employer
also gave her extra time to recover. Her employer requires peo-
ple to call a phone line when they can't come in, but Bree has
been given special permission to text because she can't handle
having a conversation on PMDD days. She's close with her man-
ager, whose wife also has PMDD, and refers to him as a surro-
gate parent. "I am forever grateful," she says.[25]

I was curious if Bree is superhumanly good at her job. What
if she wasn't an invaluable employee—would she still have gotten
accommodations? Then I wondered why I felt that she needed to
compensate for having PMDD. I understood that an employee
who does a good job and works hard gets more grace, but the
reason I trusted my boss with my PMDD diagnosis is that for
years, I'd gone above and beyond. I'd worked through holidays,
illness, and grief. Yet in retrospect it seemed ridiculous that I
needed to go to such lengths before I felt I could admit to having
a disorder.

In my grand reimagining of work, I wanted to focus on qual-
ity rather than quantity. The best work isn't done when people

are working around the clock, forcing themselves to keep moving, despite illness or grief or an emergency. Yet this is our culture. According to a 2018 study, 52 percent of Americans don't take time off and 61 percent of the people who don't take time off say it's because they are afraid they'll be seen as replaceable.[26] COVID may have made it more acceptable not to come into the office if you're sick, but there's still pressure to work from home: 67 percent of Americans said they are less inclined to take time off for illness if they work from home.[27]

Athletes are told that rest is the most important part of training. But we don't say this for any other profession, even though the same logic holds true. A 2006 study found that medical interns who worked five or more twenty-four-hour shifts in a month were 300 percent more likely to make a mistake that resulted in a patient's death.[28] Meanwhile, according to a 2013 BBC story, over half of airline pilots surveyed admitted they've fallen asleep while in charge of a plane.[29]

In 2007 media mogul Arianna Huffington passed out after working an eighteen-hour day and broke her cheekbone. The moment was a wake-up call for her. Afterward, she focused on creating a routine that would allow her to get eight hours of sleep.[30] I asked her if she thought that it would have been possible to accomplish everything she's done without working her grueling hours. "Absolutely," she replied. "A lot of what I've done happened after I learned how to work and live sustainably—you can achieve a lot more and be much more creative and empathetic if you learn how to do it without burning out and if you have a culture at work for not burning out."[31]

Yet today we seem to be headed in the opposite direction. During the COVID pandemic, the average workday lengthened by forty-eight minutes.[32] Too often, we're paid only when we work more, do more, and work ourselves into the ground. This creates unsustainable working conditions for everyone, and

that's only exacerbated for people who are managing PMDD symptoms. People with PMDD have invaluable contributions to make, and many of us are undoubtedly held back from realizing our full potential. If we were given the time to rest, the space to think, and the freedom to play, I imagine we'd see an explosion of genius.

When Colin messaged me with his theory that women were being held back because of their periods, I didn't know what to say. Or, rather, I knew exactly what I wanted to do, which was to create another one of my spreadsheets with a point-by-point comparison of our respective work histories. Yet even as I began chalking up our various accomplishments in my head, I knew I was playing a losing game, and a stupid one. I could argue I had worked more hours; Colin might argue that he's paid more. I'd respond that we are in different industries and should be graded on a curve. Moreover, there's a strange way math goes pear-shaped when bias enters the picture.

The point is that Colin and I bring different qualities to the table. Give me a story to write and a deadline, and it'll get done. Colin can bring a roomful of people together and make them laugh and laugh. His friends regularly travel across coasts to attend his parties. In an office, Colin might not be the hardest worker, but he'd be the one who made the work fun, and that is just as valuable.

However, very real inequalities exist at work. I knew a man like Colin, who was charismatic and handsome. He was also very depressed. One day, he did not show up to a business trip because he could not get out of bed, and he did not tell anyone. His team found out after the plane had taken off. He was forgiven, and his team decided they needed to be extra gentle with him and give him space.

When I was teaching in Malaysia, I knew another "Colin" who was also very handsome and charismatic. Once, he drank

so much that he was too hungover to teach at a weekend camp. The rest of us stepped in to cover. Nevertheless, throughout the year, he was often singled out for plum opportunities like TV appearances and meeting high-level government officials. Several of my female friends wondered how he'd gotten these opportunities that they too wanted.

I've watched employees at all levels adjust and accommodate other "Colins." I've seen and heard numerous stories about people turning a blind eye to incompetence or sexism or racism from Colins. "Colin didn't know any better"; "Colin didn't really mean it that way." If we can forgive Colins that much, then surely we can have compassion for people with PMDD. If we can say "Colin didn't know any better," we can say, "She needs time off" or "She was having a bad day."

I do not quibble with the hiring of Colins. There are so many. We would be at a great economic loss if we stopped, and we have already lost much by underemploying women. So go on. Keep hiring Colins and promote them when they do well. But I also say: Hire and promote Rose, who is so dedicated to her job she's willing to inject her face with Botox. Hire and promote Annika, who went from attempting suicide to picking up the pieces of her department. Hire and promote Anuhya, who spent three months in bed and still managed to lead a movement in India. If we can make allowances for Colins, we most certainly can make allowances for PMDD.

It's Not You,
It's Me (and PMDD)

A year or so after I started taking fluoxetine for a few days before my period, Usheer and I had a massive fight when he went to a ten-day conference. I love working from home, but it's easy to spend days holed up in my apartment without talking to anyone except Usheer. I planned to combat the solitude by scheduling regular outings with friends. The first couple of days, I decided I was living my best bachelorette life. By the middle of the week, I hated my best bachelorette life. The apartment was empty, all my friends were busy, and the grocery store clerk was probably getting sick of my face. By the last few days, I was counting down the hours until Usheer got back. Then Usheer called to say he actually could have been home a day earlier, but the thought of taking an early-morning flight was too much.

I fell headlong into a bottomless pit of despair. I'd been trying to hold it together, but now I couldn't. I was filled with shame. I was a grown woman. I'd spent my early twenties living alone. Still, I wanted Usheer home. Ten days of near isolation had left me a sniveling mess.

The shame crystalized into anger. On the longest vacation we'd taken—four days—Usheer had been working. I'd thought about how Usheer usually worked ten-hour days and then went

into the lab on Saturdays and Sundays. For the past month, he'd been so exhausted when he came home that he just collapsed in front of Netflix before falling asleep. One time, I'd turned down a lucrative freelance project to spend the day with Usheer after he'd been gone on a six-week business trip. I'd bought a welcome-home cake from our favorite bakery and then gone to the airport to pick him up. On the taxi ride home, Usheer told me he was planning to stop by work for an optional meeting. Usheer had supported my career dreams and put up with me creeping out of bed at 3:00 AM to write. I wanted to do the same for him, but at the moment I was tired of always coming in second place to work.

I thought I'd put this fight to bed, but now the old anger flared up. This was going to be the rest of my life, I realized. I kept waiting for Usheer to make time for me, but he didn't. I called Usheer and told him to stay at his conference because we were done and I never wanted to see him again. Then I called my parents and friends and cried.

Usheer ignored me and came home anyway. When he crossed the threshold of our apartment, I screamed at him to get out and stay in a hotel.

Once he'd left, I felt the anger drain out of me. I checked my calendar. Even though my period was already over, the rage leading up to the fight happened around my cycle, which explained my spiraling anxiety toward the later part of Usheer's trip.

As my gynecologist had dictated, I was taking 10 milligrams of fluoxetine as needed, which mostly meant I popped the pills a few days before my period. If I was having an especially rough day, I might double the dose or take pills up to a week before my period. Usheer and I used to have fights like the one we'd just had once a month. Now, we had fights like this three or four times a year. Still, I wondered if I should be taking fluoxetine throughout my entire luteal phase. My fears around antidepressants meant

I'd been trying to minimize my dose of fluoxetine, but now I wondered just how many of those fears were based on existing stigmas around mental health.

When Usheer came back the next morning, we sat down to talk about ways to spend more time together. He'd come armed with so many different solutions that my guilt over our fight tripled.

"I should have taken more meds," I told Usheer as I apologized to him. "I should have known that I'd be more stressed when you were gone."

Usheer nodded. "Why don't we talk about ways to manage your PMDD better?" he said, shelving his strategies.

Usheer had a point. Yelling at him to go stay at a hotel was inexcusable and I needed to take more medication. But that didn't mean not spending time together wasn't a problem. My good intentions quickly turned to dust. I retreated into a hermit crab shell, refusing to talk about our relationship. Then I forced myself out of it.

"It's not just PMDD," I said. "We also have a problem we need to solve."

Usheer nodded, but I had a sinking sensation in my stomach. Our fights had reduced by fourfold, but now during each major fight, Usheer would ask if it was PMDD. It was a valid question. I asked myself the same question after each fight. At the same time, I knew it was normal to fight with your partner from time to time. What was PMDD? What wasn't? I had no idea.

After my diagnosis, both I and the people closest to me knew I had a disorder. PMDD was changing my understanding of who I was. On the one hand, I was no longer a vindictive monster: there was an excellent reason for my outbursts. On the other hand, now I had a disorder, so I had less credibility. As Paula Caplan had warned me: I wasn't crazy. I was just mentally ill.

Yet regardless of the reason, our fights had an impact on

Usheer. I needed to take responsibility. My diagnosis helped me understand my emotions, but left me with a broader question: what does it mean to live a good life and to be good to others when you have PMDD?

THE FRIENDSHIP ZONE

Most of the people I spoke to said PMDD had a bigger impact on their relationships than on their work. According to IAPMD's 2018 global survey of premenstrual mood disorders, which included over 1,400 people diagnosed with PMDD, only 17 percent of participants reported losing a job due to PMDD, but 97 percent said that PMDD put a strain on their family relationships.[1] I couldn't find any statistics on friendship, which is perhaps a commentary on how society undervalues friendship. When I interviewed people, PMDD's impact on friendships ran the gamut. Some people mentioned having trouble making friends because every month they'd stir up drama. A few mentioned having close friendships marked by the occasional dustup, while others said they hid their PMDD from their friends. Others said their friend groups were hugely supportive.

Sam is in his early thirties and identifies as transmasculine and nonbinary. He has been with his partner for sixteen years. He's finishing up school now, since PMDD made it hard to complete college when he was younger. He said his PMDD had ended four or five close friendships. Sam also has ADHD and autism, and the ADHD makes him more impulsive, particularly before his period. "I just get very intense before my period," he said. "I've had a lot of fights with friends."

Sam walked me through a recent fight. He was careful to point out that PMDD wasn't an excuse and that his friend was also in a tough place. She was grieving the loss of a family member and he'd agreed to come over to support her. However, he

ended up having a panic attack over school, and his friend yelled at him. Later, he tried to hash it out with her. "I tried to say it as nicely as possible—I knew she was in a bad place and I recognized that, but it also hurt that she yelled at me while I was having a panic attack," he said. "I also didn't address the fight as quickly as I should have because in the past those conversations didn't go well if I had them before I was ready, so she was also mad about that."

I couldn't help thinking that in some ways PMDD is a good litmus test for whether someone is worth keeping in your life. I was taken by how fair Sam was in his analysis of what had happened: he did not try to use PMDD as an excuse and he was willing to take responsibility for his actions, but his friend wasn't willing to give him the same grace. Sam did say that many of his friendships that had ended over PMDD fights were friendships that needed to end anyway. Overall, Sam said that his close friends tended to be good communicators who understood PMDD.

Over and over, as I conducted interviews for this book, I was impressed by how kind, candid, and caring the people I interviewed with PMDD were. They were refreshingly forthright and willing to take ownership of their behavior. Then I realized that anyone who has PMDD that's untreated or doesn't respond to treatment has two options: develop excellent relationship maintenance and repair skills or be utterly alone.

Once again, Anuhya Korrapati set the gold standard as an example of how to live a good life in the midst of PMDD. When Anuhya had spent over three months in bed, unable to function, her roommate and best friend, Siri Sinchana, had held the household together. Siri had walked the dog, done the dishes, even pulled Anuhya out of bed to use mouthwash when Anuhya couldn't brush her teeth. Thanks to Siri, Anuhya's dog was exercised and she still had all her teeth. I wondered how they'd been able to craft such a strong friendship.

I called Siri to ask. Siri was clearly very used to having a friend with PMDD. She began the conversation by asking me how I was and how I was coping with PMDD. It was a few minutes before I could get the conversation to circle back to her.

Where Anuhya sparkled and laughed, Siri was quiet and thoughtful. I liked her instantly. She was so thoughtful that I immediately felt at ease around her, even though it was technically my job to set her at ease. "Anuhya's crazy confident," Siri said. "I'm much quieter." She still remembered walking into the classroom on her first day of college and spotting Anuhya at the front, her hair dyed a brilliant green, surrounded by a group of friends. "We weren't supposed to dye our hair bold colors. There were strict rules," Siri said. She went straight for the back. She and Anuhya didn't start talking until their second year of college, but they became fast friends.

I asked Siri if she'd ever experienced one of Anuhya's rages. "Oh, Anuhya never gets angry at her friends," Siri said. She went on to explain why they were such good friends. When Siri needed help studying economics, she found Anuhya, plunked her textbook down, and said, "Teach me." And Anuhya did. When Siri was dating an abusive boyfriend who alternated between threatening to kill himself or Siri and her parents, Siri called Anuhya because she was too afraid to tell anyone else what was going on. "We'll handle this together," Anuhya told Siri. I wondered what made Siri feel so protected by Anuhya.

Siri told me once when they were at a bar, a stranger had kept hitting on her and wouldn't go away. Anuhya told him off. When he still kept hitting on Siri, Anuhya punched him in the face and broke his nose. "I'm nonconfrontational," Siri said. "If there's a fight, Anuhya will say, 'Stand behind me,' and she takes care of it. She saves her rage for strangers—people who deserve it."

Anuhya and Siri had used the wounds the world had given them to forge a golden friendship. I'd been surprised to find the

same held true in my own friendships: pain became a crucible for creating stronger and deeper relationships. My monthly depression and anxiety attacks meant that most of my close friends were deeply empathic people who understood what it's like to be tortured by your mind. We made a habit of taking care of each other because at one point or another we'd each been bowled over by depression or anxiety or rage. At times, they'd sobbed on my shoulder. Mostly, I'd sobbed on theirs.

In the wake of my breakup with Theo, my friends promptly made it their business to take care of me. My friend Denise dedicated one day a week to taking care of me. We worked together, then she listened to me talk over long lunches. I cried in every restaurant in her neighborhood. The first time I had to return to my empty apartment after a long trip, she made sure to spend the day with me because she didn't want me to be alone, even though she wasn't feeling well.

My friend Garvi texted me for hours each day, and one fine summer day when I didn't think I was going to make it, she spent two hours on the phone talking me down even though she was on vacation with her family. My college roommates and high school friends flooded me with phone calls, packages, texts, and emails—even the ones who could least afford to take time out of their day.

When I was diagnosed with PMDD, my friends surprised me by taking great pains to make it clear the diagnosis did not change their opinion of me. PMDD helped them understand why I'd often be crying to them about monthly fights with partners and why I was grumpy and tended to disappear during certain parts of the month. Denise sat through countless hashings and rehashings of my relationship with Theo and reminded me that even if I had PMDD, I was still a good person, capable of being a good partner. When I called her up crying about fighting with Usheer and how I was always a disaster in relationships, she

pointed out the ways in which the fight was a two-person problem. We could work to solve it.

Garvi staunchly insisted that I was more than my PMDD, even when I was convinced otherwise. When I asked her how PMDD had impacted our relationship, she leaped to my defense, even though she was one of the few people other than Theo and Usheer who had experienced my rages. I knew I'd hurt her greatly more than once. "You can still get mad at me if I'm a jerk," she said. "PMDD doesn't mean that you don't get to be angry or sad or that it's not valid." If I vented to her about being upset about something—work, family, or friend drama—and I told her I was at the lowest point of my cycle and whirling through an emotional maelstrom, she'd groan: "Oh no, what a terrible confluence of events. Someone did something stressful and you happen to be out of cope." It was a much-needed reminder that it was okay to be angry and that she saw me as more than my PMDD.

Perhaps I would be an easier person to be around if I didn't have PMDD—more graceful, less cranky, certainly less likely to cancel without warning because I've got cramps or I'm emotionally lost. I've had my fair share of fights with friends, all of which were probably fueled by PMDD. In other ways, PMDD has made me a better friend. I don't think I'd be as quick to pick up my friends' 3:00 AM phone calls or drop whatever I'm doing for their emotional emergencies. I wouldn't understand the stabbing pain that makes you desperate for comfort. The monthly anguish is a reminder to be good to others, particularly my friends, who are so good to me.

LOVE AND OTHER DISASTERS

I've found romance to be much harder to navigate than friendship or work. In both work and friendship, rejection doesn't cut as keenly. You can take a vacation from work or take some space

from a friend, but it's harder to do the same in a relationship. I spoke to one woman who was using space to make her new relationship work. She characterized herself as flat-out abusive in her previous relationship when her PMDD was undiagnosed. She was determined to do right by her new partner, so she spent all her PMDD episodes hiding in her apartment. She didn't even let herself text her new boyfriend during PMDD week and instead texted her sister. She asked me if I had a better solution.

I didn't. My knee-jerk reaction was to say that I didn't think disappearing on a partner for a good part of each month would help build a solid relationship. Yet when I thought about it, her solution made a lot of sense. If you're hit by monthly rages, disappearing during bad weeks may very well be the best answer and the most loving thing you can do for someone (provided they know why you've disappeared). PMDD means there are no easy answers in romance, and sometimes love might look a little different than it does for non-PMDD couples.

In IAPMD's global survey, half the respondents reported losing a partner, while 98 percent said PMDD puts strain on their romantic relationships.[2] I'd never lost a friendship or a job to PMDD, but I had lost a romantic relationship, for good reason.

I was doing a lot better with Usheer, but before I was on treatment, I had monthly breakdowns. Even on fluoxetine, it still wasn't perfect. (See our hotel fight.) If a friend of mine was dating someone like me, I'd tell them to get the hell out. I loved Usheer. Wouldn't the most loving thing be to let him go?

Usheer disagreed. He'd dated plenty of people in the past and hadn't formed a deep connection with them. He wanted to stay together. "You bring all the color," he said. I wasn't sure what that meant, unless "color" was the scarlet and crimson hues of rage and the gray and black edges of guilt. Then sure, okay.

I spoke with Aaron Kinghorn in the U.K. to get a sense of what it's like to love someone with PMDD. Aaron is a dentist

in his forties. He and his wife, Jude, have been married eighteen years and have four children. Aaron is committed to helping partners of people with PMDD: he leads a support group for partners and wrote a book called *Hope: A Guide to PMDD for Partners and Caregivers.* His descriptions of PMDD were so devastatingly accurate and hilarious that I ended up texting them to Usheer:

"PMDD is dragging her through hell and you are coming along for the trip."[3]

"If PMS is a loving poodle, then PMDD is a starved rottweiler."[4]

"All accurate," Usheer confirmed.

Jude was able to get a diagnosis in 2011, but meds were relatively ineffective until 2018, when she got a full hysterectomy with an oophorectomy and salpingectomy (removal of the uterus, ovaries, and fallopian tubes), which eliminated most of her symptoms. "I really hadn't understood how much of her personality was shaped by PMDD until the hysterectomy," Aaron said. "Now whenever we read forums where people are debating whether or not to get the surgery, Jude stands over my shoulder going—'Do it! Just do it! I'll drive you there!'"

Before the hysterectomy, Jude would be hit with bouts of lethargy and anger. Aaron and Jude were left to slowly and painstakingly figure out how to make their lives work. Aaron didn't talk about PMDD out of respect for Jude's privacy. For a time, he even thought PMDD was normal and all relationships featured monthly outbursts behind closed doors. "It was lonely," he said. "That's part of the reason why I lead the support group now."

Overall, Aaron thinks that PMDD relationships that work have two things in common. First is the individual's ability to recognize they have PMDD and their willingness to get treatment. The hardest conversations in his support group are the ones where people think or know their partner has PMDD, but the partner doesn't want to admit it or get help. The second is

the couple's willingness to work on managing PMDD collabora-tively, because even when partners are willing to get diagnosed and treated, being with someone with PMDD isn't easy. Aaron conducted a survey of ninety-six PMDD partners. The results were hard to digest: 90 percent said PMDD had an "extreme" or considerable effect on their relationship,[5] and 73 percent said their partner's PMDD impacted their own mental health.[6] Heartbreakingly, 45 percent said they had experienced physical abuse from their partner and 11 percent said the abuse was fre-quent.[7]

During interviews, several people I talked to mentioned struggling with rage. A few said they were abusive toward part-ners but didn't describe what kind of abuse. I sympathized—rage is difficult to talk about, even more so than suicide. It's far easier to admit to being hurt than to hurting someone. People would tell me all about their suicide attempts but then gloss over their rage, a sentiment I understood. Society seems to find a woman's death more acceptable than her rage.

While not everyone with PMDD is physically abusive, PMDD creates conditions that make physical abuse more likely. My rage could be all-encompassing. During the worst of it, the best I could do was aim the books I threw at the floor, away from Usheer. Often, I went running or threw myself against the floor, trying to knock the rage from my body. Still, despite everything, I slipped up. Once I'd thrown a cheesecake at Usheer; another time, a pillow. At the time, I reasoned (with what little reason I had left) that a cheesecake and pillows were the best of terri-ble options. The day I threw the cheesecake at Usheer, I wanted to leap at him. I wanted to force him out of the apartment so I could calm down on my own. He would not leave, and I so badly wanted to make him, so I hurled a cheesecake at him. But in the cold, clear light of day, I had no excuses. I remember the loud smack the cheesecake made as it landed against Usheer's chest

and the way he doubled over in pain, shocked that I would do
this to him. Cheesecakes, it turns out, are fairly solid, better for
eating than throwing. I carry the shame of the cheesecake and
the pillows with me daily.

And this, too, this other story:

Once, Theo had backed me into a bathroom. I was out of con-
trol and screaming. "Stay away from me," I sobbed. "I might do
anything." All I wanted to do was shut the bathroom door, turn
off the light, and come out when I was calmer, but with Theo
in my face, I spiraled even faster. Theo came closer. "Please,"
I begged, "please, please, stay away from me or I'll slap you."
I warned him three times. When he kept leaning in, towering
above me, I slapped him.

Theo took himself to the doctor, who asked if he was being
abused. Theo said he didn't think so, but later he told me he'd
spot flyers for abuse hotlines and wonder if he should call. The
shame that I'd done this to him was bloodcurdling.

Years later, Theo would lose control with me. Not often, just
once or twice. I don't remember much, though sometimes a
sealed-up memory will spill open, catching me unawares. One
memory: I must have been shouting, I know that much, and he
wanted to shut me up. The next thing I knew, I was flat on my
back, his hands around my throat.

It was impossible to blame him; on the whole, I felt that I
deserved whatever I got. (If only I could remember what I'd been
shouting at him! I am sure to this day it's burned into Theo's
memory, and I'm sorry for what I said. I'm sorry that I don't even
remember.) Later, he asked me if I was scared of him. "You're not
an abuser," I told him. My throat and spine ached for days, but I
knew I'd driven him out of control. This was not the person he
wanted to be, or even was. Besides, even now I sometimes feel as
if I had started it all, long ago, with the slap.

Years have passed since I last spoke to Theo. When I think

about our relationship, I try to picture myself in Theo's shoes, living with a partner who had a disorder and didn't know it. He loved a person who, each month, would unleash a storm of anger over the slightest provocation—a lost grocery list, working late, trash left on her desk. No matter what he did, he could not placate me. He could only wait until the day the rage would fall away, only for the whole cycle to start again the next month. Yet, month after month, Theo stayed because he saw something to love despite my rages. He stayed until he could not any longer, and each day he tried to do his very best by me until he woke up one day and realized he had nothing left to give.

As the seasons have turned, and I've learned more about PMDD, I've come to feel very badly for Theo, who had no idea what he was dealing with but tried to love me anyway as best he could. I am grateful to have had the pleasure of his company for six years. I am grateful that we are now with other people. I hope he is well and found the peace I could never give him.

Still, when an interviewee mentioned a woman who'd posted a picture of herself with a black eye on a PMDD forum because her boyfriend had punched her during an episode, I hurt for her. I hope she got out. I hope she moved on. I hope she understands that she never did anything to deserve a black eye. I want her to know that there are people like Usheer in the world, who never once laid a finger on me, no matter how badly I spiraled during a PMDD episode. Still, it's easier to be compassionate with other people than with yourself. Even while I have the clarity to know that PMDD does not mean you deserve to be physically or emotionally abused, I still feel as though I drove Theo to hurt me and that with someone else he would have been kinder, gentler. It's a question I'll never know the answer to.

Even if physical abuse isn't in the picture, PMDD fosters conditions ripe for other types of abuse. In Aaron's survey, 74 percent of partners reported experiencing baiting, or being deliberately

provoked, and 61 percent reported gaslighting or unfounded accusations.[8] I plead guilty to all these behaviors multiple times during PMDD episodes. I tried therapy; I read self-help books; I talked to my friends about doing better, but ultimately nothing worked as well as medication.

Many of the people I spoke to genuinely loved their partners, wanted to do their best by them, and were filled with shame and horror over their actions during PMDD episodes. I wanted to tell them there's a difference between losing control because you have a disorder and a systematic effort to control your partner through emotional or physical abuse.

At the same time, this doesn't negate the impact of fights on partners. Aaron told me about some partners who worried that leaving an abusive partner with PMDD would be tantamount to leaving a partner with cancer. I disagreed. Abuse is abuse, regardless of why it's happening. Just as someone with PMDD has the right to choose their treatment or choose no treatment at all, a partner has the right to choose to stay in a relationship or not. If a relationship is fundamentally harmful and your partner isn't *at least* working to make amends and to fix the problem, the "why" doesn't matter. You can leave even if they have PMDD. Even if your partner *is* taking steps to fix the problem, it's completely fair to say enough is enough.

Similarly, if you have PMDD and your relationship isn't working, it's also fair to say enough is enough. PMDD doesn't mean that you don't deserve to be loved and treated with kindness—which is entirely separate from just being loved. I knew Theo loved me, but Usheer taught me that you can love someone and also be kind to them even when they are at their very worst. It is a particular brand of love and forgiveness born of total acceptance that I hope everyone gets to experience at least once in their life.

For people who are trying to make a relationship work when

there's PMDD in the picture, Aaron advised discussing red lines that can't be crossed, as well as building a strong and resilient relationship when PMDD isn't present. He noted that sometimes the best thing you can do is leave your partner alone because it gives them time to cool off and gives you both space. A PMDD episode is not the time to workshop the relationship, he said. Aaron's survey also had a number that surprised me: 54 percent of people partnered with someone with PMDD said their relationship was strong, very strong, or extremely strong.[9]

What made it worth it? I asked Aaron, with Theo and Usheer in the back of my mind.

Aaron's face lit up when he described Jude. She was his other half, someone who could dive to the heart of an issue instantly. He became dreamy as he talked about the first day he met Jude. Eighteen years and four children later, despite (or perhaps because of) navigating the cavernous landscape of PMDD together, he could still remember the moment he first met her. He watched her emerge from a crowd of people, his heart pinging. I want to get to know her, he'd thought. This love was woven into the pages of his book. He wrote:

> Your partner's achievements will have come at greater effort and cost than most of their peers. They are secret superheros, with their heroic acts largely unrecognised in public or by their peers with only their inner circle knowing. Your partner is strong. Who else has to work so hard just to get through the day, just to stay alive? Nevermind work, family, promotions or volunteering. Far from being "weak" and "helpless" they are warriors and made of solid metal. Celebrate those achievements no matter how small they may seem to others.[10]

Aaron pointed out one theme that came up often during support groups: successful PMDD relationships tended to be

emotionally deep. It's impossible to ignore relationship issues because they get dragged out and have to be dealt with.

This made me think of Jessie, the elegant dark-eyed freelancer who struggles with work, and her partner, Chris. Chris has a tendency to sweep issues under the rug, and her earlier relationships fell apart because of this. "I don't think you can sweep anything under the rug with PMDD," Chris said. "You have to solve the problems because PMDD forces them out." All their problems had to be thoroughly discussed and thrashed out.

When I asked her what made it worth it, Chris went on and on: Jessie made her a better person, cooked and made the house tidy, helped her look sharper, and had a biting sense of humor.

When I spoke with Jessie, it was easy to understand why Chris loved her so much. Jessie was honest to a fault, thoughtful, and so apologetic when she felt that her answers weren't good enough—they were always good—that I felt fiercely protective of her.

Chris admitted it was hard to pick up the slack when Jessie was exhausted from PMDD, and she had to be the breadwinner. But she, as did Aaron, agreed that the hardest symptom to deal with isn't anxiety, depression, or sluggishness, even if it means more work. The most difficult symptom is rage.

For suggestions on how to manage rage, I turned to Jess Peters. Peters is a clinical psychologist and an associate professor of psychiatry and human behavior at Brown University who studies anger and borderline personality disorder, including menstrual cycle exacerbation of those symptoms. She also put together a seminar on how therapists can help people with PMDD modulate their anger and irritability, which is available on YouTube for free.[11] Peters is careful to note that anger isn't bad—at times it is warranted and helpful. The issue is when you get angry and act in ways you regret.

Peters's first tip sounds very simple, but it's saved me a great

deal of grief. The key to managing irritability is prevention. Peters defined irritability as an increased sensitivity to stimuli. Irritability can quickly become the all-encompassing rage that destroys relationships. She pointed out it's a lot easier to bring someone down from low irritability than when they've gone over the edge with anger. Because of this, she advises people with PMDD to create a self-soothing plan or kit, including calming music or pleasant smells, or to splash cold water on their face.

However, it's far more effective to avoid getting irritated in the first place. Peters was a big advocate of avoiding irritating stimuli. For instance, you might quit social media for a week, or limit contact with people you find frustrating, or even pop in earphones when your kids are being noisy. After listening to Peters, I started opening windows, giving myself permission to leave noisy rooms, and letting Usheer know when something small bothered me. For example, Usheer and I decided to exchange token Christmas gifts even though neither of us grew up celebrating the holiday. I had my gift on time, but Usheer didn't have anything for me even though I'd specifically requested something small and easy to procure: Earl Grey tea. In the past, I would have tried to pretend nothing was wrong and then exploded a month later. Instead, we had a five-minute discussion, where Usheer explained he hadn't been ignoring me, he'd just been trying to find extra-special organic Earl Grey handcrafted by free-range fair-trade elves. I explained I didn't care about quality, I just needed caffeine. The tea appeared the next day, and no more was said about late Christmas gifts. We still had fights, of course, but I am also sure prevention helped us avoid more than one big fight.

In the event that you do end up angry, Peters had more tips. She started by explaining what anger is. She divided anger into two types: primary and secondary. Primary anger is a direct response to a stimulus: someone yells at you; you get angry.

Secondary anger is usually mixed with another underlying emotion, usually hurt. "When anger is disproportionate to the situation, it can be a cue that it's masking a secondary emotion such as shame, anxiety, or feelings of rejection," Peters said. She pointed out another symptom of PMDD is a heightened sensitivity to rejection, which can lead to more anger.

I realized every single major fight I'd had with Usheer or Theo had started because I was ashamed or hurt. Normally, I'd just say that, but in the midst of PMDD, depression and anxiety were already battering away at my self-esteem. Instead of saying I felt hurt, I just threw up a wall of anger. "Secondary anger in the short term can be empowering," Peters said, "but in the long term it creates problems, and it's important to address it."

Peters recommended avoiding actions that increase anger. This included rumination, which is getting stuck in a cycle of thoughts about how angry you are. For example, talking to a friend who validates your anger might be helpful, but it could also inadvertently add fuel to the fire if it turns into ranting. (For some people, it may be helpful to have a friend who points out it's legitimate to get angry, but if you are trying to cool down, adding fuel to the flame is not helpful.) She also recommended against using "catharsis," venting anger by throwing or hitting an object or such, since over time it strengthens the link between feeling frustrated and acting violently. She added that if unavoidable, "it's better to punch a pillow than someone's face, but catharsis is not ideal because it leads to more of the same response."

Instead of catharsis, Peters recommended channeling the angry energy into something that's still high-energy but requires you to shift your focus—such as exercise or chores.

While medication can help, Peters advises people with PMDD to also try therapy, which would allow them to work on skills such as self-soothing or how to deescalate a fight, as well

as offering a forum for discussing relationship problems.[12] Her take reminded me of asthma. Puffing an inhaler didn't mean I was automatically fit. Instead, an inhaler meant that, instead of doubling over gasping for breath two minutes into a workout, I could start exercising regularly—but I still had to do the work of running and strength training in order to improve my fitness. Similarly, medication can help you get to the point where you can start to work on relationship skills and on solving the problems in your life instead of raging or flailing about anxiously. I still had to have difficult conversations and make compromises—but now I could do that without spiraling into rage or having a panic attack. Medication doesn't turn you into a new and better person; it simply gives you the ability to make better choices.

PMDD makes romantic relationships difficult to navigate, and it also makes family relationships difficult, particularly parenting. IAPMD's survey found 97 percent of respondents said PMDD strains family relationships.[13] I don't have children, but if I did, I wouldn't want them to experience my monthly rages. I wondered how parents with children managed their PMDD, given that you can't ask your kids to stay in a hotel and they don't get to dump you when they've had too much.

Kathryn Carter, an artist in Tasmania, told me she worries more about the effects of PMDD on her ten-year-old than on her partner. "My husband can leave," she said. "My daughter can't." Kathryn has had conversations with her daughter about PMDD, but even so she feels guilty about having PMDD. "Normally I'm warm, but when PMDD comes, I'm a cold fish. I'm impatient. I'm not caring. I can see her literally shrink into herself when I snap at her. I try to isolate when I have PMDD episodes but I know that hurts her too. I can see her hunch over into herself."

Steph Cullen, who is the fundraising coordinator for IAPMD, laughed when I asked her how she was handling parenting her eighteen-month-old son and six-year-old daughter. "I'm not,"

she said. Shortly after her son was born, she had a breakdown and was hospitalized. She counts herself lucky to have had help from other family members and her husband during this time. Still, even though she's doing better now, it's a struggle. "I overcompensate," she said. "When I'm okay I go all out and try to do everything I can. But I'm not sure if that's the best approach, because when I'm not okay I have to withdraw, and my daughter is starting to notice the difference."[14]

Ashley, a friend of mine, has two young children and hasn't yet found a medication that works for her. Her children are delightful and beautifully behaved. She isn't sure what her exact diagnosis is: PMDD or PME. What she does know is that she has monthly emotional breakdowns and grapples with rage. Her children's well-being has spurred Ashley to try treatments, but if she didn't have children, she would be more hesitant. "I remember sitting on the kitchen floor holding my daughter and crying because I thought she deserved a better mother who wasn't so sick," Ashley said. "I work really hard to restrain myself around my kids. But that means when my husband comes home, I'm out of cope and he bears the brunt of my anger."[15]

Kathryn, Steph, and Ashley all worried. They worried their children would have PMDD. They worried that they were damaging their children with their PMDD and their coping mechanisms. They worried that one day their children would hate them. I wish they could have the benefit of speaking with Peters, who would validate their strategy of withdrawal during the hard parts of their cycle. I also wish they could see themselves the way I saw them: clearly trying with every fiber of their beings to do the best they could for their children. That, I thought, was more than many children get—and in my experience such care goes far.

It's unclear if my mother had PMDD, since she's postmenopausal and we can't do symptom tracking. Studies estimate that

PMDD has a heritability range of 30 to 80 percent,[16] which is to say that, at some level, researchers believe PMDD is passed on from one generation to the next, but they aren't very sure of the details. However, if I had to guess, I'd bet my mother did have some form of PMDD—although not as severe as mine. Usually, she was patient and stoic, but every so often her anger came and went like the freak summer storms that appear with no warning. Her rage could fill the house and seep through the walls, even if she was just reading silently in her room. Then, just as suddenly as her rages started, they would stop. At the time, we didn't know about PMDD, so this was simply part of life.

But for the most part, I don't resent my mother's rages, because she put so much of herself into raising me. No matter what my mother was feeling, my well-being always came first. She was the first in line at school to pick me up, even though I was always the last one out of the classroom. After school, she drilled me in math and spelling until I was top of the class, even though I did not want to study. In the evening, a freshly made dinner was always waiting on the table, even if she was so furious she couldn't bring herself to speak to me. When I was older, she was more upset than I was if we couldn't afford the trendy clothes I wanted. Often, she wrestled with guilt over her anger. Since I've learned about PMDD, I've come to appreciate how much she must have struggled. While PMDD may have made her journey harder, I have never questioned her excellence as a parent.

Kathryn's, Steph's, and Ashley's children will have the added benefit of knowing what their mothers are grappling with, something that would have helped me understand my mother. I wish as a society we had more to offer Kathryn, Steph, and Ashley— better treatments, and failing that, more help with childcare or even less exacting ideals of motherhood that acknowledge it's okay to take time away from your kids. Instead, all I can offer them is this: I am absolutely sure of one thing, that their children

will know, and already do know, just how much their mothers love them and how hard they try. That was never in question.

KNOW THYSELF: PMDD AND QUESTIONS OF IDENTITY

Before my diagnosis, I spent a lot of time feeling guilty about my relationships. I felt guilty that half the month my mind was full of vitriol. I felt guilty about screaming at my partners. I felt guilty for getting annoyed at my friends and needing time away from them. And I felt guilty that, from time to time, I snapped at my parents, even though I adore them. My explanation was simple: I was a bad person. No matter how hard I tried to make up for it, I would always be a bad person because I did bad things when I got angry, and I got angry every month. Now that I had a diagnosis, I didn't know what to make of my identity. If you have an illness, how much of you is you?

This was an even more complex question for the nonbinary and trans people I interviewed. For some of them, PMDD wasn't just an emotional storm—it was an active reminder that they were in bodies that felt wrong.

Kat Jackson is thirty-two and identifies as nonbinary. "I'm like a planet, I think of my gender identity as orbiting and fluctuating," they said. "Some days I want to feel glamorous and frilly but other days I pull out a men's shirt and want to look dapper." They were diagnosed with PMDD when they were twenty-seven but recall suffering since their first period in fourth grade. Kat struggled to get their associate's degree and now juggles working at an art gallery and modeling for artists. Kat has the double whammy of PMDD and painful periods caused by polycystic ovary syndrome. At times, Kat wasn't functional for up to a week, which made it hard to hold down a job.

"I rebel against being assigned female at birth when my periods come because it's such a terrible process," Kat said. "If all

that happened was I had to buy tampons, I think I'd be more okay with it. I hate everything about this experience and that includes being a woman. The dysphoria gets so bad when I get my period."

However, Kat's experience isn't representative of all trans or nonbinary experiences with PMDD. Sam had a different experience—but was quick to also say that his experience may not be everyone's. He's currently taking low doses of testosterone as part of his nonbinary transition. The low doses mean his period is lighter and the symptoms are easier to manage. He has some gender dysphoria, but nothing related to his period. "PMDD has impacted my life but not my identity," Sam said, explaining that he'd also grown up in an abusive Catholic household and had a brain tumor. PMDD made it harder to cope during these times, but it wasn't something he thought of as foundational to his identity given everything else that had happened to him.[17]

Kat and Sam did agree on one point: they are both huge fans of silver linings, but they can't think of any with PMDD. Both have suffered enormously because of PMDD. Sam had attempted to kill himself four times, only to wake up in the hospital the next day and get his period. Kat had also attempted suicide four times and lost two relationships to PMDD. "The relationships needed to end, but I wish I'd been less cruel. I didn't want to be this cruel," Kat said. "The whole thing has taught me just because someone acts like a monster, it doesn't mean that they are one."[18]

While I don't have gender dysphoria, I have struggled with regret. Now I had a reason for my behavior, but that didn't wipe away its consequences. Many of the people I interviewed struggled with guilt and low confidence. I thought Jessie put it best: "You're doing objectively bad things, and later when you're calmer you remember doing them. How can you feel like a good person?"[19]

In his book *From Morality to Mental Health: Virtue and Vice*

in a Therapeutic Culture, the philosopher Mike W. Martin discusses the relationship between mental health and morality. Plato thought morality and mental health were interwoven. He wrote: "It appears, then, that virtue is as it were the health and comeliness and well-being of the soul, as wickedness is disease, deformity, and weakness."[20] Martin suggests a more nuanced take: someone can be sick and also responsible for the harm they cause.[21] He argues that we are responsible for our health, both mentally and physically:

> This does not mean, of course, that we have complete control over our health. Instead, it means we are obligated to take prudent measures to care for our health within limits set by our resources, opportunities, other obligations. It implies developing health habits and seeking help when problems grow beyond our immediate control.[22]

Hanna Pickard, a professor of philosophy and bioethics at Johns Hopkins University, takes this one step further in her idea of responsibility without blame. Her first experience as a clinician was at a therapeutic community for people with personality disorders, or disorders of agency, as she called them. Several had borderline personality disorder, which impacts one's ability to regulate their emotions. (People with PMDD are often misdiagnosed with borderline personality disorder.) These patients could be extremely difficult to work with. Pickard wrote:

> They could be emotionally cruel, or extremely angry and threatening without just cause; they might self-harm or disengage from the Community without explanation, provoking high levels of anxiety in others concerned for their wellbeing.[23]

Yet the staff at the center were kind and empathic. They did not blame the patients for their behavior, but they did hold them responsible for their actions.

> Clinicians must hold [people] responsible and account-able for behavior if they are to improve and recover. But blame, in contrast, is highly detrimental. [Blame] . . . may trigger feelings of rejection, anger, and self-blame, which bring heightened risk of disengagement from treatment, distrust . . . relapse . . . and potentially even self-harm or attempts at suicide: it is essential that compassion and em-pathy be maintained.[24]

However, Pickard cautions family and friends from feeling as if they too need to practice responsibility without blame, particularly if it requires repressing their feelings. In the long run, doing so will hamper someone's ability to have an actual relationship. Rather, she urges us all to think about the ways in which we blame each other and whether blame is warranted.[25]

The moment he heard about PMDD, Usheer effortlessly slipped from *what is wrong with you* to practicing responsibility without blame. Prior to my diagnosis, Usheer would periodi-cally wonder if he should leave or try to give me ultimatums—no more fights, or he was out the door. I would have loved to prom-ise him there would be no more fights, but I couldn't. "I can promise you that we'll fight again," I'd tell him instead.

But now, whenever I have a breakdown, Usheer approaches calming me down the same way you might approach someone with an illness. He helps me lower my temperature (cold water is calming),[26] gives me a head rub or back rub, or takes me for a walk or run—all while making soothing humming noises and telling me I'm going to be okay.

But I have a harder time with the idea of responsibility without blame. Thinking about blame with regard to other people is easy. Medication had allowed me to see just how much our actions are impacted by our brain chemistry. On YAZ, I was my worst PMDD self. On Seasonique, I was calm and ate everything in the fridge. On fluoxetine a few days before my period, I didn't always feel calm but could usually remain in control, despite having occasional trouble tasting food and piercing headaches. How much agency did I have, besides the ability to pick which self to be? When you really get down to it, how much agency do any of us have? How much of our personalities is boosted or hampered, depending on society's definition of acceptable traits, by our biology?

After getting diagnosed with PMDD, I stopped obsessing over morality—but only when it came to other people. I assumed they were doing the best they could given their biology. Not everything was within their control, but I'm sure they were working to close the gap between who they were versus who they wanted to be.

Applying the logic of responsibility without blame to *myself* felt impossible. Of course, I blamed myself for my actions. I asked Anuhya Korrapati how she dealt with the guilt of PMDD. She said her therapist once told her not to worry about what happened before she was diagnosed because she didn't know what was going on and was trying her best. Now that you do know, her therapist said, you have a responsibility to manage your symptoms as best you can. I tried to focus on this and shift the narrative from *How can I be less of a shitty person?* to *What is the best life I can lead? What can I control? If I cause harm, what can I do to make it up to the people in my life?*

In order to live my best life, I decided I needed to do my best to lessen the impact of PMDD on the people I loved. Then I needed to figure out how to take responsibility for any harm

I'd caused. In my past life as a trust researcher, I studied apologies and trust betrayals. I'd learned that while you're better off not betraying anyone's trust, an effective repair can often create a stronger bond. However, an effective repair is difficult to carry out and it's not a skill we're taught. It involves a good apology in the short term and then a long-term fix for the overall problem. That struck me as all very well and good as a research topic, but now I was stuck applying this to my life.

I tried to work with what I had learned, which is this: different types of people need different kinds of apologies. In two studies, researchers tested six different types of apologies on more than seven hundred participants. These types included an expression of regret, an explanation of what happened, an acknowledgment of responsibility, a promise not to make the same mistake again, an offer of repair, and a request for forgiveness.[27] The researchers found that the most effective apologies included all six types, while the least effective apology only used one type. Overall, the most effective combination was acknowledgment of responsibility, an offer of repair, and then an explanation. However, it's important to make sure that an explanation doesn't become an excuse. A good explanation helps someone understand the context of why something happened. An excuse invalidates their emotions and tries to shift blame. It's a fine line to walk.

I decided in the case of our hotel fight that even if I couldn't control my reaction, and we had other problems we needed to figure out, such as how to spend more time together as a couple, I'd still caused Usheer harm and I needed to take full responsibility. I'd already said sorry and given him an explanation: I had PMDD. I acknowledged that having PMDD wasn't an excuse, and I should have done a better job medicating. Now, I needed to make good on an offer of repair, which also transitions into the territory of long-term fixes.

I booked an appointment with our couples' therapist so we

could go over the fight and figure out what to do if something similar happened again. I also decided to adjust my fluoxetine. By now I'd read several studies that suggested people with PMDD should take fluoxetine during their entire luteal phase. I had shied away from taking fluoxetine because it dampened my libido and made me unable to taste food, and because I was terrified of addiction and weight gain, but given all the research I'd done, I knew fluoxetine wasn't addictive and it didn't cause weight gain. I owed it if not to myself then at least to Usheer to see what happened if I tried fluoxetine for my entire luteal phase.

To figure out when I ovulated, I bought an Oura ring, which I'd heard about from Dr. Tory, who uses them in her experiments. The rings have sensors that measure your basal body temperature every morning, which is correlated with changes in hormones, making it possible to track ovulation and the start of your luteal phase.

When I started tracking ovulation, I realized that PMDD impacted far more of my life than I realized. I'd always assumed I was somewhat grumpy. I found that ovulation throws me for a loop. I go haywire for a couple of days, calm down for a few more days, and then it's a slow creep from minor to major depression and anxiety. More fluoxetine gave me more good days. Now, instead of feeling as if I had a leash on my emotions, I felt as if I had unlocked an inner layer of resilience and patience that I usually only had access to for a few days of the month.

Since I started taking fluoxetine during my entire luteal phase, Usheer and I have had a few minor fights, but none as severe as our hotel fight.

Usheer and I also met with our couples' therapist, and we talked about what to do if we had another explosive fight in the future.

Surprisingly, she was a fan of the hotel stay. "What was the alternative?" she asked. "Yelling at him and being verbally abusive?

That's what you were. The hotel might be the best option because it allows you to cool off and not do anything you'll regret later. It's not great, but it's the most acceptable option."

I'd been hoping for a magic bullet or perhaps the secret to never getting angry again. Instead, I was faced with the stone-cold reality that sometimes relationships can get hard even when you're medicated and trying your best. Sometimes your best option isn't causing no damage, it's limiting the damage and living with the reality of being imperfect.

"I wish I was so much more than this," I told her.

"No one is perfect," she told us. "You guys are so in love with each other. I can hear it in the way you speak about each other. You're going to make it. I have couples that are checked out and don't care. That's not you. You're open to acknowledging your mistakes and doing better."

When it feels like all I'm doing is failing, I repeat that to myself. Acknowledge your mistakes. Be open to doing better. Stay in love.

What Next?

After I got my diagnosis, I was torn between two diametrically opposite instincts. The first was to treat my PMDD, never speak of it again, and carry on with a new and improved life. I didn't want to be pigeonholed as sick, "crazy," or disabled. The second instinct was to shout about PMDD from the rooftops. The urge didn't start overnight, but grew gradually as I ran into people who I thought might have PMDD and didn't know. Once, on a Reddit board about relationships, I saw a man post about his girlfriend. Half the month, she was calm and loving. The other half, she'd get angry at the slightest provocation and they'd have blowout fights. He loved her but he didn't know what was wrong or how to help her. I felt like he could have been writing about me.

Another time, I read an interview with a famous actress who was always in the news for having raging fights with her husband. When I'd been dating Theo, I used to love reading about her. I felt as if she and her husband embodied our relationship: stormy and passionate. I hated it when people commented that the relationship was toxic. They didn't understand, I thought. There are many ways to love, and not all of them look pretty. Sometimes, every minute is a fight to stay together.

After I got diagnosed and treated, stormy passion was literally the stuff of my nightmares. I'd dream about the past and then jolt awake, grateful to wake up next to Usheer in the pale light of dawn, grateful that this, not my dreams, was my life.

Later, I found another interview in which the same actress mentioned having to "check herself" before her period. PMDD? I wondered.

Perhaps she didn't have PMDD. Perhaps it was something else entirely or simply an intense relationship. Hollywood actresses have access to resources the rest of us don't, so surely she'd know if she had PMDD. Still, it had taken me until I was thirty-two to figure out what was going on with my own body, which struck me as far too long. The influencer Dixie D'Amelio only received a PMDD diagnosis in 2022, in her early twenties, despite the fact that PMDD had impacted many parts of her life.[1] After she was diagnosed, she told an interviewer: "A lot of people have this, but no one talks about this at all."[2]

I was haunted by the thought of how many other people were suffering without a diagnosis. What would it take for us to get people with PMDD the help they need without further stigmatizing menstruation?

PMDD ADVOCACY

There are several organizations working on raising PMDD and PME awareness, such as Anuhya Korrapati's BeyondBlood in India and Vicious Cycle in the U.K., a project to make PMDD visible. The most eminent is IAPMD. Their mission is to "inspire hope and end suffering for those affected by premenstrual disorders through peer support, education, research and advocacy."[3] For many people, including me, IAPMD's website is one of the first stops when you suspect you have a premenstrual disorder.

IAPMD's services are exhaustive, at times even overwhelming.

IAPMD offers support groups for people with PMDD or PME and their partners. It has educational seminars for the public and seminars for training professionals on how to research and treat PMDD and PME. IAPMD has collaborated on studies and led discussions between patients and professionals. Two of its members, mother-daughter team Sheila and Brett Buchert, president of its board and its communications coordinator, respectively, created Me v PMDD, an app for tracking PMDD symptoms that has over seventy thousand users. Laura Murphy, who created Vicious Cycle, also serves as IAPMD's director of education, and when I emailed IAPMD asking if they knew anyone I should talk to, Murphy created a private Slack channel and flooded me with suggestions.

IAPMD was founded by Amanda LaFleur and Sandi MacDonald in 2013. LaFleur left in 2015 to start a nonprofit incubator to help other people realize their own nonprofit dreams. MacDonald has stayed. MacDonald punctuates her texts and messages with hearts. When I chatted with her, I didn't feel as if I was doing an interview—I felt as if I was being taken under her wing, along with everyone else who has PMDD or PME. She began and ended every conversation by asking me what I needed, followed up with a flood of resources and contacts, always with her trademark heart emoji.

MacDonald was misdiagnosed first with bipolar disorder and then with PTSD, all the while struggling with binge drinking, self-harm, rage, and jealousy. She didn't get diagnosed with PMDD until 2016, when she was in her forties. She finally had a hysterectomy in 2019. For her, IAPMD was a lifeline. "This has kept me alive," she says. "I was at such a bad place and was continuing to get worse. I really needed something to do. I felt this need to talk about it because no one has a clue."

And indeed, thanks to IAPMD's efforts, more people are getting a clue. To date, IAPMD has reached over one million

people in approximately one hundred countries, and their website gets about twenty-five thousand clicks a month.[4] Almost every person I interviewed had heard of IAPMD, referred me there, or had been referred to me by someone who was in some way connected to it.

But the work of creating awareness around PMDD and other premenstrual disorders is not easy. MacDonald has struggled with talking about PMDD from time to time. She told me, "I have these bouts where I can't talk about PMDD. But then someone will tell me the website has saved their life so it feels like we need to do this."

At times MacDonald's commitment has made it hard to live her own life. When we first spoke, she said she obsessively responds to every message because one time IAPMD was slow to respond to a helpline message, and the person who sent the message had died by suicide.

When I checked in with MacDonald a year later, in 2021, IAPMD had shut down the crisis helpline to focus on peer support because the around-the-clock responses were unsustainable. When we chatted in 2022, MacDonald seemed worn down. Her PMDD was under control after the surgery, so often she felt as if she had to be the poster child for what life looks like once everything is better.

Yet MacDonald was still very much coping with her own life. Surgery had made her life better but not perfect. In order to ensure other staff members at IAPMD get paid, she forgoes a salary most of the time and occasionally has to take jobs in similar work such as peer support or caregiving to make ends meet. Most recently, she's had to take care of older family members.

Moreover, MacDonald said, people who get better tend to move on, so turnover is high at IAPMD. A premenstrual disorder can consume your life, and frequently talking to people who are going through the same issues can be triggering. The people

who stay tend to need support. The ones who get better tend to leave. But MacDonald couldn't leave. She'd tried to, but no one stepped in to fill her shoes, and she worries IAPMD will shut down if she leaves. So, MacDonald stays. "We float from grant to grant," she said. "Money is always a pressing issue. If something gets funded, we go for it, but if it doesn't, we might have to put it on hold."

I asked MacDonald which of IAPMD's accomplishments she was most proud of. I could think of millions of things: the lecture series, the podcasts, the blog featuring updates and statement positions on news, the support groups on Facebook and Zoom. After chatting with me, MacDonald was going to take a call to mentor someone in Australia so they could start an organization like IAPMD. IAPMD even has a planning document that outlines an ambitious strategy for the future, including offerings in more languages to increase global awareness, improved clinician education about premenstrual disorders, and collaboration with researchers to work on more treatments. There was so much to choose from. I couldn't wait to hear MacDonald's answer.

MacDonald paused for a long moment. "I'm so proud that we're still here." She sounded battle-weary.[5]

I was shocked. IAPMD's survival had never even been up for debate in my mind. It does so much good work. I'd never stopped to think about the well-being of the people who ran IAPMD and what it takes to keep an advocacy organization going.

Later, I realized MacDonald's answer was symbolic of the people I'd met with PMDD and PME. They were compassionate, intelligent, and frighteningly accomplished, yet they didn't see these qualities in themselves. Instead, what they saw was their daily struggle, the enormous effort it took for them to still be here, fighting the good fight.

GETTING THE MESSAGE ACROSS

Even though many people are working to get the message out about premenstrual disorders, there's another half to the equation—our ability to absorb the message. When I started talking about PMDD, I was gratified when, every so often, someone would say, "I think I have that too!" On the flip side, I was horrified by the idea some people would use PMDD to reinforce sexism. I couldn't help thinking of Gloria Steinem's seminal essay "If Men Could Menstruate":

> What would happen, for instance, if suddenly, magically, men could menstruate and women could not?
>
> The answer is clear—menstruation would become an enviable, boast-worthy, masculine event:
>
> Men would brag about how long and how much.
>
> Boys would mark the onset of menses, that longed-for proof of manhood, with religious ritual and stag parties.
>
> Congress would fund a National Institute of Dysmenorrhea to help stamp out monthly discomforts.[6]

What would society look like if people with PMDD were in power? Perhaps good character would be associated with emotional volatility rather than with iron self-control. After all, emotional volatility means you've traveled the spectrum of human emotion. Perhaps instead of claiming someone is irrational just before their period, we might say they're kinder because they've suffered. We might even say PMDD is an indication of tortured genius.

In a different society, the stoicism we typically associate with leadership and masculinity could be seen as dysfunctional. As psychologists debated whether to include PMDD in the *DSM*, Paula Caplan submitted Delusional Dominating Personality

Disorder (DDPD).[7] The hallmarks of DDPD are an inability to establish meaningful interpersonal relationships, lack of emotional self-awareness and empathy, and a tendency to believe "women are responsible for the bad things that happen to oneself, and the good things are due to one's own abilities."[8]

The *DSM* committee assumed Caplan was joking and DDPD did not make it in.[9] However, Caplan's point still stands: what we consider normal and abnormal behavior is a distinction arbitrarily drawn by society. Often, but not always, our definition of normal and abnormal is aligned with definitions of moral behavior. For example, as a society we punish most forms of murder for the greater good. A desire to kill people without a good reason such as self-defense is seen as abnormal. However, there are several other cases where our definition of abnormal simply describes characteristics of a marginalized population and further stigmatizes them. Once upon a time, the *DSM* included homosexuality disorder, and advocates had to fight for it to be taken out.

This is not to say that PMDD shouldn't be treated. The depression, anxiety, and rage people with PMDD experience are very real. However, there's another question, which is whether our responses to these real symptoms are considered "normal" and acceptable.

There's a corollary to the PMDD problem that I like to call the female problem: We live in a society that was built by men for men. To be a woman is to live in a state of constant microaggression. There's a lot to be angry about, but women are held to a high standard of pleasant behavior. If they get angry, they are punished.

Unpacking exactly how women are constantly expected to adjust to a world that isn't set up for them to succeed is the work of a different book, but, in short, most of our infrastructure, from safety equipment to legal policies, is designed for male

bodies. Products and services designed by women for women are often stigmatized—take, for example, the way romance novels and women's magazines are often seen as trashy or unintellectual. Women earn less but pay a pink tax: a 2015 study in New York City found products marketed toward women cost 7 percent more than products marketed to men.[10] Still, women are expected to live with these microaggressions without complaining.

Research by associate professor Christine Exley at Harvard Business School shows that we expect women to be nicer than men. She conducted a series of games where respondents could predict how much they thought men and women would pay players. She found 72 percent of respondents expected women would pay low performers and high performers equally, while only 52 percent of respondents expected men to do the same. (In Exley's studies, men and women ultimately behaved similarly, and a majority said they would pay equally.)[11] Other studies show that at the office women are asked to do more grunt work that doesn't lead to promotion,[12] but turning down such requests can impact their perceived performance.[13] In addition, in male-only environments, men will volunteer for grunt work, but they volunteer less often in a mixed-gender setting, which suggests that the presence of women means men are less willing to do grunt work.[14]

In short, women are given less, asked to do more, and punished more harshly if they complain. This is unfair to all women, and particularly unfair to people with PMDD, who have less emotional bandwidth and less ability to say yes with a pleasant smile. Yet on top of the emotional turmoil PMDD creates, women with PMDD must also earn social approbation during episodes or in their aftermath if they want to keep their jobs and relationships. The question isn't why are 10 percent of women struggling with rage, depression, and anxiety, but why is this number so low given the massive injustices women face? It's no wonder feminists thought PMDD was an invention of a sexist

society—women have much to be angry about but are not given many avenues for expressing this anger. People with PMDD are caught between their biology and sexist expectations. Many people with PMDD have reported that their symptoms are less serious when they are alone. Chrisler and Caplan argued this was because they don't have to deal with the thousand irritations that come along with being female.[15] In a less sexist society, in which women were given more freedom to be angry and there were fewer microaggressions, PMDD might not be as debilitating.

Sexism aside, premenstrual disorders also sit at the nexus of two different stigmas: mental health and menstruation. Our prejudices here run deep, which creates a vicious cycle. Historically, both have been misunderstood, and because they've been misunderstood, we instinctively shy away from discussing diagnoses, which only increases the silence and the stigma. What we don't talk about, we don't know.

Menstrual stigma means we've developed a period-blind society that makes it harder for menstruators to function. Because we don't think or talk about periods, we don't think about what menstruators need. The examples are endless, but for starters, we don't make period products easily available to everyone, nor do we talk about what happens if people don't have access to period products. In India, 70 percent of all reproductive diseases are caused by poor menstrual hygiene.[16] Lack of access to period products also creates barriers to education and, later, work. In the U.S., where period products are still taxed in twenty-two states,[17] a quarter of teenagers have missed class because they couldn't afford products.[18] It's not just the onset of menstruation that creates barriers. In the U.K., Bloomberg reported that about nine hundred thousand women quit their jobs due to an undiscussed reason: menopausal symptoms.[19] This loss is our loss: another Bloomberg report calculated that empowering women

to participate in the modern economy could add a potential $20 trillion to the global GDP.[20]

We're not doing much better with mental health. In a survey conducted across ten countries, about 30 percent of the participants studied had mental health symptoms that warranted seeing a doctor. However, 58 percent of people with a clinically severe mental health condition have not asked for help.[21] Heartbreakingly, 36 percent of people said they didn't seek help because they believed they could manage on their own, while 34 percent simply didn't know what kind of help to ask for or how to get help.[22] There's still much we don't understand about the brain chemistry of mental health disorders, but we do know that mental illness is not about a failure of self-control. We do not say people with diabetes should try harder to regulate their diabetes without medication. Nearly all of us will be impacted by some sort of mental health or menstrual health issue (or both) during our lifetimes, even if it's just watching someone we love struggle to get support and treatment.

We have a choice. We can condemn people who have painful periods or destabilizing mental health disorders to suffer in silence, or we can provide support and understanding. In the 1980s, feminists argued that a PMDD diagnosis would stigmatize all women because we live in a sexist society. What if we could build a new reality, one where people can talk about any biological struggle and receive the support they need without shame or stigma?

One of my favorite advocates who works toward that mission is Chelsea Wilde, a writer who runs the Instagram account @PMDDMemes. Wilde went through a decade-long fight to get a formal PMDD diagnosis. She originally started the account, which is pretty much what it says on the tin—popular Internet memes with captions about PMDD—to complain. Much to her

surprise, it took off and became a hit in the PMDD community. Today, Wilde regularly receives and posts original memes and memes submitted by people with PMDD.

One popular meme features two pictures of the model and TV host Heidi Klum. In the first, she's glammed up in a leopard-print dress. In the second, she's wearing an alarmingly realistic worm costume that, well, makes her look like a worm. The caption for glammed-up Klum reads: "PMDD Week 1–2." The worm costume caption reads: "PMDD Week 3–4." Accurate.[23]

I was struck by how many of the jokes in @PMDDMemes weren't all that different from the sexist PMS comics and memorabilia that populated media in the '80s and '90s. But unlike those jabs, @PMDDMemes comes from within the community. It's become a center for support. The mission is to educate rather than denigrate.

Wilde frequently gets messages asking for more information and resources and makes a point of responding to as many as she can. She also has a strict set of internal rules she follows to make sure the memes she posts are trans-inclusive; protect the identity of children, even if their parents are all right submitting their photos for memes; and don't tout snake-oil treatments.[24] A recent post shows people falling over a raging fire. The caption reads: "Treating PMDD with essential oils." In the comments, Wilde asks readers to weigh in with a PMDD treatment that didn't work. "I'll go first," she wrote. "5 years of sugar-free gluten-free processed food-free strict as hell diet and tons of supplements and vitamins." The comments are full of people debunking common PMDD myths such as that a better diet can cure it, with one user summing up the mood: "It'll be shorter to talk about what I haven't tried."[25]

@PMDDMemes started off as a way for people to use dark humor to bond over the side effects of PMDD, but it's sparked

many conversations about diagnosis, treatment, and support. It's the starting point of what I'd hope for in a PMDD utopia.

It's surprisingly difficult to picture the specifics of what a perfect society for people with PMDD would look like. Free tampons, pads, and menstrual cups for everyone? The ability to flexibly schedule exams and meetings around periods? A culture that rewards PMDD characteristics rather than DDPD characteristics? My daydream often fizzles and sputters to a stop because I'm so steeped in our current society and its biases that I have trouble picturing a different life, one where I don't have to hide for a week when I feel awful.

What I can picture is a different environment. I dream of a world where people can talk about PMDD without fear of judgment or hearing stupid comments like "Have you tried yoga?" (Yes, and it didn't help.) I dream of researchers finding out more about women's health so that taking birth control doesn't feel like a game of side-effect roulette. I dream of entrepreneurs coming up with different products and services for menstruation so people have choices. I want to watch TV shows and read books that show people living with PMDD. But more than that, I want portrayals of periods to become normal so we can understand the diversity of experiences. I once chatted with someone whose periods were so heavy she frequently bled through her clothes in public and developed a fear of leaving her house. She didn't realize her periods were abnormal until well into adulthood because no one around her was talking about menstruation. I want everyone to find their period or mental health struggle or both represented in the media.

This world will come into existence not because of one person, but because many people are having an ongoing conversation, multiple conversations, about premenstrual mood disorders, about mental health, and about periods.

This starts with you and it starts with me. It starts by choosing to speak up about what we've been taught to stay silent about, and in return learning to be good listeners—that is, to react without judgment, to ask questions instead of silencing someone by shaming them. It might start with a comment as simple as "Could you lend me a pad or some painkillers?" Or, "I'm sorry, I'm going to have to cancel because I have PMDD." Response: "Here's a pad, can I get you anything else?" Or, "Hope you feel better soon!" This sounds simple—and it is. The question is, why aren't we having more of these conversations?

We still need to do more work to destigmatize periods, but surely today's society has evolved to the point where we can have a more nuanced discussion, like the one that's going on at @PMDDMemes. Some people need treatment for their premenstrual symptoms while others don't. This is not a judgment or a statement of value. It is merely a fact. We can help people get support and empower them to lead better lives, or we can continue to let them suffer just because we want to stigmatize biological realities they cannot control. Let's choose empowerment.

RECENTLY, AS I was rereading the discussion between feminists and psychiatrists around PMDD, I realized much of it was about people with PMDD instead of *by* people with PMDD. And because of that, one important truth gets sidelined: getting treatment is empowering. Treatment saves lives and makes them worth living.

Taking fluoxetine during my luteal phase has given me my life back, and I see this play out month after month. Shortly after I started taking fluoxetine for the entirety of my luteal phase, Usheer and I were invited to a karaoke party for one of his friends. I was not thrilled. I'm a bad singer and terrified of singing in

public. I told Usheer I'd only go if he didn't pressure me to sing and if he backed me up if someone else tried to make me sing.

A few songs into the party, someone handed Usheer the mic. He turned, handed it to me, and said, "Do you want to sing?"

I wondered if Usheer had lost his mind. Rage washed over me, filling me up from my toes to my head, pressing against my eyeballs. I had almost forgotten what this rage felt like. I'd almost started to believe it was a thing of the past, yet here it was again.

Luckily, the room was dark and it was easy to create a bubble of space where I could breathe slowly and evenly, text a few friends to vent, and take a few minutes to calm down. Even so, once we left the party, my rage lay waiting for us both.

"What were you thinking?" I hissed as soon as we left the room.

"I'm sorry," Usheer said. "I wasn't thinking."

That was evident. In the past, I would have said that. Instead, I made a calculation: sarcasm wasn't going to get me anything. I needed to find out what had gone wrong. "I was so clear that I don't enjoy singing in public," I said. "How could I have been any clearer?"

"You were," Usheer said simply. His shoulders were hunched. "I feel awful. I don't know what happened. I'll never do this to you again."

"Good," I said. "Let's never have this conversation again." Each word was laced with a razor blade of rage. Usheer shrank further into himself as I spoke. I opened my mouth again. In the past, the rage would have poured out of me, and in a few moments I would have been screaming on the sidewalk. The next few days would be riddled with sleepless nights and more screaming and crying. I wondered what would happen tonight. We were both exhausted from a long week of work. We'd been looking forward to dinner and then spending Sunday binge-watching a show, our snouts tucked into bags of chips, but instead here we were fighting.

"We will never need to have this conversation again," Usheer said.

Suddenly, all I could see was that he loved me and was furious with himself for hurting me. He was berating himself over and over, and all I could think about was how much I loved him and how lucky I was to have him in my life.

I did something I'd never been able to do before. I tucked my rage into my back pocket and threaded my arm through Usheer's. "It's okay," I said. "We'll move on. Don't be too harsh on yourself."

We kept walking, and with each step I could feel my rage melt away as the cool evening breeze blew around us.

"How can I make this up to you? Pizza? Ice cream?" Usheer asked.

"Both," I told him, because I like to play hardball with reparations, especially if they involve food.

"A year ago, one of us would be sleeping on the couch and it'd take us all week to repair this," I told Usheer once we'd found pizza.

"I know," he said. "I was worried about it. I'm glad we're going to have a good night."

And he was right. We ate our pizza and ice cream as we gossiped about the party. Then, hand in hand, we headed home. Above us, thousands of stars sparkled, piercing the dark night with the soft hope of their silver light.

Epilogue

When I was in the middle of writing this book, my friend Dineda sent me a congratulatory note. I hadn't heard from her in over a decade, and I immediately proposed a catch-up call. I'd met Dineda at my first job.

When I arrived in Washington, D.C., fresh out of college, I floundered. I did not know how to make friends in an office or set up an apartment. Dineda swept me under her wing. She marched around the office introducing me to everyone. Then she fixed up my internet and took me shopping for pots and pans. When she left for a new job, I wandered around the hallways bereft, like a duckling who had lost its mother. We meant to keep in touch, but after I left for Malaysia, we lost track of each other.

"Tell me about this book," she said the moment I called her. "You were always talking about how much you wanted to write. What's it about?"

"Women's health," I said. I was still figuring out how to talk about PMDD. My latest strategy was to avoid uncomfortable questions by saying "women's health." It was the blandest answer I could invent. Unfortunately, it was so bland it raised more questions than it answered.

"Okay. What about women's health?" Dineda asked.

"Well, periods."

"What about periods?"

"Um, well, severe PMS?" I said. People usually didn't know what PMDD was when I mentioned it.

"That's great!" Dineda cried.

I was used to that response. Usually, the conversation would go silent, the other person would clear their throat, and we'd change the subject. I waited for the inevitable awkwardness. It didn't come.

"No, you don't understand," Dineda said. "I really mean it's great. I am so happy you're writing this book. I have PMDD."

I screamed. Our catch-up call turned into an hour-long heart-to-heart followed by a second one. We compared stories and the shape of our PMDDs—where our stories overlapped, where they differed, and how we'd coped and masked.

"I would never have talked about this if you hadn't told me about your book," Dineda said. I was the first person she'd talked to about PMDD except her partner.

After talking with Dineda, I started to get more comfortable talking about PMDD socially. I dropped my "women's health" line and just went for "PMDD." Sometimes, my candor shut down the conversation. Once a man started singing "awkward" after I told him about PMDD, and I wondered if I should start rapping so we could both star in our own awkward musical. But more often, it opened unexpected doors. Once, on a plane ride, the man in the neighboring seat asked me why I was writing about PMDD.

"Because I have it," I said, and grinned at him like a shark. We would be stuck together for the next three hours.

I could see the discomfort settle over him like a blanket. Then he blinked and shoved it aside. "I used to research breast cancer," he told me. "You would not believe the things we don't know about women's bodies." We ended up talking for the whole flight.

I started to realize that if I was more comfortable talking

about menstruation and mental health, the people around me became more comfortable. Gradually, I started to hear all kinds of stories: not just about PMDD, but about periods as well. A woman on a plane told me she had to drop out of an expedition to climb Mount Everest because of her painful periods. She hadn't told anyone on the expedition, and she hadn't been able to find a treatment that worked. She was en route to see yet another gynecologist. She loaded me up with so many podcasts and references, I told her she should write her own book. "Maybe I will," she said.

Originally, I hadn't wanted to talk about PMDD because I was afraid that would become my entire identity. People would look at me differently, and they would forget that I was a person beyond my disorder. As I started talking to other people, I realized they had the exact same fears—whether it was about PMDD, menstruation, mental health, or anything else that was stigmatized. Yet during our conversations, I soon found out that talking about stigmatized conditions actually opened the door to getting to know other people better. I swapped business cards with the researcher and hugged the woman. I hope she climbs Everest one day.

In time, I hoped, every conversation we had about PMDD could be like the one Brett Buchert envisions.[1]

While most of the people I'd spoken to were diagnosed in their twenties or thirties and still adjusting to life with a diagnosis, Brett, who is twenty-seven, was diagnosed as a teenager and has worn the identity of PMDD for a long time. She created one of the first symptom-tracking apps, Me v PMDD; served as the peer-support lead at IAPMD; and popularized the phrase "PMDD warrior."

In conversation, Brett seems shy—she has a quiet voice and a curtain of long brown hair. Yet her ideas were so audacious they left me speechless.

A few years ago, she took a step back from embracing PMDD warrior as a major part of her identity for two reasons. First, many of her PMDD symptoms were under control, but she had new ones that didn't seem to be about PMDD. Second, Brett wasn't happy about the existing conversations around PMDD. She helped organize a discussion on PMDD between professionals and patients. She was hoping for an overhaul of PMDD as a diagnosis, but it didn't happen. "We talk about what's bad about it, but not the good parts," she explained.

"The good parts?" I asked. I did not understand.

"I think there can be good parts," she said. Brett pointed out that several of the people she met with PMDD tended to be empathic and self-aware. When she asked people with PMDD what their Myers-Briggs personality type was, many said INFJ— introverted, intuitive, feeling, judging. "It's the rarest personality type," she said. "Maybe there's strengths to having PMDD."

After talking with Brett, I looked up INFJs and found they make up 2 percent of the population and are known for being emotional and analytical as well as sensitive.[2] Short of conducting my own study of PMDD personality types, I couldn't corroborate Brett's observation, but on the whole I loved interviewing people with PMDD. They are thoughtful, emotionally astute, and disarmingly self-aware. After our interviews, several people reached out to add more details to their story, share tidbits they'd found, or just send their best wishes.

I began thinking about the ways in which I was grateful to PMDD. PMDD taught me to take responsibility and get good at apologizing and repairing relationships. It helped me stand my ground, both in relationships and at work. The wild mood swings meant I did some of my best writing because I was surfing a wave of emotion. True, I don't like having to slow down for a few days each month, but on the flip side, I'm the kind of person who'd probably work until I burned out anyway. Occasionally

before my period, I would be struck by incredible joy that left me in a heady golden haze. Now that I'm treated, the golden hazes aren't quite so heady anymore.

Brett wonders if the joy is also a part of PMDD that we don't register because we demonize the menstrual cycle and mental health diagnoses. She finds that when she's about to menstruate, she's more spiritual. Simple daily rituals like taking a shower can feel like a religious experience.

Today, Brett's moving on from being a PMDD warrior. She acknowledges she's able to do this because her symptoms are under better control. Yet I understood the impulse. I manage my asthma, but I don't talk about it much or think about it as obsessively as PMDD. In time, I hope PMDD will become like asthma—something I manage but otherwise don't think much about. It's part of me, but not all of me.

Thanks to medication, my PMDD has mostly simmered down to some exhaustion, mild anxiety, and depression a few days before my period. While I do miss the heady golden hazes, they were rare enough that they don't make the return of the rage worth it. Yet even before I was treated, I lived a full life that was far more than PMDD. I have stories about selling pet rocks, scrubbing elephants, and eating fried crickets. I worked; I traveled; I loved and I lived. PMDD was part of my life, but it was not all of it, and I could see that Brett felt the exact same way as she thought about who she was and what she wanted her life to look like.

"I'm writing the next chapter of my life," Brett said. "I still don't know what it'll be. I'm sensitive to changes in my cycle. I'll admit that. But maybe I don't want a death sentence where I live a half life because I have a PMDD diagnosis or have to take out my uterus." She paused and looked straight at me, summing up the hopes and dreams of everyone I'd spoken to. "Maybe I just want to be a person."

ACKNOWLEDGMENTS

This book started as a daydream that kept me company during solitary runs. It turned into a journey where I made new friends, became closer to old ones, and realized none of us are truly alone. I am grateful to the many, many people who made this journey with me.

First, my thanks to everyone who told me their premenstrual disorder story. There are far too many of you to name, and some of you did not want to be named. I am grateful for each of you. Thank you for your courage and your candor. I think of you often.

Dr. Tory Eisenlohr-Moul tucked me under her wing and spent hours walking me through the science of PMDD. Any mistakes that remain are my own. I'm grateful to her lab and colleagues, with a special mention for Professor Graziano Pinna, Katja Schmalenberger, Jaclyn Ross, and Jordan Barone, who took time out of their busy days to talk about their research.

Dr. Peter Schmidt answered question after question about PMDD, while throwing in several much-needed giraffe jokes. In addition to learning about PMDD, I now know what ossicones are. Thank you for your patience and for reviewing innumerable drafts. Thank you to the team at NIMH for coordinating

my research visit, with particular gratitude to Shau-Ming Wei, Karen Berman, David Goldman, Sarah Rudzinskas, Neelima Dubey, and Anna Mikulak.

Anne Figert's excellent book *Women and the Ownership of PMS* was instrumental for understanding the debate over the inclusion of LLPDD in *DSM-III-R*. Thank you for your advice, support, and the many textbooks you gifted me. I will do my best to pass it forward, as you did with me.

Helen King graciously walked through menstrual history with me and did not laugh when I told her I needed to compress Western menstrual history into a couple of pages. Thank you for your time and your passion for getting the history exactly right. Any mistakes that remain are purely my fault.

A thousand thank-yous to the staff at IAPMD. In particular, Sandi MacDonald sent a flurry of emails to the community, making it possible for me to write this book. Laura Murphy, a spectacular star, set up a Slack channel with suggestions and advice, and connected me with dozens and dozens of people to talk to.

Much gratitude to Anuhya Korrapati, who wrote me weekly emails so I could get a sense of PMDD through someone else's eyes.

Thank you to Peter Bernstein, my agent, and his partner, Amy Bernstein, for their consummate professionalism when faced with a flailing, wailing fifty-page book proposal and for finding it the perfect home with Lee Oglesby and Ruben Reyes at Flatiron.

Flatiron is truly the perfect home: working with Lee Oglesby and her assistant, Ruben Reyes, has been utterly glorious. Somehow even though I gave them a completely different proposal, they managed to see exactly what this book could be and pushed me to write the book I'd always wanted to write but was desperately trying to avoid. Lee, I am eternally grateful for your vision

and your bone-deep commitment to creating a better, more inclusive world. Your questions were an education in kindness—both to myself and others—and reshaped my thinking. Thank you for looking after my book, and for looking after me.

Ruben, you're a wickedly talented word magician. Thank you for taking my masses of messy paragraphs and cutting and polishing them until gems fell out. Thank you both for working with me through questions like: how do you write about suicide and abuse while also wanting to throw in a bad joke about cheesecake? I could not imagine a kinder, more ethical, or more brilliant team.

My deepest gratitude to Amelia Possanza for her enthusiastic support from the get-go, and to Katherine Turro, Erin Kibby, Morgan Mitchell, and the rest of the Flatiron team for taking a chance on this book!

I'm infinitely grateful to Hannah Furfaro, eagle-eyed and compassionate fact-checker; Angela Gibson for her sorely needed copyedits; and Laury Frieber for her thorough and compassionate legal read. Any mistakes that remain are my responsibility.

Much gratitude and love to the Octos, who've waded through dozens of revisions over the years with good humor and grace. Much thanks to Yichen Shi-Naseer (Lily), Madeleine Hall, Meghana Ranganathan, Nancy Crochiere, and Rich Sullivan for reading through my drafts and combining thoughtful critiques with deep sensitivity. Thank you for pushing me to stay true to my vision even when I swore I didn't have a vision. An extra thanks to Meghana for writing with me at 5:00 PM every day, prepping me like a general when I was on revise and resubmit, and then scouring every chapter of this book, sometimes with one-day notice. I wouldn't be here without you. Much thanks to Michelle Hoover for introducing us all through the Novel Incubator.

And thank you to my fellow writers: E. B. Bartels loaded me up with her book proposal template, much good advice, and my first interview and then check-ins over ramen. From the get-go, Michelle Bowdler provided a primer in how to handle writing the painfully personal without being personally pained. Lise Brody sat with me in the Saturday writing trenches—thank you for sliced apples and cheese, pasta, innumerable walks, and all your support. Joy Batra sat with me in the weekday writing trenches, whether on Zoom or over pastries (er, salads), and talked me out of making bad Twitter decisions. Thank you for adding so much grace and diplomacy to these pages and my life.

I have been extraordinarily lucky in my friends. Much gratitude to Garvi Sheth, Denise Lin, Jamie Hittman, Nic Johnston, Wynter Kell Carnahan Arden, Siri Raasch, Alex Ravich, Valerie Ollis, Heidi Liu, Chao Cao, Alfred Miller, Younjoo Sang, and Sandra and Raageen Kanjee. Thank you all for your friendship and the thousands of ways it manifests lighting up my life. Also, I would be nowhere without the group chat/board of directors: Denise Lin, Garvi Sheth, Shiehan Chou, Jackie Cheng, Kevin McLarnon, Albert Lee, Christine Lu, and Lex. Thank you for weighing in on every decision great and small, and listening to me quaa.

My thanks to my parents, Subash Gupta and Che Lin Woo, both of whom thought writing a book on menstruation and mental illness was a fantastic idea. Dad: The neighbors keep messaging me saying they're having great conversations with you about periods while you do yardwork. I have so many questions and I'm not sure I want the answers. Mom: Thank you so much for your enthusiastic support. The first time I mentioned this book, you lit up and said, "This is going to be so important." Then you called every week asking for my word count. Thanks, I think? Please don't keep track of the Amazon reviews this time around.

And, of course, my love and thanks to Usheer: who comes home with pockets full of plant cuttings and jars full of pond water, a firm believer that anything can grow with enough sunlight and care. You witnessed much and yet you are still here and day by day we continue to grow.

APPENDIXES

APPENDIX A
RESEARCH CRITERIA FOR LLPDD IN *DSM-III-R*

Diagnostic Class: Conditions for Further Study

A. In most menstrual cycles during the past year, symptoms in B occurred during the last week of the luteal phase and remitted within a few days after onset of the follicular phase. In menstruating females, these phases correspond to the week before, and a few days after, the onset of menses. (In nonmenstruating females who have had a hysterectomy, the timing of luteal and follicular phases may require measurement of circulating reproductive hormones.)

B. At least five of the following symptoms have been present for most of the time during each symptomatic late luteal phase, at least one of the symptoms being either (1), (2), (3), or (4):

1. marked affective lability, e.g., feeling suddenly sad, tearful, irritable, or angry
2. persistent and marked anger or irritability
3. marked anxiety, tension, feelings of being "keyed up" or "on edge"
4. markedly depressed mood, feelings of hopelessness, or self-deprecating thoughts
5. decreased interest in usual activities, e.g., work, friends, hobbies
6. easy fatigability or marked lack of energy
7. subjective sense of difficulty in concentrating
8. marked change in appetite, overeating, or specific food cravings
9. hypersomnia or insomnia
10. other physical symptoms, such as breast tenderness or swelling, headaches, joint or muscle pain, a sensation of "bloating," weight gain

C. The disturbance seriously interferes with work or with usual social activities or relationships with others.

D. The disturbance is not merely an exacerbation of the symptoms on another disorder, such as major depression, panic disorder, dysthymia, or a personality disorder (although it may be superimposed on any of these disorders).

E. Criteria A, B, C, and D are confirmed by prospective daily self-ratings during at least two symptomatic cycles. (The diagnosis may be made provisionally prior to this confirmation.)

APPENDIX B
RESEARCH CRITERIA FOR PMDD IN *DSM-IV*

Diagnostic Class: Conditions for Further Study

A. In most menstrual cycles during the past year, five (or more) of the following symptoms occurred during the final week before the onset of menses, started to improve within a few days after the onset of menses, and were minimal or absent in the week postmenses, with at least one of the symptoms being either (1), (2), (3), or (4):

1. markedly depressed mood, feelings of hopelessness, or self-deprecating thoughts
2. marked anxiety, tension, feelings of being "keyed up" or "on edge"
3. marked affective lability (e.g., mood swings; feeling suddenly sad or tearful or increased sensitivity to rejection)
4. persistent and marked anger or irritability or increased interpersonal conflicts
5. decreased interest in usual activities (e.g., work, school, friends, hobbies)
6. subjective sense of difficulty in concentration
7. lethargy, easy fatigability, or marked lack of energy
8. marked change in appetite, overeating, or specific food cravings
9. hypersomnia or insomnia
10. a subjective sense of being overwhelmed or out of control
11. other physical symptoms such as breast tenderness or swelling, joint or muscle pain, a sensation of "bloating," weight gain

Note: In menstruating females, the luteal phase corresponds to the period between ovulation and the onset of menses, and the follicular phase begins with menses. In nonmenstruating females (e.g., those who have had a hysterectomy), the timing of luteal and follicular phases may require measurement of circulating reproductive hormones.

B. The disturbance markedly interferes with work or school or with usual social activities and relationships with others (e.g., avoidance of social activities, decreased productivity and efficiency at work or school).

C. The disturbance is not merely an exacerbation of the symptoms of another disorder, such as major depressive disorder, panic disorder, dysthymic disorder, or a personality disorder (although it may be superimposed on any of these disorders).

D. Criteria A, B, and C should be confirmed by prospective daily ratings during at least two symptomatic cycles. (The diagnosis may be made provisionally prior to this confirmation.)

APPENDIX C
DIAGNOSTIC CRITERIA FOR PMDD IN *DSM-5*

Timing of Symptoms

A. In the majority of menstrual cycles, at least five symptoms must be present in the final week before the onset of menses, start to improve within a few days after the onset of menses, and become minimal or absent in the week postmenses.

Symptoms

B. One or more of the following symptoms must be present:
1. marked affective lability (e.g., mood swings, feeling suddenly sad or tearful, or increased sensitivity to rejection)
2. marked irritability or anger or increased interpersonal conflicts
3. markedly depressed mood, feelings of hopelessness, or self-deprecating thoughts
4. marked anxiety, tension, and/or feelings of being keyed up or on edge

C. One (or more) of the following symptoms must additionally be present to reach a total of five symptoms when combined with symptoms from criterion B above:
1. decreased interest in usual activities
2. subjective difficulty in concentration
3. lethargy, easy fatigability, or marked lack of energy
4. marked change in appetite; overeating or specific food cravings
5. hypersomnia or insomnia
6. a sense of being overwhelmed or out of control
7. physical symptoms such as breast tenderness or swelling; joint or muscle pain, a sensation of "bloating" or weight gain

Severity

D. The symptoms are associated with clinically significant distress or interference with work, school, usual social activities, or relationships with others.

Consider Other Psychiatric Disorders

E. The disturbance is not merely an exacerbation of the symptoms of another disorder, such as major depressive disorder, panic disorder, persistent depressive disorder (dysthymia), or a personality disorder (although it may co-occur with any of these disorders).

Confirmation of the Disorder

F. Criterion A should be confirmed by prospective daily ratings during at least two symptomatic cycles (although a provisional diagnosis may be made prior to this confirmation).

Exclude Other Medical Explanations

G. The symptoms are not attributable to the physiological effects of a substance (e.g., drug abuse, medication or other treatment) or another medical condition (e.g., hyperthyroidism).

NOTES

CHAPTER ONE: THE PMDD PROBLEM

1. Jeff Livingston, "Understanding Hormones: The Roles of Estrogen and Progesterone," *Medika Life*, June 13, 2020, https://medika.life/understanding-hormones-the-roles-of-estrogen-and-progesterone; Adriana Velez, "It's Complicated: The Relationship Between Your Heart and Hormones," HealthCentral, February 24, 2021, https://www.endocrineweb.com/conditions/heart-disease/heart-hormones.
2. "The Menstrual Cycle, Explained," Clue, January 30, 2023, https://helloclue.com/articles/cycle-a-z/the-menstrual-cycle-more-than-just-the-period.
3. UCSF Health, "The Menstrual Cycle," June 24, 2022, https://www.ucsfhealth.org/en/education/the-menstrual-cycle.
4. "Menstrual Cycle, Explained."
5. "Luteal Phase of the Menstrual Cycle: Symptoms and Length," Cleveland Clinic, n.d., https://my.clevelandclinic.org/health/articles/24417-luteal-phase.
6. Valencia Higuera and Crystal Raypole, "PMS: Premenstrual Syndrome Symptoms, Treatments, and More," Healthline, January 28, 2022, https://www.healthline.com/health/premenstrual-syndrome.
7. "About PMS," NAPS—National Association for Premenstrual Syndromes, n.d., https://www.pms.org.uk/about-pms/.
8. JoAnn V. Pinkerton, Christine J. Guico-Pabia, and Hugh S. Taylor, "Menstrual Cycle-Related Exacerbation of Disease," *American Journal of Obstetrics and Gynecology* 202, no. 3 (2010): 221–31, https://doi.org/10.1016/j.ajog.2009.07.061.
9. Ibid.
10. Nancy Foldvary-Schaefer and Tommaso Falcone, "Catamenial Epilepsy:

Pathophysiology, Diagnosis, and Management," *Neurology* 61, no. 6, supplement 2 (September 1, 2003): S2–15, https://doi.org/10.1212/wnl.61.6_suppl_2.s2.

11. Robert L. Reid, "Premenstrual Dysphoric Disorder (Formerly Premenstrual Syndrome)," *Endotext,* ed. Kenneth R Feingold et al., MDText.com, January 1, 2000, http://pubmed.ncbi.nlm.nih.gov/25905274/.

12. Ibid.

13. Shirley Ann Hartlage, Dana L. Brandenburg, and Howard M. Kravitz, "Premenstrual Exacerbation of Depressive Disorders in a Community-Based Sample in the United States," *Psychosomatic Medicine* 66, no. 5 (September 1, 2004): 698–706, https://doi.org/10.1097/01.psy.0000138131.92408.b9.

14. Pinkerton, Guico-Pabia, and Taylor, "Menstrual Cycle-Related Exacerbation of Disease."

15. Steven M. Paul and Robert H. Purdy, "Neuroactive Steroids," *FASEB Journal* 6, no. 6 (March 1, 1992): 2311–22, https://doi.org/10.1096/fasebj.6.6.1347506.

16. M. W. McEnery and R. E. Siegel, "Neurotransmitter Receptors," *Elsevier EBooks,* January 1, 2014, 552–64, https://doi.org/10.1016/b978-0-12-385157-4.00044-0.

17. Liisa Hantsoo and C. Neill Epperson, "Allopregnanolone in Premenstrual Dysphoric Disorder (PMDD): Evidence for Dysregulated Sensitivity to GABA-A Receptor Modulating Neuroactive Steroids Across the Menstrual Cycle," *Neurobiology of Stress* 12 (May 1, 2020): 100213, https://doi.org/10.1016/j.ynstr.2020.100213.

18. Tory A. Eisenlohr-Moul et al., "Are There Temporal Subtypes of Premenstrual Dysphoric Disorder?: Using Group-Based Trajectory Modeling to Identify Individual Differences in Symptom Change," *Psychological Medicine* 50, no. 6 (2019): 964–72, https://doi.org/10.1017/s0033291719000849.

19. Tori Morales, "PMDD, Autism, and ADHD: The Hushed Comorbidity," *ADDitude,* November 17, 2022, https://www.additudemag.com/pmdd-autism-adhd/.

20. Emre Soydas, Yakup Albayrak, and Basak Sahin, "Increased Childhood Abuse in Patients with Premenstrual Dysphoric Disorder in a Turkish Sample," *Primary Care Companion for CNS Disorders,* July 24, 2014, https://doi.org/10.4088/pcc.14m01647.

21. Uriel Halbreich et al., "The Prevalence, Impairment, Impact, and Burden of Premenstrual Dysphoric Disorder (PMS/PMDD)," *Psychoneuroendocrinology* 28 (August 1, 2003): 1–23, https://doi.org/10.1016/s0306-4530(03)00098-2.

22. "PMS & PMDD," MGH Center for Women's Mental Health, January 28, 2019, https://womensmentalhealth.org/specialty-clinics-2/pms-and-pmdd/.

23. Higuera and Raypole, "PMS: Premenstrual Syndrome Symptoms, Treatments, and More."

24. Ibid.

25. Author interview with C. Neill Epperson, December 12, 2022.

26. Ibid.

27. Neelima Dubey et al., "The ESC/E(Z) Complex, an Effector of Response to Ovarian Steroids, Manifests an Intrinsic Difference in Cells from Women with Premenstrual Dysphoric Disorder," *Molecular Psychiatry* 22, no. 8 (January 3, 2017): 1172–84, https://doi.org/10.1038/mp.2016.229.

28. IAPMD, "Volunteer Orientation 2022," internal PowerPoint presentation, November 29, 2022.

29. Vicious Cycle PMDD, "Facts and Figures About PMDD—Vicious Cycle PMDD," March 9, 2023, https://www.viciouscyclepmdd.com/facts-figures.

30. Teri Pearlstein and Meir Steiner, "Premenstrual Dysphoric Disorder: Burden of Illness and Treatment Update," *Focus* 10, no. 1 (January 1, 2012): 90–101, https://doi.org/10.1176/appi.focus.10.1.90.

31. Author interview with Katja Schmalenberger, July 11, 2022.

32. Author interview with Tory Eisenlohr-Moul, July 11, 2022.

33. Emma M. Steinberg et al., "Rapid Response to Fluoxetine in Women with Premenstrual Dysphoric Disorder," *Depression and Anxiety* 29, no. 6 (June 1, 2012): 531–40, https://doi.org/10.1002/da.21959.

34. Author interview with Tory Eisenlohr-Moul, July 11, 2022.

35. Ibid.

36. Holly Yan, "Donald Trump's 'Blood' Comment About Megyn Kelly Draws Outrage," CNN, August 8, 2015, https://edition.cnn.com/2015/08/08/politics/donald-trump-cnn-megyn-kelly-comment/index.html.

CHAPTER TWO: THE PERIODIC SILENCE AROUND MENSTRUATION

1. World Bank Group, "Menstrual Health and Hygiene," World Bank, May 18, 2022, https://www.worldbank.org/en/topic/water/brief/menstrual-health-and-hygiene.

2. "Overcoming Period Stigma in the Workplace," DPG, May 19, 2019, https://dpglearn.co.uk/blog/human-resources/overcoming-period-stigma-in-the-workplace/.

3. Jennifer Weiss-Wolf, *Periods Gone Public: Taking a Stand for Menstrual Equity* (Arcade, 2019), 3–4.

4. Tina Charisma, "A Brief History of Onscreen Periods," *Vulture*, April 1, 2021, https://www.vulture.com/article/periods-in-movies-and-tv.html.

5. Joan C. Chrisler, "Leaks, Lumps, and Lines," *Psychology of Women Quarterly* 35, no. 2 (April 18, 2011): 202–14, https://doi.org/10.1177/0361684310397698.

6. Amanda Fortini, "First Blood: Introducing 'Menstrual Activism,'" *Salon*, October 6, 2009, https://www.salon.com/2009/10/06/menstruation _moment/.

7. Delfin A. Tan, Rohana Haththotuwa, and Ian S. Fraser, "Cultural Aspects and Mythologies Surrounding Menstruation and Abnormal Uterine Bleeding," *Best Practice and Research Clinical Obstetrics and Gynaecology* 40 (April 2017): 121–33, https://doi.org/10.1016/j.bpobgyn .2016.09.015.

8. Julie Hennegan et al., "Women's and Girls' Experiences of Menstruation in Low- and Middle-Income Countries: A Systematic Review and Qualitative Metasynthesis," *PLOS Medicine* 16, no. 5 (May 16, 2019), https://doi .org/10.1371/journal.pmed.1002803.

9. Rojita Adhikari, "Bringing an End to Deadly 'Menstrual Huts' Is Proving Difficult in Nepal," *BMJ* 368, February 14, 2020, m536, https://doi.org/10 .1136/bmj.m536.

10. Tan, Haththotuwa, and Fraser, "Cultural Aspects," 124.

11. Ibid., 126.

12. Ibid., 127.

13. Ibid.

14. Erving Goffman, *Stigma: Notes on the Management of Spoiled Identity* (Touchstone, 1986), 4.

15. Ingrid Johnston-Robledo and Joan C. Chrisler, "The Menstrual Mark: Menstruation as Social Stigma," *The Palgrave Handbook of Critical Menstruation Studies* (Palgrave Macmillan, 2020), 181–99, https://doi.org/10 .1007/978-981-15-0614-7_17.

16. Yu-Ting Chang, Mark Hayter, and Mei-Ling Lin, "Pubescent Male Students' Attitudes Towards Menstruation in Taiwan: Implications for Reproductive Health Education and School Nursing Practice," *Journal of Clinical Nursing* 21, no. 3–4 (February 25, 2011): 516, https://doi.org/10 .1111/j.1365-2702.2011.03700.x.

17. Chrisler, "Leaks, Lumps, and Lines."

18. Erchull and Crisler, cited in Johnston-Robledo and Chrisler, "Menstrual Mark."

19. Char Adams, "Kiran Gandhi, Period Runner, Speaks Out Against Critics," *People*, August 13, 2015, https://people.com/celebrity/kiran-gandhi -period-runner-speaks-out-against-critics/.

20. Elaine Showalter and English Showalter, "Victorian Women and Menstruation," *Victorian Studies* 14, no. 1 (September 1970): 83–89, http:// www.jstor.org/stable/3826408.

21. Marquis de Sade, *The 120 Days of Sodom* (Supervert, 2002), 226, http://www.16beavergroup.org/pdf/120_days_of_sodom.pdf.

22. Ibid., 343–49.

23. Rhea Parsons, "The Portrayal of PMS on Television Sitcoms," *MP: An Online Feminist Journal* 1, no. 1 (December 2004): 40, http://academinist.org/wp-content/uploads/2010/06/010104Parsons_PMS.pdf.

24. *All in the Family*, season 3, episode 24, "The Battle of the Month," written by Norman Lear, Michael Ross, and Bernard West, directed by Bob LaHendro and John Rich, aired March 24, 1973, on CBS.

25. John Brady, "Keep Archie Engaging and Enraging," *New York Times*, February 24, 1974, https://www.nytimes.com/1974/02/24/archives/keeping-archie-engaging-and-enraging-keeping-archie-engaging.html.

26. Little_Jemmy, "AITA for Picking Up Glass with a Sanitary Napkin," Reddit, May 17, 2021, https://www.reddit.com/r/AmItheAsshole/comments/neym2f/aita_for_picking_up_glass_with_a_sanitary_napkin.

27. "Almost Half of Girls Aged 14–21 Are Embarrassed by Their Periods," Plan International, January 5, 2018, https://plan-uk.org/media-centre/almost-half-of-girls-aged-14-21-are-embarrassed-by-their-periods.

28. Tomi-Ann Roberts et al., "'Feminine Protection': The Effects of Menstruation on Attitudes Towards Women," *Psychology of Women Quarterly* 26, no. 2 (June 2002): 131–39, https://doi.org/10.1111/1471-6402.00051.

29. Anne Figert, *Women and the Ownership of PMS: The Structuring of a Psychiatric Disorder (Social Problems and Social Issues)* (Aldine Transaction, 1996), 11.

30. *Taxi*, season 5, episode 24, "Simka's Monthlies," written by James L. Brooks, Stan Daniels, and David Davis, directed by Harvey Miller, aired June 15, 1983, on NBC.

31. Parsons, "The Portrayal of PMS," 42.

32. Johnston-Robledo and Chrisler, "Menstrual Mark."

33. Chang, Hayter, and Lin, "Pubescent Male Students," 516.

34. Margaret L. Schmitt et al., "'It Always Gets Pushed Aside': Qualitative Perspectives on Puberty and Menstruation Education in U.S.A. Schools," *Frontiers in Reproductive Health* 4 (October 21, 2022), https://doi.org/10.3389/frph.2022.1018217.

35. Office of Communications, "Puberty and Precocious Puberty," NIH, June 21, 2021, https://www.nichd.nih.gov/health/topics/puberty.

36. Beth Greenfield, "What's the State of Menstrual Education in U.S. Schools? 'Significantly Lacking,' Say Experts," Yahoo News, November 10, 2018, https://www.yahoo.com/now/whats-state-menstruation-education-u-s-schools-significantly-lacking-say-experts-130030452.html.

37. Bodyform, "Fear Going to School Less," February 10, 2023, https://www.bodyform.co.uk/our-world/fear-going-to-school-less/.

38. Lars Jacobsson, "What Causes Stigma?," *World Psychiatry* 1, no. 1 (January 31, 2002): 25–26.

39. Graham Thornicroft et al., "Stigma: Ignorance, Prejudice or Discrimination?," *British Journal of Psychiatry* 190, no. 3 (2007): 192–93, doi:10.1192/bjp.bp.106.025791.

40. Plato, *Timaeus* (Harvard University Press, 1925), http://www.perseus.tufts.edu/hopper/text?doc=Perseus:text:1999.01.0180:text=Tim.:page=91.

41. Tan, Haththotuwa, and Fraser, "Cultural Aspects," 123.

42. Ibid.

43. Helen Rodnite Lemay, *Women's Secrets: A Translation of Pseudo-Albertus Magnus' De Secretis Mulierum with Commentaries* (State University of New York Press, 1992), 60.

44. Markus Führer, "Albert the Great," *Stanford Encyclopedia of Philosophy*, Summer 2022 edition, ed. Edward N. Zalta, https://plato.stanford.edu/archives/sum2022/entries/albert-great.

45. Lemay, *Women's Secrets*, 1.

46. Sari Katajala-Peltomaa, *Demonic Possession and Lived Religion in Later Medieval Europe* (Oxford University Press, 2020), 46–48.

47. Sarah Ferber, "Demonic Possession, Exorcism, and Witchcraft," in *The Oxford Handbook of Witchcraft in Early Modern Europe and Colonial America*, ed. Brian P. Levack (Oxford University Press, 2013), 32, https://doi.org/10.1093/oxfordhb/9780199578160.013.0033.

48. History.com editors, "History of Witches," History.com, October 20, 2020, https://www.history.com/topics/folklore/history-of-witches.

49. Michael Stolberg, "The Monthly Malady: A History of Premenstrual Suffering," *Medical History* 44, no. 3 (July 1, 2000): 301–22, https://doi.org/10.1017/s0025727300066722.

50. Ibid., 312.

51. Elaine Showalter, *The Female Malady: Women, Madness and English Culture, 1830–1980* (Virago Press, 1985), 129–30.

52. Ibid., 8.

53. Ibid., 26–32.

54. Ibid., 52–53.

55. Ibid., 57.

56. Ibid., 62–65.

57. Ibid., 65.

58. Ibid., 172.

59. Helen King, "Once Upon a Text: Hysteria from Hippocrates," in *Hysteria*

Beyond Freud, ed. Sander L. Gilman et al. (University of California Press, 1993), 4–5.

60. Ilza Veith, *Hysteria: The History of a Disease* (University of Chicago Press, 1970), 4–15.

61. King, "Once Upon a Text."

62. The Pink Book, "Diphtheria," n.d., https://www.cdc.gov/vaccines/pubs /pinkbook/dip.html.

63. Murray Peshkin, "Béla Schick as I Know Him," *International Archives of Allergy and Immunology* 12, no. 1–2 (1958): 11–16, https://doi.org/10 .1159/000228438.

64. Béla Schick, "Das Menstruationsgift," trans. Jennifer Zelinsky, *Wiener klinische Wochenschrift* 33, no. 19 (May 1920): 395–96, https://archive.org /details/wienerklinischew33unse.

65. Frank von Krogmann, "Béla Schick (1877–1967) und seine Entdeckung: 'Das Menotoxin,'" *Würzburger medizinhistorische* 17 (1998): 21–30. Translated for author by Google Translate.

66. J. A. Bryant, D. G. Heathcote, and V. R. Pickles, "The Search for 'Menotoxin,'" *Lancet* 309, no. 8014 (1977): 753, https://doi.org/10.1016 /S0140-6736(77)92199-7.

67. Von Krogmann, "Béla Schick."

68. Author interview with Jamie Hittman, June 9, 2022.

69. Bernhard Zondek, "Does Menstrual Blood Contain a Specific Toxin?," *American Journal of Obstetrics and Gynecology* 65, no. 5 (1953): 1065–68, https://doi.org/10.1016/0002-9378(53)90636-X.

70. Afton Vechery, "Why Is Women's Health Still So Under-Researched?," *Fortune*, March 9, 2021, https://fortune.com/2021/03/09/womens-health -research-fda-trials/.

71. Rieke Van Der Graaf et al., "Fair Inclusion of Pregnant Women in Clinical Trials: An Integrated Scientific and Ethical Approach," *Trials* 19, no. 1 (January 28, 2018), https://doi.org/10.1186/s13063-017-2402-9.

72. Vechery, "Why Is Women's Health Still So Under-Researched?"

73. Deb Gordon, "It's Long Past Time to Invest in Women's Health," HealthyWomen, June 16, 2021, https://www.healthywomen.org/your-care/past -time-invest-womens-health.

74. Nicola Slawson, "'Women Have Been Woefully Neglected': Does Medical Science Have a Gender Problem?," *The Guardian*, November 2, 2020, https://www.theguardian.com/education/2019/dec/18/women-have-been -woefully-neglected-does-medical-science-have-a-gender-problem.

75. Allison R. Casola et al., "Menstrual Health Stigma in the United States: Communication Complexities and Implications for Theory and Practice,"

Journal of Midwifery and Women's Health 66, no. 6 (February 22, 2021): 725–28, https://doi.org/10.1111/jmwh.13216.

76. Linda Searing, "The Big Number: Women Now Outnumber Men in Medical Schools," *Washington Post*, December 23, 2019, https://www.washingtonpost.com/health/the-big-number-women-now-outnumber-men-in-medical-schools/2019/12/20/8b9eddea-2277-11ea-bed5-880264cc91a9_story.html.

77. "Endometriosis," Yale Medicine, August 11, 2022, https://www.yalemedicine.org/conditions/endometriosis.

78. Pearlstein and Steiner, "Premenstrual Dysphoric Disorder."

79. Toni Brannagan, "How You Can Overcome Period Shame," Thinx, September 19, 2018, https://www.thinx.com/thinx/blogs/periodical/archive/overcome-period-shame-swns-infographic.

80. Barbara Goldberg, "U.S. Women Push Back Against Stigma, Cost of Menstruation," Reuters, March 10, 2016, https://www.reuters.com/article/us-usa-menstruation/u-s-women-push-back-against-stigma-cost-of-menstruation-idUSKCN0WA1RG.

CHAPTER THREE: THE BRIEF, SENSATIONAL HISTORY OF PMS

1. P. M. Shaughn O'Brien, Andrea Rapkin, and Peter J. Schmidt, ed., *The Premenstrual Syndromes: PMS and PMDD* (CRC Press, 2007), 2.

2. Robert T. Frank, "The Hormonal Causes of Premenstrual Tension," *Archives of Neurology and Psychiatry* 26, no. 5 (November 1, 1931): 1053, https://doi.org/10.1001/archneurpsyc.1931.02230110151009.

3. Author interview with Jamie Hittman, February 10, 2023.

4. Karen Horney, *Feminine Psychology* (W. W. Norton, 1967), 99.

5. Ibid., 101.

6. Ibid., 102.

7. Bianca Zietal, "Katharina Dorothea Dalton (1916–2004)," *Embryo Project Encyclopedia* (2017), https://embryo.asu.edu/pages/katharina-dorothea-dalton-1916-2004.

8. Raymond Greene and Katharina Dalton, "The Premenstrual Syndrome," *BMJ* 1, no. 4818 (May 9, 1953): 1007–14, https://doi.org/10.1136/bmj.1.4818.1007.

9. Ibid.

10. Ibid.

11. Caroline Richmond, "Katharina Dalton," *The Guardian*, September 29, 2004, https://www.theguardian.com/news/2004/sep/30/guardianobituaries.health.

12. Katharina Dalton, "Effect of Menstruation on Schoolgirls' Weekly Work," *BMJ* 1 (January 30, 1960): 326, https://doi.org/10.1136/bmj.1.5169.326.

13. Katharina Dalton, "Menstruation and Crime," *BMJ* 2, no. 5269 (December 30, 1961): 1752–53, https://doi.org/10.1136/bmj.2.5269.1752.

14. Lee Solomon, "Premenstrual Syndrome: The Debate Surrounding Criminal Defense," *Maryland Law Review* 54, no. 2 (January 1, 1995): 571, https://digitalcommons.law.umaryland.edu/cgi/viewcontent.cgi?article =2947&context=mlr.

15. Candy Pahl-Smith, "Premenstrual Syndrome as a Criminal Defense: The Need for a Medico-Legal Understanding," *North Carolina Central Law Review* 15, no. 2 (January 1, 1985): 246, https://archives.law.nccu.edu/cgi /viewcontent.cgi?article=1480&context=ncclr.

16. Ibid.

17. "A British Woman Who Said Pre-Menstrual Tension Drove Her . . ." UPI, November 11, 1981, https://www.upi.com/Archives/1981/11/11/A -British-woman-who-said-pre-menstrual-tension-drove-her/4609374 302800/.

18. Solomon, "Premenstrual Syndrome."

19. Joan Chrisler, "Hormone Hostages: The Cultural Legacy of PMS as a Legal Defense," in *Charting a New Course for Feminist Psychology*, ed. Lynn Collins, Michelle Dunlap, and Joan Chrisler (Praeger, 2002), 240.

20. Anne Figert, *Women and the Ownership of PMS: The Structuring of a Psychiatric Disorder* (Routledge, 2017), 38. All citations are from this edition unless otherwise noted.

21. "International Classification of Diseases, (ICD-10-CM/PCS) Transition," n.d., https://www.cdc.gov/nchs/icd/icd10cm_pcs_background.htm.

22. Author interview with Janet Williams, July 27, 2022.

23. Allan V. Horwitz, "*DSM-I* and *DSM-II*," *The Encyclopedia of Clinical Psychology*, May 28, 2014, 1–6, https://doi.org/10.1002/9781118625392 .wbecp012.

24. Jack Drescher, "Out of DSM: Depathologizing Homosexuality," *Behavioral Sciences* 5, no. 4 (December 4, 2015): 565–75, https://doi.org/10 .3390/bs5040565.

25. Peter Falkai, Andrea Schmitt, and Nancy Andreasen, "Forty Years of Structural Brain Imaging in Mental Disorders: Is It Clinically Useful or Not?," *Dialogues in Clinical Neuroscience* 20, no. 3 (September 1, 2018): 179–86, https://doi.org/10.31887/dcns.2018.20.3/pfalkai.

26. Author interview with Allan Horwitz, April 29, 2022.

27. Shadia Kawa and James Giordano, "A Brief Historicity of the *Diagnostic and Statistical Manual of Mental Disorders*: Issues and Implications for the Future of Psychiatric Canon and Practice," *Philosophy, Ethics, and Humanities in Medicine* 7, no. 1 (2012): 2, https://doi.org/10.1186 /1747-5341-7-2.

28. Allen Frances, "Robert Spitzer: The Most Influential Psychiatrist of His Time," *Lancet Psychiatry* 3, no. 2 (February 1, 2016): 110–11, https://doi.org/10.1016/s2215-0366(16)00007-9.

29. American Psychiatric Association, "DSM History," https://www.psychiatry.org/psychiatrists/practice/dsm/about-dsm/history-of-the-dsm#section_2.

30. Frances, "Robert Spitzer: The Most Influential Psychiatrist of His Time."

31. Benedict Carey, "Psychiatrist Giant Sorry for Backing Gay 'Cure,'" *New York Times*, May 18, 2012, https://www.nytimes.com/2012/05/19/health/dr-robert-l-spitzer-noted-psychiatrist-apologizes-for-study-on-gay-cure.html.

32. Figert, *Women and the Ownership of PMS*, 38.

33. Ibid., 39.

34. Ibid., 50.

35. Author interview with Ira Glick, January 3, 2023.

36. Ibid.

37. Ibid.

38. Marcel Laurentiu Romanescu et al., "Sex-Related Differences in Pharmacological Response to CNS Drugs: A Narrative Review," *Journal of Personalized Medicine* 12, no. 6 (May 31, 2022): 907, https://doi.org/10.3390/jpm12060907.

39. Figert, *Women and the Ownership of PMS*, 40.

40. Ibid.

41. Gwyneth A. Sampson, "1 Premenstrual Syndrome," *Ballière's Clinical Obstetrics and Gynaecology* 3, no. 4 (December 1989): 687–704, https://doi.org/10.1016/s0950-3552(89)80060-4.

42. Ibid.

43. Figert, *Women and the Ownership of PMS*, 40.

44. Ibid., 41.

45. Ibid.

46. Paula J. Caplan, *They Say You're Crazy: How the World's Most Powerful Psychiatrists Decide Who's Normal* (Da Capo Lifelong Books, 1996), 86.

47. "Masochistic Personality Disorder," *APA Dictionary of Psychology*, https://dictionary.apa.org/masochistic-personality-disorder.

48. Figert, *Women and the Ownership of PMS*, 42.

49. Ibid., 43.

50. Ibid., 45.

51. Caplan, *They Say You're Crazy*, 98.

52. Author interview with Janet Williams, July 27, 2022.

53. Figert, *Women and the Ownership of PMS*, 48.

54. Ibid., 40.

55. Molly Sinclair, "Whispered Issue: Hormones and Women's Stability,"

Washington Post, September 2, 1984, https://www.washingtonpost.com
/archive/opinions/1984/09/02/whispered-issue-hormones-and-womens
-stability/f338997b-4597-43c2-b273-43dbb96e048a/.

56. Joan C. Chrisler and Paula J. Caplan, "The Strange Case of Dr. Jekyll and Ms. Hyde: How PMS Became a Cultural Phenomenon and a Psychiatric Disorder," *Annual Review of Sex Research* 13 (November 15, 2012): 285.

57. Chrisler, "Hormone Hostages," 241.

58. Ibid., 242.

59. *Married . . . with Children*, season 3, episode 4, "The Camping Show," written by Sandy Sprung, Marcy Vosburgh, and Michael G. Moye, directed by Garry Cohen, aired December 11, 1988, on Fox.

60. "Pride and Prejudice: A Latter Day Comedy," (2003), YouTube, https://www.youtube.com/watch?v=42XYXw5FNKY.

61. Sinclair, "Whispered Issue."

62. Chrisler and Caplan, "Strange Case," 284.

63. Sinclair, "Whispered Issue."

64. Chrisler and Caplan, "Strange Case," 284.

65. Carolina Aragão, "Gender Pay Gap in U.S. Hasn't Changed Much in Two Decades," Pew Research Center, March 1, 2023, https://www.pewresearch.org/fact-tank/2021/05/25/gender-pay-gap-facts/.

66. Jodi Kantor and Megan Twohey, "How to Measure the Impact of #Me-Too?," *New York Times*, October 3, 2022, https://www.nytimes.com/interactive/2022/10/03/us/me-too-five-years.html.

67. Figert, *Women and the Ownership of PMS*, 151.

68. Author interview with Allen Frances, November 14, 2022.

69. Author email with Sally Severino, May 14, 2022.

70. Ibid.

71. Ellen Frank and Sally Severino, "Premenstrual Dysphoric Disorder: Facts and Meanings," *Journal of Practical Psychiatry and Behavioral Health* (1995): 20–28.

72. Author interview with Sally Severino, May 25, 2022; email with Severino, May 30, 2022.

73. Author interview with Sally Severino, May 25, 2022.

74. Stephen W. Hurt et al., "Late Luteal Phase Dysphoric Disorder in 670 Women Evaluated for Premenstrual Complaints," *American Journal of Psychiatry* 149, no. 4 (April 1, 1992): 525–30, https://doi.org/10.1176/ajp.149.4.525.

75. Author email with Sally Severino, May 14, 2022.

76. Figert, *Women and the Ownership of PMS*, 158.

77. Caplan, *They Say You're Crazy*, 137.

78. Ibid.

79. Author email with Sally Severino, May 14, 2022.
80. Ibid.
81. Caplan, *They Say You're Crazy*, 123.
82. Figert, *Women and the Ownership of PMS*, 162.
83. Author interview with Joan Chrisler, November 24, 2020.
84. Author interview with Paula Caplan, March 4, 2021.
85. Clay Risen, "Paula Caplan, 74, Dies; Feminist Psychologist Took On Her Profession," *New York Times*, August 2, 2021, https://www.nytimes.com /2021/08/02/health/paula-caplan-dead.html.
86. Author interview with Tory Eisenlohr-Moul, November 10, 2020.

CHAPTER FOUR: THE DIAGNOSIS BLIND SPOT

1. MGH Center for Women's Mental Health, "Teen PMS and PMDD Guide," May 16, 2018, https://womensmentalhealth.org/resource-2/patient-support -services/teen-pms-and-pmdd-guide/.
2. "List: APA-DSM-IV_ DSM-IV-TR TASK FORCE," Alliance for Human Research Protection, n.d., https://ahrp.org/list-apa-dsm-iv_-dsm-iv-tr -task-force/.
3. Jean Endicott et al., "Is Premenstrual Dysphoric Disorder a Distinct Clinical Entity?," *Journal of Women's Health and Gender-Based Medicine* 8, no. 5 (June 1, 1999): 663–79, https://doi.org/10.1089/jwh.1.1999 .8.663.
4. Carla Spartos, "Sarafem Nation," *Village Voice*, December 5, 2000, https:// www.villagevoice.com/2000/12/05/sarafem-nation/.
5. Eli Lilly, Annual Report, March 28, 2001, https://investor.lilly.com/node /26311/html.
6. Jeff Swiatek, "10 All-Time Greatest Eli Lilly Drugs," *IndyStar*, December 29, 2015, https://www.indystar.com/story/money/2015/12/28/10-all -time-greatest-eli-lilly-drugs/76070470/.
7. Ibid.
8. "A Pill That Changed the World," *The Economist*, August 3, 2001, https:// www.economist.com/unknown/2001/08/03/a-pill-that-changed-the -world.
9. Spartos, "Sarafem Nation."
10. "Lilly Loses Court Fight over Prozac Patent," *New York Times*, January 15, 2002, https://www.nytimes.com/2002/01/15/business/lilly-loses-court -fight-over-prozac-patent.html.
11. "Lilly Seeks to Sell New Prozac Version," *New York Times*, March 15, 2000, https://www.nytimes.com/2000/03/15/business/lilly-seeks-to-sell -new-prozac-version.html.

12. Eli Lilly, Annual Report.

13. "Lilly Seeks to Sell New Prozac Version."

14. John O'Neil, "Cut Back on Prozac, with New Prozac," *New York Times*, March 6, 2001, https://www.nytimes.com/2001/03/06/health/cut-back -on-prozac-with-new-prozac.html.

15. Shankar Vedantam, "Renamed Prozac Fuels Women's Health Debate," *Washington Post*, April 29, 2001, https://www.washingtonpost.com/archive/politics /2001/04/29/renamed-prozac-fuels-womens-health-debate/b05311b4-514a -4e65-aaa5-434cb2934271/.

16. Ibid.

17. "Early Sarafem Commercials," YouTube, 1:00, https://www.youtube.com /watch?v=2TPtuPt_5Uc.

18. Paula J. Caplan, "The Debate About PMDD and Sarafem," *Women and Therapy* 27, no. 3–4 (March 3, 2004): 55–67, https://doi.org/10.1300 /j015v27n03_05.

19. Eli Lilly, Annual Report.

20. Vedantam, "Renamed Prozac."

21. Spartos, "Sarafem Nation."

22. Tung-Ping Su et al., "Fluoxetine in the Treatment of Premenstrual Dysphoria," *Neuropsychopharmacology* 16 (May 1, 1997): 346–56, https://doi .org/10.1016/s0893-133x(96)00245-x.

23. John Fauber, Kristina Fiore, and Matthew Wynn, "For One Condition, the Drugs Came Before the Disorder," *Milwaukee Journal Sentinel*, November 15, 2016, https://www.jsonline.com/story/news/investigations /2016/11/16/one-condition-drugs-came-before-disorder/93823042/.

24. Caplan, "Debate About PMDD and Sarafem."

25. Ibid.

26. Jennifer Daw, "Is PMDD Real?," *Monitor on Psychology* 33, no. 9 (October 2002): 58, https://www.apa.org/monitor/oct02/pmdd.

27. Ray Moynihan, "Controversial Disease Dropped from Prozac Product Information," *BMJ* 328 (February 12, 2004): 365, https://doi.org/10.1136 /bmj.328.7436.365.

28. Emma Steinberg et al., "Rapid Response to Fluoxetine in Women with Premenstrual Dysphoric Disorder," *Depression and Anxiety* 29, no. 6 (June 1, 2012): 531–40, https://doi.org/10.1002/da.21959.

29. Fauber et al., "For One Condition."

30. Sharon Begley, "The 'DSM-5': Introducing the Latest Edition of Psychiatry's Diagnostic Bible," *Pacific Standard*, June 14, 2017, https:// psmag.com/social-justice/dsm-psychiatry-diagnostic-bible-mental -disorders-58075.

31. Peter Schmidt et al., "Differential Behavioral Effects of Gonadal Steroids

in Women with and in Those Without Premenstrual Syndrome," *New England Journal of Medicine* 338, no. 4 (January 22, 1998): 209–16, https://doi.org/10.1056/nejm199801223380401.

32. Author interview with Peter Schmidt, June 2, 2023.

33. Robert L. Reid, "Premenstrual Dysphoric Disorder (Formerly Premenstrual Syndrome)," table 1, *Endotext*, ed. Kenneth R Feingold et. al., MD Text.com, January 1, 2000, http://pubmed.ncbi.nlm.nih.gov/25905274/.

34. C. Neill Epperson et al., "Premenstrual Dysphoric Disorder: Evidence for a New Category for DSM-5," *American Journal of Psychiatry* 169, no. 5 (May 1, 2012): 465–75, https://doi.org/10.1176/appi.ajp.2012.11081302.

35. American Psychiatric Association, "DSM-5-TR Fact Sheets," n.d., https://www.psychiatry.org/psychiatrists/practice/dsm/educational-resources/dsm-5-tr-fact-sheets.

36. Tamara Kayali Browne, "Is Premenstrual Dysphoric Disorder Really a Disorder?," *Journal of Bioethical Inquiry* 12, no. 2 (June 1, 2015): 313–30, https://doi.org/10.1007/s11673-014-9567-7.

37. Jeppe Schroll and Mette Petri Lauritsen, "Premenstrual Dysphoric Disorder: A Controversial New Diagnosis," *Acta Obstetricia et Gynecologica Scandinavica* 101, no. 5 (April 21, 2022): 482–83, https://doi.org/10.1111/aogs.14360.

38. Jon Jureidini and Leemon B. McHenry, *The Illusion of Evidence-Based Medicine: Exposing the Crisis of Credibility in Clinical Research* (Wakefield Press, 2020), 160.

39. Author interview with Peter Schmidt, August 30, 2022.

40. Peter Zachar and Kenneth S. Kendler, "A DSM Insiders' History of Premenstrual Dysphoric Disorder," in *Philosophical Issues in Psychiatry III: The Nature and Sources of Historical Change*, ed. Kenneth S. Kendler and Josef Parnas (Oxford University Press, 2014), 355.

41. Additional analysis run by Tory Eisenlohr-Moul on September 12, 2022, on a dataset from the following article: Liisa Hantsoo et al., "Patient Experiences of Health Care Providers in Premenstrual Dysphoric Disorder: Examining the Role of Provider Specialty," *Journal of Women's Health* 31, no. 1 (January 1, 2022): 100–9, https://doi.org/10.1089/jwh.2020.8797.

42. Hantsoo et al., "Patient Experiences."

43. Will Dunham, "Tall Tale: Study Reveals That Giraffes Are Four Species, Not One," Reuters, September 8, 2016, https://www.reuters.com/article/us-science-giraffe/tall-tale-study-reveals-that-giraffes-are-four-species-not-one-idUSKCN11E2PE.

44. Jean Endicott, John Nee, and William T. A. Harrison, "Daily Record of Severity of Problems (DRSP): Reliability and Validity," *Archives of Women's*

Mental Health 9, no. 1 (January 1, 2006): 41–49, https://doi.org/10.1007/s00737-005-0103-y.

45. IAPMD, "Tracking Your Cycle & Symptoms," https://iapmd.org/symptom-tracker.

46. Ibid.

47. Sam Dolnick and An Rong Xu, "He Had a Dark Secret. It Changed His Best Friend's Life," *New York Times*, December 16, 2022, https://www.nytimes.com/2022/07/08/nyregion/brooklyn-homeless-shelter-friendship.html.

48. Caplan, "Debate About PMDD and Sarafem."

CHAPTER FIVE: THE TREATMENT VOID

1. Author interview with Ruta Nonacs, March 9, 2021.

2. Thomas Reilly et al., "Intermittent Selective Serotonin Reuptake Inhibitors for Premenstrual Syndromes: A Systematic Review and Meta-Analysis of Randomised Trials," *Journal of Psychopharmacology* 37, no. 3 (2023): 261–67, https://doi.org/10.1177/02698811221099645.

3. Author interview with C. Neill Epperson, December 12, 2022.

4. Author interview with Namrata Menon, December 4, 2020.

5. Kabir Garg, C. Ganesh Kumar, and Prabha S. Chandra, "Number of Psychiatrists in India: Baby Steps Forward, but a Long Way to Go," *Indian Journal of Psychiatry* 61, no. 1 (January 1, 2019): 104–5, https://doi.org/10.4103/psychiatry.indianjpsychiatry_7_18.

6. Caitlin White, "Investing in a Diverse Mental Health Workforce Is Critical in This Moment," HealthCity, August 12, 2021, https://healthcity.bmc.org/policy-and-industry/investing-diverse-mental-health-workforce-critical-moment.

7. Author email with Namrata Menon, March 6, 2021.

8. Author interview with Vonda Burris, August 11, 2022.

9. Author interview with Anna Metzler, November 30, 2020.

10. Anna Metzler (@annanmetzler), "Unbelizable first solo trip . . ." TikTok, March 28, 2022, https://www.tiktok.com/@annanmetzler/video/7080366024863927595?is_copy_url=1&is_from_webapp=v1.

11. Author interview with Tanya Valor, December 9, 2020.

12. Sarah Nowell (@myholisticjourneywithPMDD), "I am what a person with an invisible illness looks like," Instagram, August 8, 2021, https://www.instagram.com/p/CSTwt4isIWU/.

13. Author interview with Sarah Nowell, February 18, 2021.

14. Author interview with Ruta Nonacs, March 9, 2021.

15. Suzanne McGee, "For Women, Being 13 Pounds Overweight Means Losing $9,000 a Year in Salary," *The Guardian*, July 19, 2017, https://www

.theguardian.com/money/us-money-blog/2014/oct/30/women-pay-get -thin-study.

16. Irene Van Woerden et al., "Young Adults' BMI and Changes in Romantic Relationship Status During the First Semester of College," *PLOS ONE* 15, no. 3 (March 26, 2020): e0230806, https://doi.org/10.1371/journal.pone .0230806.

17. "Attempts to Lose Weight Among Adults in the United States, 2013–2016," CDC, n.d., https://www.cdc.gov/nchs/products/databriefs/db313 .htm.

18. Adam Felman, "What Is Addiction?," *Medical News Today,* June 4, 2021, https://www.medicalnewstoday.com/articles/323465.

19. Stephanie Watson, "Serotonin: The Natural Mood Booster," Harvard Health Publishing, July 20, 2021, https://www.health.harvard.edu/mind -and-mood/serotonin-the-natural-mood-booster.

20. Author interview with Pedro Martinez, November 22, 2022.

21. Steven D. Targum, "Identification and Treatment of Antidepressant Tachyphylaxis," *Innovations in Clinical Neuroscience* 11, no. 3–4 (February 28, 2014): 24–28.

22. Author interview with Pedro Martinez, November 22, 2022.

23. Author interview with Ruta Nonacs, March 9, 2021.

24. American Psychiatric Association, *Diagnostic and Statistical Manual of Mental Disorders, Fifth Edition Text Revision* (American Psychiatric Association Publishing, 2022), 197.

25. Ibid.

26. Ibid.

27. Pearlstein and Steiner, "Premenstrual Dysphoric Disorder."

28. Author interview with Tory Eisenlohr-Moul, August 16, 2022.

29. Author interview with Meredith Davis, October 29, 2020.

30. Kyle Strimbu and Jorge A. Tavel, "What Are Biomarkers?," *Current Opinion in HIV and AIDS* 5, no. 6 (November 2010): 463–66, https://doi.org /10.1097/coh.0b013e32833ed177.

31. Author interview with Peter Schmidt, August 30, 2022.

32. "What is Sephranolone?," Asarina Pharma, n.d., https://asarinapharma .com/sepranolone.

33. Lara Tiranini and Rossella E. Nappi, "Recent Advances in Understanding/ Management of Premenstrual Dysphoric Disorder/Premenstrual Syndrome," *Faculty Reviews* 11 (April 28, 2022), https://doi.org/10.12703/r/11-11.

34. "What is Sepranolone?"

35. Ibid.

36. Ibid.

37. Asarina Pharma, "Asarina Pharma Reports Topline Results from Phase

IIb Study in PMDD," press release, November 4, 2020, https://mb.cision
.com/Main/17069/3093737/1233403.pdf.
38. Ibid.
39. Ibid.
40. IAPMD, "What Happened to the PMDD-Specific Treatment (Sepra-
nalone) That Was Being Developed?," n.d., https://faq.iapmd.org/en
/articles/4005826-what-happened-to-the-pmdd-specific-treatment
-sepranalone-that-was-being-developed.
41. Torbjörn Bäckström et al., "A Randomized, Double-Blind Study on Ef-
ficacy and Safety of Sepranolone in Premenstrual Dysphoric Disorder,"
Psychoneuroendocrinology 133 (September 23, 2021): 105426, https://doi
.org/10.1016/j.psyneuen.2021.105426.
42. Ruta Nonacs, "Sepranolone: A New Treatment for PMDD?," MGH Center
for Women's Mental Health, April 14, 2022, https://womensmentalhealth
.org/posts/pmdd-sepranolone.
43. Author interview with Tory Eisenlohr-Moul, November 10, 2020.
44. Jorge Lolas-Talhami, Juana Lafaja-Mazuecos, and D. Ferrández-Sempere,
"Is Premenstrual Syndrome a Uterine Inflammatory Disease? Retrospec-
tive Evaluation of an Etiologic Approach," *Open Journal of Obstetrics and
Gynecology* 5, no. 6 (June 3, 2015), https://doi.org/10.4236/ojog.2015.56044.
45. "Diclofenac (Oral Route)," Mayo Clinic, n.d., https://www.mayoclinic.org
/drugs-supplements/diclofenac-oral-route/proper-use/drg-20069748?p=1.
46. "Diclofenac," MedlinePlus, n.d., https://medlineplus.gov/druginfo/meds
/a689002.html.
47. Lolas-Talhami, Lafaja-Mazuecos, and Ferrández-Sempere, "Is Premen-
strual Syndrome a Uterine Inflammatory Disease?"
48. K. A. Stump-Sutliff, "What Is Cryotherapy?," WebMD, February 12, 2018,
https://www.webmd.com/cancer/cervical-cancer/what-is-cryotherapy.
49. Lolas-Talhami et al., "Is Premenstrual Syndrome a Uterine Inflammatory
Disease?"
50. IAPMD, "I've Heard about the Chilean Doctor, Jorge Lolas, Who Claims
He Has Cured People of PMDD. Is There Any Scientific Basis to Support
Dr. Lolas' Treatment Approach?," n.d., https://faq.iapmd.org/en/articles
/2728806-i-ve-heard-about-the-chilean-doctor-jorge-lolas-who-claims
-he-has-cured-people-of-pmdd-is-there-any-scientific-basis-to-support
-dr-lolas-treatment-approach.
51. Katharine Sanderson, "Two New Journals Copy the Old," *Nature* 463, no.
7278 (January 2010): 148, https://doi.org/10.1038/463148a.
52. Author interview with Peter Schmidt, November 22, 2022.
53. Substantial_Leg6760, "Stephanie Wolff at the Novus anti-aging center in
studio city, california?," Reddit, March 24, 2022, https://www.reddit.com

/r/PMDD/comments/tn6vwi/stephanie_wolff_at_the_novus_antiaging
_center_in/.

54. Author interview with Laura Beckman, November 8, 2022.

CHAPTER SIX: MAKING WORK WORK

1. Author interview with Allen Frances, November 14, 2022.
2. Author interview with Danielle Lenhard, May 2, 2022.
3. Author interview with Jessie, November 24, 2022.
4. "Guide to Disability Rights Laws," ADA.gov, November 21, 2022, https://www.ada.gov/resources/disability-rights-guide/.
5. Commonwealth of Massachusetts, "Employment Rights of People with Disabilities," Mass.gov, https://www.mass.gov/service-details/employment-rights-of-people-with-disabilities.
6. "Employees' Practical Guide to Requesting and Negotiating Reasonable Accommodation Under the Americans with Disabilities Act," Job Accommodation Network, https://askjan.org/publications/individuals/employee-guide.cfm.
7. Author interview with Heidi Liu, November 17, 2022.
8. Author interview with Alison Green, November 25, 2022.
9. Author interview with Rose, June 8, 2022.
10. Author interview with Moira Campbell, December 12, 2022.
11. Author email with Annika Waheed, November 28, 2022.
12. Author interview with Annika Waheed, June 16, 2022.
13. Carolina Aragão, "Gender Pay Gap in U.S. Hasn't Changed Much in Two Decades," Pew Research Center, March 1, 2023, https://www.pewresearch.org/fact-tank/2021/05/25/gender-pay-gap-facts/.
14. Richard Fry, "Women Now Outnumber Men in the U.S. College-Educated Labor Force," Pew Research Center, October 12, 2022, https://www.pewresearch.org/fact-tank/2022/09/26/women-now-outnumber-men-in-the-u-s-college-educated-labor-force/.
15. "Women in the Workplace," McKinsey & Company, 2019, https://wiw-report.s3.amazonaws.com/Women_in_the_Workplace_2019_mobile.pdf.
16. Ibid.
17. Emma Hinchliffe, "Female CEOs Run Just 4.8% of the World's Largest Businesses on the Global 500," *Fortune*, August 3, 2022, https://fortune.com/2022/08/03/female-ceos-global-500-thyssenkrupp-martina-merz-cvs-karen-lynch/.
18. Sarah O'Connor, "Punitive Sick Leave Rules Make Us All Pay," *Financial Times*, December 14, 2020, https://www.ft.com/content/8a5bccb5-ba86-4a0c-9777-d1283945106d.
19. Angela Haupt, "Menstrual Leave: Why Some Companies Are Offering

Time Off for Periods," *Washington Post*, May 25, 2022, https://www
.washingtonpost.com/wellness/2022/05/25/menstrual-leave-spain-paid
-benefits/.

20. Editorial Team, "Average Sick Days Per Year," Indeed, February 26,
 2021, https://www.indeed.com/career-advice/career-development/sick
 -days-per-year-average.

21. Haupt, "Menstrual Leave."

22. Julia Hollingsworth, "Should Women Be Entitled to Period Leave? These
 Countries Think So," CNN, November 21, 2020, https://edition.cnn.com
 /2020/11/20/business/period-leave-asia-intl-hnk-dst/index.html.

23. Author interview with Alison Green, November 25, 2022.

24. Department for Business, Energy and Industrial Strategy and Kevin Hol-
 linrake, "Millions of Britons to Be Able to Request Flexible Working on
 Day One of Employment," GOV.UK, December 5, 2022, https://www.gov
 .uk/government/news/millions-of-britons-to-be-able-to-request-flexible
 -working-on-day-one-of-employment.

25. Author interview with Bree Inkson, December 19, 2020.

26. U.S. Travel Association, "State of American Vacation," 2018, https://
 www.ustravel.org/system/files/media_root/document/StateofAmerican
 Vacation2018.pdf.

27. *People* Staff, "Americans Are Scared to Take Sick Days While Working
 from Home Amid Pandemic, Survey Finds," *People*, November 18, 2020,
 https://people.com/human-interest/americans-are-scared-to-take-sick
 -days-while-working-from-home-amid-pandemic-survey-finds/.

28. Laura K. Barger et al., "Impact of Extended-Duration Shifts on Medical
 Errors, Adverse Events, and Attentional Failures," *PLOS Medicine* 3, no. 12
 (December 12, 2006): e487, https://doi.org/10.1371/journal.pmed
 .0030487.

29. "'More Than Half' of Pilots Have Slept While Flying," *BBC News*, Septem-
 ber 27, 2013, https://www.bbc.com/news/uk-24296544.

30. Denise Garcia, "Ariana Huffington Describes the 4-Step Nighttime Rou-
 tine She Follows Every Day," CNBC, July 25, 2016, https://www.cnbc.com
 /2016/07/25/arianna-huffington-night-time-routine.html.

31. Shalene Gupta, "Arianna Huffington Wants Employers to Take Mental
 Health and Wellness More Seriously," *Fast Company*, June 7, 2022, https://
 www.fastcompany.com/90758972/arianna-huffington-wants-employers
 -to-take-mental-health-and-wellness-more-seriously.

32. Jena McGregor, "Remote Work Really Does Mean Longer Days—
 and More Meetings," *Washington Post*, August 4, 2020, https://www
 .washingtonpost.com/business/2020/08/04/remote-work-longer-days/.

CHAPTER SEVEN: IT'S NOT YOU, IT'S ME (AND PMDD)

1. "Facts and Figures," Vicious Cycle, https://www.viciouscyclepmdd.com /facts-figures.
2. Ibid.
3. Aaron Kinghorn, *Hope: A Guide to PMDD for Partners and Caregivers*, unpublished manuscript, November 2022, 7.
4. Ibid., 9.
5. Ibid., 176.
6. Ibid., 39.
7. Ibid., 178.
8. Ibid., 126.
9. Ibid., 183.
10. Ibid., 65.
11. IAPMDglobal, "PMDD / PME—Understanding and Coping with Premenstrual Anger, Irritability, & Hypersensitivity," December 14, 2022, https:// www.youtube.com/watch?v=VLqxb6Pc8MQ.
12. Author interview with Jess Peters, June 7, 2022.
13. "Facts and Figures," 2.
14. Author interview with Steph Cullen, December 6, 2022.
15. Author interview with Ashley, December 1, 2022.
16. Edwin R. Raffi and Marlene P. Freeman, "The Etiology of Premenstral Dysphoric Disorder: Five Interwoven Pieces," MGH Center for Women's Mental Health, https://womensmentalhealth.org/specialty-clinics-2/pms -and-pmdd/the-etiology-of-pmdd/.
17. Author interview with Sam, February 8, 2023.
18. Author interview with Kat Jackson, June 14, 2022.
19. Author interview with Jessie, November 24, 2022.
20. Plato, *Republic*, trans. F. M. Cornford (Oxford University Press, 1945), 444e.
21. Mike W. Martin, *From Morality to Mental Health: Virtue and Vice in a Therapeutic Culture* (Oxford University Press, 2006), 20.
22. Martin, *From Morality to Mental Health*, 4.
23. Hanna Pickard and Lisa Ward, "Responsibility Without Blame: Philosophical Reflections on Clinical Practice," in K. W. M. Fulford et al., eds., *The Oxford Handbook of Philosophy and Psychiatry* (2013; online ed., Oxford Academic, September 5, 2021), 1135, https://doi.org/10.1093/oxfordhb /9780199579563.013.0066.
24. Ibid.
25. Ibid., 1150.
26. John S. Kelly and Ellis Bird, "Improved Mood Following a Single Immersion

in Cold Water," *Lifestyle Medicine* 3, no. 1 (2021): e53, https://doi.org/10 .1002/lim2.53.

27. R. J. Lewicki, B. Polin, and R. B. Lount, "An Exploration of the Structure of Effective Apologies," *Negotiation and Conflict Management Research* 9 (2016): 177–96, doi:10.1111/ncmr.12073.

CHAPTER EIGHT: WHAT NEXT?

1. Nancy Schimelpfening, "Dixie D'Amelio Reveals She's Living with Premenstrual Dysphoric Disorder," Healthline, October 26, 2022, https://www.healthline.com/health-news/dixie-damelio-reveals-shes-living -with-premenstrual-dysphoric-disorder.

2. Pretty Basic Podcast (@prettybasicofficial), "Dixie opens up to us about recently being diagnosed with PMDD," TikTok, October, 19, 2022, https://www.tiktok.com/@prettybasicofficial/video/7156232120602479915?is _copy_url=1&is_from_webapp=v1.

3. "Our Story," IAPMD, https://iapmd.org/about.

4. Author interview with Sandi MacDonald, December 7, 2022.

5. Ibid.

6. Gloria Steinem, "If Men Could Menstruate," *Women's Reproductive Health* 6, no. 3 (July 3, 2019): 151–52, https://doi.org/10.1080/23293691 .2019.1619050.

7. Kaye-Lee Pantony and Paula J. Caplan, "Delusional Dominating Personality Disorder: A Modest Proposal for Identifying Some Consequences of Rigid Masculine Socialization," *Canadian Psychology* 32, no. 2 (April 1, 1991): 120–35, https://doi.org/10.1037/h0078977.

8. Ibid.

9. Allen Frances, "'Diagnosisgate' Deconstructed and Debunked," *Huff-Post*, May 6, 2015, https://www.huffpost.com/entry/diagnosisgate-paula -caplan_b_6818644.

10. New York City Department of Consumer Affairs, "From Cradle to Grave: The Cost of Being a Female Consumer," December 2015, https://www1 .nyc.gov/assets/dca/downloads/pdf/partners/Study-of-Gender-Pricing -in-NYC.pdf.

11. Shalene Gupta, "Too Nice to Lead? Unpacking the Gender Stereotype That Holds Women Back," HBS Working Knowledge, November 10, 2022, https://hbswk.hbs.edu/item/too-nice-to-lead-unpacking-the-gender-stereotype -that-holds-women-back.

12. "Gender Differences in Accepting and Receiving Requests for Tasks with Low Promotability | Gender Action Portal," n.d., https://gap.hks.harvard .edu/breaking-glass-ceiling-%E2%80%9Cno%E2%80%9D-gender -differences-declining-requests-non%E2%80%90promotable-tasks.

13. Katherine Ridgway O'Brien, "Just Saying 'No': An Examination of Gender Differences in the Ability to Decline Requests in the Workplace," Ph.D. diss. (Rice University, 2014), 48, https://scholarship.rice.edu/bitstream /handle/1911/77421/OBRIEN-DOCUMENT-2014.pdf?sequence=1 &isAllowed=y.

14. "Gender Differences."

15. Chrisler and Caplan, "Strange Case," 298.

16. Navpreet Kaur and Roger W. Byard, "Menstrual Health Management: Practices, Challenges and Human Rights Violations," *Medico-Legal Journal* 89, no. 4 (November 11, 2021): 241–46, https://doi.org/10.1177 /00258172211052111.

17. Alliance for Period Supplies, "Tampon Tax," September 21, 2022, https:// allianceforperiodsupplies.org/tampon-tax/.

18. Thinx & PERIOD, "State of the Period," May 2021, https://period.org /uploads/State-of-the-Period-2021.pdf.

19. Lizzy Burden, "Women Are Leaving the Workforce for a Little-Talked-About Reason," Bloomberg, June 18, 2021, https://www.bloomberg.com /news/articles/2021-06-18/women-are-leaving-the-workforce-for-a-little -talked-about-reason.

20. Adriana Dupita, Abhishek Gupta, and Tom Orlik, "Want to Add $20 Trillion to GDP? Empower Women," Bloomberg, March 8, 2021, https:// www.bloomberg.com/news/articles/2021-03-08/a-20-trillion-economic -boost-through-empowering-women-map.

21. "Mental Health Has Bigger Challenges than Stigma," Sapien Labs, 2021, https://mentalstateoftheworld.report/wp-content/uploads/2021/05/ Rapid-Report-2021-Help-Seeking.pdf.

22. Ibid.

23. @PMDDMemes, "PMDD Week 1–2; PMDD Week 3–4," Instagram, November 3, 2022, https://www.instagram.com/p/CkfLb7quv2h/?utm _source=ig_web_copy_link.

24. Author interview with Chelsea Wilde, November 14, 2022.

25. @PMDDMemes, "When you try to fix PMDD symptoms with essential oils," Instagram, March 16, 2023, https://www.instagram.com/p/CSTwt4isIWU /https://www.instagram.com/p/Cp104XQMhtF/.

EPILOGUE

1. Author interview with Brett Buchert, November 29, 2022.

2. Kendra Cherry, "INFJ: Introverted, Intuitive, Feeling, Judging," *Verywell Mind*, August 4, 2022, https://www.verywellmind.com/infj-introverted -intuitive-feeling-judging-2795978.

ABOUT THE AUTHOR

Shalene Gupta is a reporter whose work has appeared in *Fortune, The Atlantic*, ESPN, *Fast Company*, and *Harvard Business Review*. She is the coauthor of *The Power of Trust: How Companies Build It, Lose It, Regain It* with Harvard Business School professor Sandra Sucher. She has a BA in writing seminars and psychology from Johns Hopkins University and an MS from Columbia Journalism School.